Winning Tactics for Women Over Forty

How to take charge of your life and have fun doing it

Anne DeSola Cardoza and Mavis B. Sutton

Mills & Sanderson, Publishers
Bedford, Massachusetts
1988

Published by Mills & Sanderson, Publishers
Box U, Bedford, MA 01730
Copyright © 1988 Anne DeSola Cardoza and Mavis B. Sutton

All rights reserved. No part of this book may be reproduced without permission from the publisher, except by a reviewer who may quote brief passages in a review; nor may any part of this book be reproduced, stored in a retrieval system or copied by mechanical photocopying, recording or other means, without permission from the publisher.

LIBRARY OF CONGRESS
Library of Congress Cataloging-in-Publication Data

Cardoza, Anne.
 Winning tactics for women over forty: how to take charge of your life and have fun doing it / Anne DeSola Cardoza & Mavis B. Sutton.
 p. cm.
 Bibliography: p.
 ISBN 0-938179-09-8 (pbk.): $9.95
 1. Middle aged women—United States—Psychology. 2. Middle aged women—United States—Life skills guides. 3. Middle aged women—Employment—United States. 4. Single women—United States. 5. Self-actualization (Psychology) I. Sutton, Mavis B., 1935- II. Title
HQ1059.5.U5C37 1988
305.4—dc19 87-34768
 CIP

Dedication

This book is dedicated to Carolyn, Margaret, Elisabeth, Adonica, Renee, Naomi, Marilyn, Stefani, Minda, Diana, Bradlee, Yetta, Barbara, Sarah, Pat, Merble, Loretta, Eileen, Rosa, Betty, Karen, Anna, Joyce, Engin, Carmen, Deborah, Jane, Lorraine, Sylvia, Sadja, Dorothy, Raenice, Sophie, Catherine, Shirley, Amina, Rachelle, Bea, Marian, Lois, Dasha, Ena, Barbara, Elfriede, Maria, Linda, Pearl, Arlene, Charlotte, Keleen, Miriam, Augustine, Geraldine, Luz, Linette, Gina, Gislene, Sonia, Lilliana, Edith, Nettie, Sulma, Dolores, Irma, Mimi, Lillia, Alba, Marlyn, Marva, Nancy, Lucy, Evelyn, Marguerite, Renate, Ellen, Corliss, Lottie, Michelle, Bernadette, Ellyce, Angela, Nelia, Mildred, Victoria, Elizabeth, Mildred, Conchita, Patrica, Kathleen, Virginia, Hilda, Crystal, Iris, Esperanza, Belinda, Phillis, Frances, Adrienne, Mary, Gwendolyn, Irene, Sheila, Keiko, Laurease, Glenda, Vivian, Ann Marie, Christine, Gloria, Isabelle, Patricia, Marietta, Jean, Angelica, Rita, Judith, Dirce, Emma, Helen, Monsie, Susan, Angela, Bertha, Agatha, Ilona, Ola, Lydia, Wanda, Camille, Zoila, Theresa, Alice, Marcella, Lucille, Annick, Jacqueline, Almeda, Juanita, Cassie, Myrna, Ruth, Monica, Josiane, Janet, Armanda, Joanne, Yves, Deana, Netta, Angelina, Rosalia, Alicia, Marjorie, Nolita, Yvonne, Sandra, Monserrat, Adele, Micheline, Merlyn, Donna, Cherrimin, Alena, Prazel, Mimose, Rose Marie, Moirespe, Yolanda, Carol, Ernestine, Blaire, Iris, Camilla, Ruperta, Martha, Vernie, Anne, Marie-Lourdes, Diann, Marianne, Julie, Jasmine, Sandy, Elienne, Beryl, Sadako, Adeline, . . . and in loving memory of Birdie.

Cover design by Lyrl Ahern, Acton, MA
Typesetting by CopyRight, Inc., Bedford, MA
Printing/Manufacturing by Little River Press, Miami, FL

Contents

Introduction ix

Personal, Interpersonal and Social Aspects

1. The Times Are Really Changing! 3
 How our early conditioning needs re-evaluation.

2. My Disposition Depends on You! 17
 How we grew up expecting to depend on someone else forever and ever.

3. My Disposition Depends on Me! 31
 The secret of it all: self-approval, self-esteem, and self-love.

4. What Will You Do When He Is Far Away? 43
 Triumphing over personal loss.

5. How We Wish We Were in Love Again! 55
 Dating and mating again, after forty.

6. Life As a Shadow 69
 How to find fulfillment as a Corporate Wife.

7. Was There a Tavern in Your Town? 77
 Drugs, alcohol and the addicted woman.

8. We've All Got Lots of Living to Do! 87
 The challenge of passing years.

9. Facing Those Blues in the Night 99
 Conquering depression.

10. Beyond the Rainbow 115
Making your dreams come true.

11. Your Body, Your Soul 125
Here's to your very good health!

12. Say, Look Us Over! 135
Looking your best after forty.

Economic and Financial Challenges

13. What If We Don't Have a Barrel of Money? 149
Taking care of your financial situation.

14. Should We Call the Whole Thing Off? 159
What you need to know about separation and divorce.

15. It's Back to Work We Go! 169
Getting back into the job market.

16. Home Is Where the Heart Is 185
Finding affordable ways to live.

National and Global Perspectives

17. What a Wide and Wonderful World We Live In! 195

18. I Am, I Can, I Will! 211

Appendix

Counseling or Referral 221

Displaced Homemakers 221

Employment and/or Advocacy 222

Contents vii

Housing	222
Legal	223
Medical	223
Minority Women	223
Older Women	224
Widows	224
Volunteers	224
Professional Organizations	224
Women Business Owners	227
Miscellaneous	227

Introduction

The woman who arrives at the age of forty in this society faces a watershed in her development. On one hand, she is surrounded by an onslaught of advertising, both in print and on the television screen, extolling the glories of youthful vigor and beauty, while on the other, she faces the challenge of renewed personal growth that is essential in order to create a joyful life-after-children. Which to believe? The bombardment of images telling us that the best years of our life are over and gone, or our own intuitive feelings that we are about to step out onto a new, exciting, untraveled but rewarding path?

This is the time to challenge and disprove the Mythmakers! Youth is not necessarily glorious, not necessarily fulfilling, not necessarily romantic, and not necessarily the best time of our life. In its own way, time and place, it has been a period of growth, learning and experiment. But that phase, just like the larva stage of the caterpillar, is now finished. It is time for the butterfly to emerge!

Women who are able to look society in the eye and declare, "A pox on your myths—I am over forty and I am just learning to spread my wings and fly!", is the woman who will be able to face the future with courage, and the second part of life as a climax, instead of a decline. Even if you are a survivor of widowhood, separation, divorce, abuse or abandonment, you can learn to turn adversity into triumph. Throughout this book you will meet women who are exponents of pioneering, non-traditional ways of thinking and acting. You will learn how you too, like them, can seize fortyhood, fiftyhood or sixtyhood as an invitation to new growth, becoming the instigator and activator of your own good fortune. Yes, there

are real problems to be faced, but, given the choice, would you rather cave in to the difficulties of change or loneliness, or stand up and fight?

We will tackle money problems, housing problems and social problems among others, but we will think of them not as insurmountable obstacles on our path, but rather as hurdles which we can choose to go over, under, around or through. We will sometimes talk in terms of winning or guerilla tactics because the woman over forty tackling the established social order can be likened to the jungle tactician facing the organized militia. Both have a notable lack of supplies, funds, support and organizational knowhow. Both are faced with what appear to be insurmountable odds. Both need a superabundance of courage, determination, self-motivation and intelligence. The tools we will provide will become your arsenal. We will teach you how to use a whole new bag of tricks—not necessarily to usurp the old order of things, but certainly to make a place for yourself within it.

So, if you are the kind of woman who does not want to just sit there and grow older, but who wants to be able to take this wonderful opportunity that has been presented you by that imposter called Time, and to make the very most of it, then this book is for you!

Personal, Interpersonal and Social Aspects

1

The Times Are Really Changing!

How our early conditioning needs re-evaluation.

A woman's greatest period of growth potential occurs after the age of forty! How many of us believe, know, or have given any thought at all to this incredible fact? It is vitally important for women to realize that this exciting, energizing period of new growth occurs at a time when we have been taught to think that it is all over, bar the shouting. For years, we have been accustomed to adjusting our pace by looking to men for permission to grow, without understanding that men and women often develop at different rates, and at different times.

Remember when you were in school, and the girls were outstripping the boys in all ways, maturing faster physically, getting better grades? And then, suddenly, the boys caught up and became taller. Their voices dropped and we found that, for some reason, we could not do math anymore! That's when we began to learn to suppress our own natural drive toward winning, our own natural thrust for power and success. When we were young, winning was not considered ladylike. It was neither feminine nor appropriate to perform better than a boy. This led many of us down the garden path and into an overconsciousness of looks and dress, in order to "make

a good match," thereby assimilating power by reflecting it from a mate. This reflected glory led in turn to our dependence on a male, our need for his approval and support to convince us that we were really all right, and to our own loss of a sense of personal accomplishment–ability.

Let's think about men. Consider the fact that the forty-five year old man has often reached his peak in business and passed it physically. He may seek more nurturance and more youth-renewing activities as he feels himself to be in competition—both for career status and for women—with men younger, fitter and stronger than he is himself. Many a man past forty-five will change partners, discarding the spouse who reminds him of his own chronology and mortality, and choosing instead one who will make him feel, he believes, younger and more desirable again. An older man will often seek out the flattery which a younger woman is likely to give him, while a younger woman may look for the apparent sophistication and financial solidity of an older partner. Despite the gains made in the 1970s by the Women's Movement, there are still many young women, accustomed to receiving attention and financial support from father and unsure of their own capabilities, who will seek out a similarly powerful paternal figure in the shape of husband or lover. As a successful businessman said, when describing the recent second marriage of a professional colleague, "His wife has become interested in activities of her own. The more successful he became, the more she had to fight for her own identity. He's very successful and he gets lots of attention. His wife was taking him for granted, but a younger person looks up to him and flatters him, making him feel important. If a man has lost that adoration at home, he wants to get it back! It's mixed in with recapturing lost youth. A new person doesn't expect him to do menial chores. She just makes him feel good!"

As men turn to such supposedly youth-renewing and comforting activities as second marriages or May-December relationships, many women in their forties or fifties are seeking activities which will make them feel more grown-up, independent, responsible and powerful. Concern with physical appearance takes second place to concern for financial security and meaningful experiences,

especially in the world of work. We are ready to look outward, to take on independent projects, to open businesses, and generally to take a more active role in acquiring personal achievements. In many families, children have grown and flown, often to the far reaches of the continent, and those of us who have identified too strongly with motherhood have to grapple first with a sense of bereavement and then with the urgency of restructuring an old role into something new but equally important.

On the other hand, there are some wormen who are changing their lives by electing to become first-time mothers after forty. Others, challenging tradition, are waiting until menopause to adopt a child. Many of these first-time mothers are single, and do not plan to marry. More and more women are choosing divorce after twenty years or longer, opting to leave marriages that have proved to be painful, and risking the difficulties of re-entering the job market. The times are indeed changing, however slowly, and we are beginning to exercise choice. Women's lifestyles are, in fact, becoming extremly diverse and individualized. Certainly there is more acceptance now than ever before of non-traditional roles, expecially among women themselves.

At the same time, many women in midlife, especially those who have had to face severe loss or drastic life changes, are suffering from symptoms of self-doubt, fear of authority, craving for approval, or dread of abandonment and eventual Bagladyhood. These fears stem primarily from the fact that many of us have not had enough opportunity to develop and hone our skills and self-confidence in the rough and tumble of the marketplace, where rejection, aggression and a drive for power and autonomy are commonplace. Many women have an overwhelmingly difficult time handling the rejection that all of us, simply as members of the human race, must deal with—unless we are living the removed and protected life of a hermit. Not until we are able to recognize and understand our longstanding need to look to others for approval of ourselves and our actions, will we be able to reverse this harmful habit. Only by giving ourselves confirmation or blessing, instead of judgement, will we finally be able to appreciate our own talents. It is time to toss out that old fear of offending if we relish our own achievements, and

the similar fear that we will upset other people if we do not vanish safely into the crowd. Such continued self-denial leads us on a steadily downward path and often into the realms of ill-health, anxiety and depression. If we do not learn to tackle the pain of continued subservience, we can too easily welcome the apparent relief of a few too many tranquillizers or that daily glass or two of wine to numb the reality of an unfulfilling life.

Just as plants have a need to grow and to reach for the light, so too does a human being. For many years, we have nourished and nurtured others. Now we are offered the wonderful opportunity of letting go of former responsibilities, nurturing ourselves and seeing just how far we can go. And of course, how far each of us can go depends on how we view and respect ourselves.

Every women over forty is her own Soldier of Fortune. As midlife women, we are trying to preserve our heritage and feel good about ourselves at a time when fear of aging and the threat of becoming obsolete seem to endanger our very survival. The advertising industry, controlled mainly by men, continues to overuse the bikini beach beauty motif in its efforts to sell just about anything, thereby equating youthful good looks with desirability, and reinforcing the message that, as far as women are concerned, older is not better. Such daily indoctrination through the print media does as much damage to young women as it does to us, because it infers that, once they pass twenty-five or thirty, they will suddenly become undesirable. Additionally, any woman who sits in front of her television set absorbing the daily subliminal message beamed at her by the all too familiar Father/Daughter news-team, realizes soon enough that there is not going to be much support out there in the Real World for her emancipation. The cards are on the table and if she wants to win at this game, she is either going to have to bluff her way to victory or stack the deck in her own favor.

It is up to us to rise to the challenge of disproving these mythmakers because ours has been the *Generation of Change*. Raised to devote our lives to others, we are the ones who have had to re-group and re-design our lifestyles as society's emphasis has changed, swinging from approval of only the Nuclear Family lifestyle of father, mother and children, to a poorly defined, "You

wanted liberation, now you've got it!" challenge. Unlike our daughters who, as a consequence of the gains made by the Women's Movement, are preparing as diligently as their brothers for places in the high-priced job market, we brought into an old fashioned and now outdated belief system of marriage, motherhood and happy-ever-after. We are now told that we should instead be both holding our own in today's competitive job market and preparing to underwrite our generally pensionless future. For thousands of women this has meant finding ourselves with little or no appropriate training or experience with which to achieve such worthy results. We are in a position similar to that of the child movie star whose studio contract expires at puberty. On top of this, we face the stress of competing for jobs, promotions, dollars, and respect with younger women, as well as men of all ages—not a position with which we feel comfortable, having been socialized to nurture all these people, rather than compete with them! Then there is the factor of divorce, widowhood or abandonment which many of us are forced to face at just the same critical juncture in our development.

It is still possible, however, in spite of a late start, to develop the lifestyle we fear we have missed, if we are willing to take some chances, make some changes, develop new strategies and increase our own power. As mature women, we have everything in common! We all need the means to make our lifestyles enjoyable, affordable, self-controllable and effective. Let us start to achieve these goals by borrowing some techniques from the men and adapting the military strategy of Command, Control, Communications and Intelligence, known in military shorthand as "C^3I." A young army doctor describes C^3I as, "A system for insuring that a commander is able to communicate and receive intelligence from his units in the field, thereby retaining and executing control of a situation. C^3I results in a bi-directional flow of information." We will keep this description in mind while adapting the system to our own social battlefront situations.

Midlife women feel particularly vulnerable about personal survival and endurance, but any woman who can learn to understand and develop *her own power* can increase her arsenal of sophisticated techniques with which to take on the world. Most women do not

know their own strength! Your development of a reliable and enduring personal C^3I can reduce the ambiguity associated with years of underestimating your own abilities. Not until a woman has taken control of her own lifestyle, can she learn to manage and survive crisis.

In order to move from a familiar but dangerous state of dependence to independence, and to develop confidence-building techniques that will reduce tensions and the threat of midlife catastrophe, consider the following strategies, representing every woman's personal C^3I:

1. Never automatically accept other people's barriers, restrictions or negative belief-systems about you or your situation. Expressing, listening to, or believing in negative attitudes is both easy and lazy. Remember that there are always choices, and that you have free will!
2. Always question Authority. The authority figure may know less than you realize... or even less than you do!
3. Remember that any rule can be broken and every platitude repealed. Become the reformer in your own life by questioning old habits, instituting changes and reaching for new growth.
4. Do not be shy about receiving Attention. Women have traditionally sought Approval—from parents, teachers, husbands, bosses and even from children. Approval may make you feel temporarily secure, but Attention is much like free advertising and can be more valuable to you in the long run.
5. Try to empower others as you gain power for yourself. Like the successful entrepreneur, find a need and fill it!
6. Plan a campaign and set specific goals for yourself, remembering that a major campaign is usually won only after a series of minor skirmishes and setbacks.
7. Determine to re-create yourself in a new image of your own choosing!
8. Learn that you are entitled to receive, and not just to give.

9. Don't take rejection personally! And don't give up! Think of every problem as a challenge to your ingenuity rather than something that brings you to a stop. Life is a process, a never-ending path on which you are the traveler.
10. Never stay in a rut just because it is comfortable! Become a risk-taker and find new ways to think—especially about yourself!

Whenever you are confronted with a challenge, instead of handling it in a routine manner, realize that you have a choice of strategies and that there are at least three approaches from which you can choose. They are:

Traditional (or habitual),
Innovative (or intuitive),
Practical (or sensible).

Abbreviate these three to the acronym TIP, suggesting movement, and learn to vary your style. Don't approach each problem that comes along in the same old way. If you are going to be the fighter in your own campaign for a better life, remember that guerilla fighters do not follow Standard Operating Procedures! Most of us fall into the habit of responding to situations in a certain way. Someone says something to us and it "pushes a button." Whenever an event or a comment pushes a button for you, look at your response. Is it automatic? Do you respond with words or actions that you don't even think about? Are your responses helpful to you in most situations, or not? Does an ingrained response move you forward or simply serve as a defense to keep you in the same familiar place? If we think in chess terms, are you simply a pawn being pushed along one small space at a time, or are you a Queen with unlimited potential for movement in any direction?

Remember that you must become the only one in *real* charge and control of your own life, because you are the only one who *really* knows what your needs are. Others, especially family members and friends, who believe they have the best intentions at heart, will have their own hidden agendas where you are concerned. Use these tactics to re-model the facilities and equipment that you employ, whether in the form of speech or behavior patterns. How

can you re-design your environment through the use of new and improved plans and procedures, or new ways of thinking? Don't let life just happen to you! Open yourself up to the awareness that *now* is the ideal time to accept the challenge of midlife, to grow and prosper, and to become at peace with yourself.

It is difficult and unnecessary to pin age parameters on the term "midlife," so let us define it as that period during which you realize that circumstances and relationships around you are changing and that you are moving into a new role. This may be due to the sudden departure of children for college. It may be due to widowhood, divorce or separation. It may be perceived suddenly when you become a mother-in-law for the first time, or when your husband loses his job. It may coincide with the onset of menopause and an awareness of physical changes. It is a period similar in many ways to adolescence, a period of turbulence, of clarification and re-definition of your personhood.

From a survey we made of women in midlife, it becomes clear that there are three major battlefields or areas of concern. The women surveyed, whether single, married, separated, divorced or widowed, expressed anxiety over the following aspects of life:

Social—including personal, family and working relationships

Economic—including financial, housing, employment and medical situations

Global—including nuclear threat, world hunger, world peace and the state of the environment

With these challenges in mind, let us begin our campaign by an attack upon the Number One problem area, namely Social or Personal concerns. While it is true that the phrase "The feminization of poverty" is rapidly becoming more than mere words, with the majority of our nation's poor expected by the year 2000 to be women and children, no woman can hope to conquer her economic disadvantages before she has established herself in the position of Commander-in-Chief of her own life. This means knowing, respecting and loving who you are. It also means rallying yourself from the apparent defeats of a broken marriage, widowhood, or the loss

of any primary role such as Mother, or simply from the fear of growing older and having time pass you by. And it means using that newfound self-confidence to attack the second area of concern by creating emotional and economic security for yourself.

Although women are concerned about global issues, it is impossible to improve the conditions of the planet without first taking care of our own home. In other words, let us move from the individual to the group, from the smallest to the largest, from the microcosm to the macrocosm, remembering that the individual is an intimate and indispensable part of the whole. Only when we have tackled our personal and interpersonal concerns, can we move to attack our financial and economic problems. Once we have those vanquished, we can then make a sortie into the field of global politics, impacting in a personal way upon conditions relating to world peace, world hunger and the threat of nuclear destruction.

Remember that to help our larger family is impossible without first being in a position to help ourselves! Traditionally, few women over forty have had a power base. Money is power. Position is power. Knowledge is power. Now is the time, initially through knowledge and self-understanding, to build *an internal power-base* from which you can stage your legitimate attack upon a reluctant establishment. Once you feel better about yourself, you can achieve anything you want!

Throughout this book, we are going to consider the multiple choices available to women over forty today, because this is what will distinguish our generation of forty-plus from previous generations. This period in Western society is one of challenge and choice for mature women, whereas our mothers and grandmothers were, for the most part, settled into an unchanging role by the time they reached our age. They could count on the status quo. We cannot. They could expect to be respected, even revered for their age and wisdom. We cannot.

On the other hand, they could not expect to begin a new career once their children had left the house. We can! They could not anticipate moving to a town, state or country of their choice. We can! They could not believe in the possibility of financial independence after a lifetime of economic dependence. But we can!

This is a wonderful period in which to reach a fortieth or fiftieth birthday! Think of yourself as being inside a room with many doors. For many years you may have stayed in this secure and familiar room, regarding it either as a nest or a prison, or perhaps a combination of the two. Now you are being invited—or pushed by circumstance—to choose one of the doors and venture out. Will it be a doorway to education, to a career, to a divorce? Will it lead to excitement and achievement? That will be up to you. But you must understand that the old fetters that kept women "in their place" are daily being broken by women just like you, women who are looking forty, or fifty, or sixty in the eye, and saying, "Now it's time for me to find out who I really am, and what I can do!"

In each chapter of this book, you will learn about specific choices made by real individuals who are making their own non-traditional ways through the potential minefields of midlife. These women are representative of all those who have been brave enough to challenge the subliminal or overt inequities of the system under which we live, by making self-directed choices that they believe will lead them to greater independence and self-esteem. Like you, each woman had been conditioned in childhood and early womanhood to expect certain circumstances in her life, but has had to reassess her situation and readjust in order to successfully cope with changing times and expectations. Each woman will be identified by her first name only for the sake of privacy, but each story is completely true.

The first choice-maker/change-maker you will meet is an unmarried woman over forty who decided, that for her, life would be incomplete if she did not give birth to a child. Many single women approaching forty feel this way, but few are bold enough to follow through and act on their intuitive feelings. We were, after all, raised to believe in marriage before motherhood. We were raised to believe in the sanctity of marriage, one marriage which would last a lifetime. It takes a lot of courage to consider non-marriage and the desirability of bearing and raising a child completely alone, but Gail listened to an "inner voice."

Now forty-two, Gail was born in Arizona but grew up in a suburb of Los Angeles, California. Her father was a science teacher and her mother a professor of music. Gail and her four siblings were all taught to play muscial instruments from a very early age. At the age of nine, Gail chose the violin as here special instrument, and says that she always knew from that time that she would be a professional violinist. As she says, "I didn't really have to decide. It just fell right in my lap!"

She went through the public school system with honors, and studied music privately. From high school she went on to college in California, and suddenly found that for the very first time in her life, she was having trouble academically. She describes herself as being "freaked out" by the experience, but was saved by her musical skill. In her second year of college, she auditioned for the Los Angeles Philharmonic, and was accepted—at the age of nineteen. During this period of childhood and adolescence, she describes herself as being always of an independent spirit, never experiencing loneliness. In fact, sent to Girl Scout camp, she thought the homesickness referred to by the other girls meant "being sick of home."

After five years with the orchestra, she moved to the East Coast because of personal difficulties she was experiencing with another musician, a man she felt wanted to dominate both her and her music. She had never really been alone or apart from her family for any extended period before this, and the following year was painful as she learned how to live and act truly on her own for the first time in her life. During that first year, she went through a severe crisis in self-confidence as she struggled with the problems of being alone in a strange city.

After one year in Boston, Gail moved to New York to work for a friend who was the president of a firm that recorded music for television commercials. She began to play her violin for the advertising themes known as "jingles." This was to become a steady source of income as she received residuals each time the jingle was broadcast. She became a free-lance professional musician, working throughout the state of New York, playing for Broadway shows, at major music festivals, and as Principal Violin for two prominent philharmonic orchestras. She decided to complete her

college education as well, receiving a BA in Philosophy in 1983. She is currently enrolled in a graduate program that she plans to finish at her own pace.

During this period in New York, Gail developed and sustained a serious, long-term love relationship with a fellow musician. They expected to marry eventually, and to raise a family of three. As she says, however, "The first step was to live together, and we never could do it. We had separate apartments, and every time we were about to move in together, there was always a fight. I wound up going to shrinks and asking, 'What's wrong with me?' We never really got to the bottom of the problems, and after a while, he found a younger woman. I accepted and encouraged it because I realized our relationship just wasn't going to work out, even though it had lasted for eight years. Then, two months before my fortieth birthday, he took his toothbrush out of my apartment! I wept for two days until I realized that my life was my own again."

On the day of her fortieth birthday, Gail flew to Florida to be with a friend who had composed the music for a new ballet. After the opening, she went outside the theater and sat on the beach by herself. She thought to herself, "I'm forty, and this is a major thing! I guess I'll never have children." After mulling over this idea, she decided, sadly, that a childless life had its advantages, and that she would just have to make the best of it.

One month later, however, an old friend who lived abroad, came to town and stayed in her small apartment. Another musician, he too enjoyed jazz concerts, as she did. They spent time going to concerts and philosophizing about life. Although they were not intimate, one evening, as Gail describes it, "It dawned on me that I *did* want to have a child, and this would be my chance! So I asked him, would he be the father? He was pretty shocked at first, but he thought about it for a few days. At that time, we didn't converse really, we just poeticized! It was very romantic! He finally decided it would be all right, and we had a ten-day affair, wild and wonderful! Still, I really thought I had missed my ovulation time, and I didn't expect to be lucky enough to conceive right away. I realized, though, that I wanted to have a baby so badly that, if this failed,

I would find another father. I knew I wouldn't use artificial insemination, and I wouldn't think of tricking some guy. It would have to be someone I liked and respected and he would have no financial responsibility. I would give the child my name, and I would simply do it alone.

"Then I found I was, in fact, pregnant, and it was wonderful! Totally wonderful! But I went through some terrible trips during the first trimester when I felt I couldn't do it alone, and decided I was being terribly arrogant. But the father of the child was supportive, as was my sister. Without those two, I couldn't have gone through with it. I never felt so vulnerable and helpless in my life. The fact of being able to raise a child on my own with no help scared me! This anxiety lasted for about six weeks, but after that, the pregnancy was great. I was physically so healthy! I didn't need much sleep and I had no morning sickness. Such energy and vitality!"

Gail's child, a girl, just had her second birthday. How does this first-time, single mother feel now? "I feel wonderful! Now that I have her, I have no doubts that I made the right move. She's adding immensely to my life. I still have some times when I feel I need someone else close who knows her and knows me. I need a family around. I can't be objective about her, but I'm developing a network of women friends with children. There are three women I can talk to real closely about baby problems, and I do go out and ask! I pick up the phone and say 'Help!' much more than I ever used to. Of course, people ask about the missing father. I always respond that I'll tell my daughter the truth when the time is right. Her father came from abroad and spent a week with her when she was eight months old. He was very supportive. Of course, it left me for a while with a sense of loss that he chose to stay with his wife, and not with me. I guess, on the whole, I'm glad he is far away physically, but I'm also glad he calls once a month to be supportive, to care, and to be a friend."

Is Gail happier now? "Yes, definitely. My priorities have fallen into a much better place. I can't say I wouldn't marry if it seemed to add to my existence, but I'm very aware that the kind of man who would fit the bill is very rare. I'm content. I don't feel like

I'm missing anything. I'm lucky because I only work part-time but I get a full-time salary, so I can spend lots of time with the baby. I can't imagine being away from her from nine to five on a regular basis. She keeps me company, but I don't want to load her down with that responsibility. I do have a lover, now. He's an old friend from a long time ago who came back into my life right after the baby was born. It makes me feel like I have an ideal situation. I must have lucky stars shining for me!"

Gail made a decision that flies in the face of convention. She felt that the tradition of marriage as the necessary precursor of motherhood was going to deny her the joy of giving birth to and raising her own child. Remember the C^3I we mentioned earlier? Her C^3I meant taking *Command* of her own personal situation (one which had not been giving her maximum satisfaction), and *Controlling* it by using her *Intelligence* in the choice of a father and at the risk of rejection, *Communicating* her desire to the man she had chosen to fulfill her deeply felt need to have a child.

Certainly it took courage to make this decision, and certainly it will take continued couurage and determination to cope with the demands upon her as the sole parent of a lively, growing individual, in the face of subtle or overt social prejudice. She is, however, radiant, and feels a completion with her child that she might have missed forever had she chosen not to follow her heart and determine her future for herself, but simply resigned herself to the end of a long-term relationship that just did not work out as planned. The stigma of being an unmarried mother is rapidly disappearing as mature women choose motherhood without marriage and demonstrate that this lifestyle can bring its own joy and fulfillment.

As the years pass, we constantly learn and relearn that nothing remains static. We discover that nothing is as certain as changing circumstance. If we want to be happy, we must learn to follow the voice within. It may guide us onto unexpected highways and byways but can be counted on to lead us, if we let it, toward our own definition of Happy Ever After.

2

My Disposition Depends on You!

How we grew up expecting to depend on someone else forever and ever.

By far the biggest hurdle most women over forty face is the refocusing of energies from *Other* to *Self*. We have been taught, subtly and overtly, that we exist in order to make someone else happy, comfortable and secure. There is, of course, no real fault to be found in this philosophy. Women are nurturers by nature and we want to live in such a manner that we improve the quality of life of those around us, either by example or by direct contact. However, for many women, something has happened on the road to fulfillment. Instead of simply complementing others' lives, we have instead all too often made their lives the fulfillment of our ambition and have become dependent upon their success at the expense of our own.

It has been said that the truth behind the stereotype of the Jewish Mother, popularly criticized for being over-involved with her grown children's lives, is that here was a typical woman of intelligence, energy and aptitude who was denied the opportunity to get out and create her own success. True! And not just of Jewish Mothers, but

of so many mothers. Mothers of all nations and races have traditionally been encouraged to deny their own talents in favor of developing those of their children, or of creating an environment in which their husbands' talents can flourish. But we have found that we can support someone else's dream for just so long! Somewhere along the way many of us have lost our sense of personal identity because it has become almost entirely absorbed in that of another individual. Not only that, but the very one upon whom we have lavished our time and attention may have grown too accustomed to our face, and may feel a need to kiss it goodbye!

Fortunately, it is never too late to remember who we really are and to reconstruct our lives by examining our patterns of thinking and making constructive changes.

As an example, let us consider the case of Ruth, a woman of fifty who has been married for twenty-six years and who has raised three children. Her daughter is married, one son is in college and her youngest son has just graduated from high school. Her husband is completely involved in his executive job which takes him away from home for weeks at a time, and she suspects that he may be seeing another woman. As her youngest son backs his car out of the driveway on his way to college in a faraway state, she suddenly bottoms out in a panic of self-pity and loss.

This scenario, or a variation of it, is repeated daily throughout the United States, Canada, Australia and the United Kingdom. The woman in question may even be a working mother rather than a full-time homemaker like Ruth, someone who has maintained a low or middle-level position in the business world for many years, but who has never considered her work to be the prime factor in her life. Always it has been the family that is important, and suddenly the family is not there any more. For thousands of women in their forties or fifties, so much energy has been given to husband or family that any change of role feels like the equivalent of a job loss. What's to be done in a situation like this?

In considering Ruth's situation, think back for a moment to our reminder, TIP—Traditional, Innovative, or Practical approaches to every problem. The Traditional solution to this type of situation would be for Ruth to ignore her feelings, hoping either that the

problem will just go away, or that she will somehow adjust to it. Further, the traditional point of view would suggest that Ruth was probably to blame for the circumstances anyway because she wasn't exciting or glamorous enough to keep her husband at home. Many older women might, in fact, say to her, "What do you expect? Men are all alike! Let him run around—a man needs that." The most likely result would be that Ruth would continue to suffer. Her resentment at both her loss of identity and importance and the diminished source of her approval would continue to fester and eventually her body, which always reacts to what is going on in the mind, could manifest this imbalance in the form of migraine headaches, spastic colon, or some other physical ailment.

Would an Innovative approach be a better method for handling her crisis? The guerilla fighter's approach to tackling what appears to be an overwhelming situation, is first to establish a base camp, from which he groups his forces and assesses his strength. In Ruth's case, she could borrow this technique by taking the opportunity to gather herself together and assess her situation by doing some self-discovery exercises, one of which is shown on page 21. Let's call this The Base Camp Exercise because it aims at resolving basic issues such as, "What exactly is going on in my life?", "Where do I fit?", "What is my role or mission?"

Using an Innovative approach does not mean that you discard your feelings. Rather, you should feel that you are allowed to recognize them. Feelings should be felt, not suppressed. They should be acknowledged and examined, rather than swallowed whole like unpalatable pills. So, if you were Ruth, facing this or a similar situation, you might first call a good friend and tell her how miserable this change of circumstances is making you feel. If you are lucky, this will be a friend who has gone through a similar experience herself, one who will tell you how fortunate you are that your life is about to open up for you at long last. If, however, it is a friend who agrees with you that life has dealt you and all women a bad hand, that society is against you, and that you're never going to get anywhere, then hang up and call someone else.

Once you have shared your feelings with enough people, it is time to take stock. The best way to do this is with pencil and paper.

Somehow, putting thoughts down in black and white gives them credibility. You now have to take them seriously instead of just letting them rattle around in your head, making noise and getting you nowhere.

Begin by writing down the Heading, *What Is*. This is going to be Column Number One. The next column should be headed, *My Feelings*, and the third, *What I Want*. Under your first heading, list everything that has been happening to you, and under the second, how you feel about it. You may find yourself hesitating to write words like Resentful, Angry, Let Down, Neglected, Abandoned or Afraid, but do it anyway! It is when feelings are undefined that they can get the better of you. When you label them, you can take a good look at them and then decide to do something about them. You might even want to give them personalized characteristics in order to defuse some of their power over you. Be creative! For example, you might think of Worry as a large, soft, fuzzy, black gorilla. If you can see it that way, imagine that you can pick that gorilla up and put it in a chair in a corner of your living room. Once it is in the chair, you can stare it down and make it shrink. That will be the first intimation of the power you possess in your own mind, your own imagination, to control your feelings and to make them work for you instead of allowing them to control your actions and your future. You are going to make your willpower work for you instead!

Writing down what you want under Column Three may take some thought. If you have been focused primarily upon your family, you may not even know what it is you do want. You may feel incapable of achieving anything at all. If this is true of you, know that you are not alone. You have just joined a club of some million members. It is a transitory club, however, just there for you to park in momentarily while you think things over. In any case, put down a Goal, even if it has to be relatively undefined at this point. Job, New Home, Travel or Happiness are some examples.

Bear in mind that these feelings and goals should be You-oriented because you are working now on breaking your old dependency mold. By writing down your innermost thoughts, you will be able to see whether or not you are still inclined to piggyback your future

onto someone else's. Does your achievement dpend on another individual? Does your happiness depend upon getting married again? On moving closer to your children? For instance, suppose that Ruth had listed the following:

What Is	My Feelings	What I Want
Joe and the kids have left me.	Hurt, angry, lonely, afraid.	To have an affair. To get even. To feel better.

Her goals are very understandable under the circumstances, if we look at the feelings she is experiencing. In her anger at her husband she seeks revenge, and from her fear of loneliness she seeks companionship. Will she feel like a whole, healthy person by having a revengeful liaison? At first she may, but in the long run, probably not! What might begin as an attempt to feel loved and needed again, may only lead to further dependency. However, writing her thoughts down in this way will at least enable her to look at her current belief system and to ask herself, 'Is this what I really want?'

It would be healing for her to admit that she is also angry at her children for growing up and leaving her. This is perfectly normal. A necessary right of passage is bound to provoke strong emotions. The more passive participant in such a drama (usually the mother) will suffer far more than the active participant. Children who are leaving and setting out in search of new experiences are not likely to pay much attention to what is happening on the home front. Their attention is focused on the future, as Ruth's must now be.

Sitting still and seeing life change around you can be very disquieting, very threatening, and very fear-provoking. If you are currently facing loss or change in any form, be sure to do this exercise over and over again in order to get at and look at what is driving your motor right now. Often, the first time you do an exercise like this, only surface emotions are brought out. Repeating it a second

and third time, allowing your intuition to flow freely, will bring up to the surface factors that normally lie hidden from conscious awareness. Even if some of your feelings or wants sound bizarre, even if they seem unhealthy (by your own standards or those of society), get them out and write them down where you can see them. Remember that there is no need for you to share your notes with anyone else. You are spending private time on an important private enterprise!

When you have finished the exercise, look at the *What Is* column. How many of your entries relate to other people in your life? Is your future being programmed by others? Look at your list of *Feelings*. Are they acceptable to you? Look at Column Three, *What Do I Want?* How many of these entries need other people for their fulfillment?

While you are considering what you have put down, don't do any judging! Simply notice what proportion of your happiness and self-esteem hinges upon what other people are doing. Be aware, too, that your negative emotions, the ones about which you may feel guilty or uncomfortable, are part of the human condition. You are the ringmaster of this circus, however, and you are the one who can decide which feelings should be subdued and which given free rein.

The third column is involved with your future. It looks forward. Are your future dreams, wants and needs dependent upon others or are you about to move in and take over for yourself?

So much for Traditional and Innovative strategies. What about the Practical? Again, considering Ruth's position, what would be a practical approach to her problem?

Remember our C^3I? Command, Control, Communications, Intelligence! Who commands this situation? Who has control? Are the lines of communication open? Is intelligence being used—or emotion?

A practical maneuver will always put C^3I in your hands. Ruth will be able to command and control her part in this potential combat zone once she uses her intelligence and initiates communications with family members, particularly her husband. She can begin by writing a list of C^3I goals:

Goal One: Assume *Command*! Take charge of this situation—don't just let it happen! How do I feel about taking charge? Why am I reluctant? What am I afraid of losing if I accept responsibility for my own actions and my own future? Am I giving my rights away by default?

Goal Two: Take *Control* over what is happening to me instead of behaving like a helpless bystander! If I don't have control now—how can I get it?

Goal Three: *Communicate* with my husband, remembering that communicating successfully means give and take, speaking and listening, and being honest about my feelings. Get the facts! Is the situation what I think it is? Don't be afraid!

Goal Four: Use *Intelligence*, not emotions. What must I do to develop a plan to handle this challenge for my ultimate benefit?

We fall so easily into old paterns of behavior that much of what we think of as Action is really Reaction. It is necessary to look both ways before crossing the street, so we learn to do it all the time, without thinking. The action has actually become an automatic reaction, and it is necessary. But ask yourself how many of your *present* actions and responses are automatic, developed to be appropriate for a former time and place, but unnecessary and unsuitable for today? For example, do you always jump to please? Are you the one who goes without or takes second place? Can you ever say No? Study your lists to understand yourself better and make up your mind that you will no longer be blown about like a leaf in the wind, dependent upon the gusts and eddies around you, but that you will control the currents and choose your own flight path!

Sheila tried for years to control an unhappy marital situation through means that might be termed 'traditionally female'; means she had absorbed unthinkingly as a young girl. Not until circumstances forced her to look at her lifestyle was she able to establish a C^3I of her own, thereby reshaping the entire relationship and

determining her own future. She is a vibrant, beautiful woman in her late forties. To meet her now, it is hard to imagine the amount of stress she fought and overcame while trying to salvage a bad marriage and find personal fulfillment outside wife and motherhood. Today she is a self-sufficient Vice President in Charge of Operations at a large, state bank, but once upon a time she was dependent upon a husband for her very existence. Then she was the full-time, at-home mother of three—two teenagers and a nine-year old—struggling to understand the issues that were tearing her marriage apart, and yearning for some way to feel better inside.

She admits that for many of her marriage's twenty years she knew there were problems, but that she didn't acknowledge to herself or to anyone else that she was unhappy. Her husband had suffered from alcoholism in their early married years, but had attended a recovery program and given up drinking. As she says about those early years, "I thought I was in control of things, very clever and bright. I wanted him to be financially successful and to do certain things, and I put my fate in his hands. His drinking was a problem for the first ten years, and I joined Al-Anon for support and to learn how to cope with the drinking. Joining that organization really made a huge difference in my life because it made me look at the way I was living—my Cinderella thing—my fears, my dependencies, my criticisms.

"When the drinking stopped, it opened up ways to fulfill myself, so I started to think about going to graduate school or going into business. I was interested in both those areas. I had a lot of fear about business, though, because in school I had always been a marginal math student at best, and I felt—how could I ever make it in the business world when I don't even know how to add fractions?"

In spite of her fears, Sheila felt an increasingly urgent need to develop her own talents and to give up some of her dependency on her husband. Her husband, however, had grown up in an era when having a wife working outside the home was interpreted as a reflection of a husband's inability to support his family, and he resisted all her efforts to find new interests outside the home. She says that while she was considering her options she did it all basically without discussing it with her husband because, "As soon

as he would hear this he would go crazy, and then things would get very rocky. It became more of an introspective kind of thing. I had so many fears! The idea of going to graduate school and taking the exams, I just couldn't handle! Luckily my sister took me aside one day and told me about a management program for women at a local college. She said, 'Why don't we just go and talk to them?' Do you know, I had so much fear, I said I couldn't go. Why? Because in my mind I didn't know where to park the car!"

Sheila struggled with her fears about enrolling in graduate level courses, but her sister pushed her to give it a try, and she did join a program designed especially for women re-entering school after a long absence. When asked if she would have been able to do it without the support of her sister, she says, "I think I would have found someone else to help me. I did have a lot of friends in Al-Anon, although the network of friends I thought I had in the neighborhood was crumbling. As well as my husband, all those women who were raising children were also threatened by my wanting to go back to school, and told me my children would be ruined and go on drugs, and so on. You see, it was in a very Catholic tradition and my husband was very verbal about how much he disapproved of all this. That, of course, fed my fear that the marriage was going to dissolve, and the whole idea of divorce was terribly frightening. I *lived* in fear until a good friend asked me to look at why I was willing to accept so much fear in my life. So, one day, I walked around my home thinking about that. It was a beautiful home and I looked at all these little attachments and I said, this is what I'm afraid of—financial insecurity, and not having a man in my life, even if he isn't exactly what I wanted. Afraid of disapproval. Afraid because of my children. I was afraid he was going to take my children away from me. And he did threaten me with that. He told me, 'I'll take those children and I'll turn them against you.' That's when I quietly decided that I had to at least try graduate school and when I started, I didn't let him know."

Sheila told her husband a few months into her program that she was attending graduate school. "All the financial controls that he could use, he did. Financial and emotional. I put blinders on. I just set my goal and kept at it. I felt I had to keep my feet moving

in the direction I wanted to go and I couldn't allow all these fears to stop me. In fact, I think I had done something even more basic than that. I think I had made a decision to look at the role of fear in my life and look at the way that I had allowed it to control me. I just didn't choose to let that happen to my life anymore."

What followed was a lengthy period of extreme distress for Sheila and her family. She had made the important decision to stay in school, and she felt that everything would have to fall into place from that decision. She did not want to stay in the marriage because of insecurity, and she realized that wherever it was that she was going to be in five years time, she was going to have to be the one to take responsibility for it, and she was going to have to take care of those insecurities. "It didn't mean the marriage would break up, necessarily. Maybe it would, maybe it wouldn't. Who knew? The point is, I wanted to be in a position to make a free choice. I forced myself to walk through fearful situations and most of it had to do with creating my own dream, that I wanted to be a professional person."

Sheila worked hard at her college work, but meanwhile the marriage continued to deteriorate. While she was taking an internship as part of her program, her husband took away her car. She borrowed money and bought an old station wagon for four hundred dollars. When she would drop her children off at the local golf club, they were embarrassed by their dented and rusty form of transportation. She, however, called the car her Freedom Wagon. She borrowed money from both her father and her sister to pay for school until she was able to obtain a student loan, and by the time she finished all her courses, the marriage was almost at an end. Her husband attempted to sabotage her job interviews, and her children had become so critical of her that she put herself into therapy. Next, her husband threatened to sell their house. Real Estate brokers would show up unexpectedly while she was cooking dinner. Violence was threatened and she found herself a lawyer who told her not to get a divorce until she had a job.

Finally, she landed an entry level management position with her present employer. Her plan was to wait a year before filing for divorce, but as soon as her first paycheck arrived, her husband

demanded it. "I refused to give it to him and that's what really precipitated the divorce. That became the critical point. I just decided I couldn't wait any longer."

Two months after starting her new job, the first one in over twenty years, she filed for divorce. All financial assistance stopped. Foreclosure was threatened. She feels, "I was going to be punished for this, and economics and the children were to be the tools." Eventually, since Sheila and her husband could not come to an agreement, their case went to court.

After the settlement, she stayed on for a while in the twelve-room house she could not afford. She could not pay the oil bill so she used kerosene heaters. She took in a boarder to make ends meet. "I even considered making it a weekend bordello! I would do anything! I thought there just had to be more creative ways of getting money into the house."

When asked why she did not crack under all these pressures, she replies, "I had a goal and that goal was to be strong and independent and financially secure. I also had a very strange experience! One day I noticed that every one of my fears had actually happened to me. Every one of those reasons I had used not to go to school had come to pass! I realized this and I had to deal with it. I had been afraid of losing my children, and sure enough, after the divorce they all went to live with their father. Their leaving was particularly painful, but I had developed, by then, a very strong feeling of what was right for me, and I trusted that. I knew I didn't always do things the right way, but I knew it was the best I could do at the time, and it was a matter of moving ahead and letting the chips fall where they may. I had no control over results. I only knew I had to put one foot in front of the other and keep moving. If I had motives that I knew were for revenge, I learned to put them aside and ask myself, 'What feels best for you?' "

When Sheila is asked if all that pain was worth it, she says, "Absolutely, absolutely!" Has she stopped growing? "Never! There is no such thing!" Her advice to any woman who feels trapped in a situation she does not like but dares not leave, is to "Get quiet with yourself and understand what it is that is missing in your life. What is keeping you there, and what are you getting out of it? You're

always getting something out of it! Whether it's covering the fear of being independent or the fear of being tested, whatever it is, you've got to understand that there's a pay-off to you and you've got to find out what that pay-off is. And that's just self-honesty. Maybe it's a fear of authority or loss of approval, but it's an all pervasive feeling, living in fear, and there's *nothing*, no man, no person, worth living in fear for!"

Sheila's children are reconciled to her new life-style now, and her former husband has remarried. One son lives with Sheila, and one with his father, while the third is away at aschool. She lives in a small apartment, but plans to purchase a small house with its own garden soon. She has a new man in her life, but no plans to remarry. She loves her job, and above all, she loves the new woman she has become—the almost completely fearless, financially independent, mature professional!

Sheila's life changed because she had the courage to stand up for what she believed was best for her, even at the risk of alienating her own children. Deliberately carving out a path for yourself that contradicts everything you have been taught as a child and as a young woman is a risky and often lonely business. At the end of a journey like Sheila's, the question must be raised as to how the children would have fared if her marital situation had remained unchanged. Our automatic, traditional, reaction would probably be that the children would have been better off in a two-parent environment. But would they? If two married adults have come to a point of no-love, what effect does this have on those younger ones who live with them, hearing and sensing their anger and unhappiness on a daily basis? Is this the Norman Rockwell myth? How many of us hang onto troubled marriages for fear of upsetting our children, while ignoring our own inner needs? Who can say that children growing up in a household in which one parent remains continually frustrated and dissatisfied, will learn to understand the importance of personal growth and the mutual respect that is necessary for a harmonious marriage? Sheila's children will face their own challenges as they mature and marry, and it may be that they will not appreciate their mother's struggle for emotional survival until they are in a position of wedded give and take, but one benefit

they will always have is the knowledge that their own mother, by taking control of her own life, enabled herself to grow through pain and struggle, to become a contented, contributing and capable human being.

3

My Disposition Depends on Me!

The secret to it all: self-approval, self-esteem and self-love.

Do you ever say to yourself, "I wish I could be like......."? And then do you compare yourself to that certain someone and feel less than wonderful? Do you ever say to yourself, "I'm over forty and I haven't accomplished anything!"? In order to understand yourself and those around you better, and to put yourself on an Achievement Path, take a look at the members of your immediate family, your co-workers or friends, and other people you may not know quite as well. Think back to some old friends, teachers or acquaintances, too. Without thinking too long and hard about it, pick out those men or women you have most admired, the ones who seem to be the most happy and fulfilled, the ones who usually radiate a certain air of success or happiness, or who are simply nice to be around. Write down their names and then, by means of the following simple exercise, analyze their Star Quality, one by one.

For example, here is the list of Most Admired, drawn up by Susan, a shy, recently divorced woman:

Uncle John.
Miss McGinniss, my grade school teacher.
Joe, the mechanic at my garage.
Alice, my beautician.
Mr. Horne, the choir director.

Next to each name on your own list, write down the qualities that you feel distinguish these people from others you know, the characteristics that seem to stand out and make them special in their own way. How do *you* see them? Why do you admire them? What is it that you envy about them? Make it personal! Susan's list looks like this:

Uncle John: Always ready for fun and a good time—outings, picnics, ball games, parties, or trips to the beach. Always persuaded my mother to let us go with him.

Miss McGinniss: Always expected the best from her students, but never criticised anyone in front of the class. Made me feel secure. Had a limp, but never spoke about it.

Joe: Never complains, even if I bring the car in for repairs late in the day. Always cheerful, even in the worst weather.

Alice: Takes plenty of time with me. Really wants me to be satisfied with her work, and to leave the shop looking and feeling better.

Mr. Horne: Really loves what he does. Has so much enthusiasm for the music that he makes us want to do our best at each rehearsal, no matter how much time it takes.

From your comments, extract or distill the underlying major elements in each one. The list above might be redefined as:

Uncle John: Zest for living.
Miss McGinniss: High expectations for and motivation of others; denial of impediment.
Joe: Cheerfulness and desire to please.
Mr. Horne: Infectious enthusiasm and determination.

You will probably notice other elements in addition to those listed above. Some characteristics appear to be common to all the individuals mentioned. The most obvious, perhaps, is the enthusiasm each one has for what he or she does, whether it is hairdressing, teaching, choir directing, or repairing automobiles. There is a liveliness or intensity about each one that translates into a positive outlook. With each one there is an absence of complaint. There is also the factor that each is involved in some way with other people, a commonality of sharing.

Finalize your own list of the men and women you admire or envy most. What is it that strikes you about them? What stands out in your memory of them? When your list is complete, compare your analysis with the characteristics listed below to see how many times the same or similar attitudes show up among the happy or successful people you know. Or, if you prefer, use the list below and compare or match up each quality to the individuals you have listed. Which styles or attitudes show up most frequently?

- Enthusiasm.
- Cheerfulness.
- Self-motivation.
- Encouragement of others.
- Determination or will-power.
- Ambition.
- Generosity.
- Interest in or concern for others.
- Overcoming of serious difficulty, such as death of a loved one, divorce or separation, job loss, financial problems, illness or accident.
- Variety of hobbies or interests.
- Reliance on self.
- Lack of complaints or criticisms of others.
- Love and respect of self and others.
- Lack of fear.

How many common factors do you find among the people you admire, respect or wish you could emulate? What makes them special? And in what ways are you like or unlike them?

Next step—self analysis! Using the same procedures as before, write down your own name. How many of those elements of success and self-fulfillment can you apply to yourself?

Be honest, but not over-critical! The most profound reason, by far, for so many women's apparent lack of achievement or growth and our inability to make constructive changes, is rooted in our lack of self-approval and self-love. As you complete this short exercise, pay attention to your thought processes about yourself.

- Are you consistently repeating negative comments that you heard at home when you were small?
- Have you internalized inhibiting beliefs about your capabilities simply because you heard them as a child in school?

For example, many women honestly believe that they are hopeless at math when the fact is that they use arithmetic every day of the year in paying bills, making change, and deciding upon the best and most economical buys at the supermarket or department stores. Such a negative image stems from schooldays and has never been updated and erased. As long as any negative belief stays in your system it hinders new growth and accomplishment, even on a small scale. Most of us remain victims of our childhood circumstances, and this is often due, in the case of women over forty, to the fact that we have never had the opportunity to prove ourselves in the competitive marketplace, where we would have been forced to grow up, and to reevaluate our internalized self-deprecation.

So, repeat the exercise—think of it as taking personal inventory—and look as objectively as you can at the results. If you have difficulty doing it, simply copy the list above and, next to each positive quality—Enthusiasm, Cheerfulness, etc.—place a check mark or grade yourself on a scale of One to Ten.

When you have finished, look at the results. How did you score? Are there other qualities you possess that are not on the original list? What about "ability to work hard," "reliability," or "creativity?" Just how would you describe yourself?

If you have a close friend or family member with whom you are willing to share your exploration, ask him or her to write down or to tell you just what aspects of you he or she perceives as being

outstanding. You may be pleasantly surprised to find that your friends are far less critical of you than you are of yourself. Watch the list grow, and try to absorb the picture you are presenting to the world.

If, however, one of your friends indicates that you consistently demonstrate an unlikeable trait, take a very good look at your reaction!

- Do you feel extremely defensive?
- Do you rush to give reasons for your behavior?
(Sentences beginning with 'Yes, but. . .' are often an indicator of automatically defensive and unthinking responses.)
- Do you feel angry at the suggestion that you are less than perfect?

If so, relax! Ask yourself, "Is this really how I look to others?" When someone else's evaluation means so much to you, this usually indicates a lack of confidence on your own part. People who are really free, whose disposition depends upon themselves, usually have a sense of humor about their shortcomings and such a good solid sense of their own value that criticism can be accepted, considered, evaluated and then either discarded or accepted and acted upon. Rarely does a seemingly negative comment throw them off balance. The more you come to appreciate yourself, the less pain you will feel when someone points out that you may be a little less than perfect. The actual physical feelings of discomfort that have a habit of hitting you right in the solar plexus will gradually disappear as you learn to love yourself more and to need others' approval less. Truly happy people know they are not perfect, but they forgive and love themselves anyway!

For women over forty who have generally spent a lifetime nurturing others and have been dependent upon husbands, children or parents for their identity, this refocusing from Outer to Inner, from Other to Self, presents a very real challenge! In many cases, women who are caught in unhappy or unfulfilling marriages have become so dependent upon the family structure for their security and existence, that they feel unable to make any kind of move to change the situation. The danger, in cases like this, is that if the unhappiness

or quiet desperation is allowed to continue unchecked, your physical and mental health becomes slowly undermined and disease (dis-ease) can manifest. Once that happens, it is even more difficult, although not impossible, to effect positive change and to take control of your own future well-being. However, if we are going to tackle life head on and make the latter part of life the best part of life, we must start by taking the giant step of liking and appreciating, trusting and relying on ourselves. *My disposition depends on me!* So take another look at your self-analysis, and decide which areas are not as complete as you would like them to be. Are you as cheerful as you could be? Do you motivate yourself? Do you act or react? Are you an optimist or a pessimist? This is the right time and the right day to decide on the changes you want to make in yourself and for yourself.

It is all too easy to fall into the rut of unfulfillment, too comfortable to slip into a routine of letting someone else set the pace. Often this happens and we're not even aware of it. You can recognize this if you feel not *un*happy, yet not really happy either, and spend most of your days in a state of mild unease. One reason that romance novels and soap operas are so popular in this country is that they provide the excitement most women feel is missing from their own lives—the thrill, without the risk! After forty, it is time to put the excitement into your own life. Become a player, not a spectator! You can allow yourself to develop now, at a time in your life when other people do not need you as much as they once did. Count on yourself, not on husband, former husband, parents or children! How many women do you know who regale you with their grown children's exploits? How much more satisfying it would be if they could regale you with their own! *My disposition depends on me!*

If you think it is too late or even impossible to take charge of your own life and turn it around, then meet Rosa, a subservient wife who, after her long marriage to a longshoreman reached a potentially dangerous state, managed to go and find help, to leave her home—penniless—and to establish herself for the first time in her life as an individual instead of the neglected and abused half of a couple.

Rosa was born in a small town in Italy. Her schooling was interrupted by World War II, so her formal education was actually terminated at the age of ten. As she says, "The way my mother brought me up, I never knew I was an abused child. So much so! It was a small town in Italy, and you have to discipline, and that meant Ping, Pong, Pong!" (indicating that she was slapped around the head). "Me being the oldest in the family, there was a lot of responsibility put on me from six years old. I couldn't reach the sink, but I had to wash the dishes and when one slipped, she beat the life out of me. She told me how ugly I was, how this, how that! I had no self-esteem, so to be loved and be liked I had to be always pleasing other people. I end up hating instead, because it was always 'you have to.' I never did anything with a 'pleasing,' because I was never aware there was a Me inside! I was doing for her, and for my brother and sisters. To me, I was doing everything for her."

In her late teens Rosa married a local boy, and soon thereafter, as a young bride, came to the United States and settled in New York City. Her married life was very typical of European marriages of that time. Her husband worked on the docks, while she stayed at home, raising their two children. The role that had been forced upon her as a child was reinforced by the marriage. He went to his job, went out socializing, and behaved like a free man. She, still believing in the traditional ways, became essentially a domestic servant, resentful of the inequality of the partnership. She describes the marriage this way. "I was in the house to keep his respectability as a man of the world. Like everybody knows him as a nice, respectable person. While I was staying there, I was keeping a lid on it. He could do whatever he wanted. He could go wherever he wanted to go. He had a car. I couldn't follow."

As the children grew older, Rosa's unhappiness and restlessness increased. She is a woman who loves to learn and who has always felt frustrated about her lack of education. She is very intelligent and very handsome. She needed to get outside the house. She wanted to complete her education, but her husband wanted the domestic situation to remain just the way it was. In her anger and because of her inability to stand up for herself after the conditioning of her childhood, she retreated into herself, internalizing her

pain, and rheumatoid arthritis began to develop, painfully disfiguring her hands. The situation worsened. "What happened to me, I got sick. Which I think had a lot to do with the frustration because, you see, my marriage was no good since the beginning, but did I know about it? I was still pushing. I was drowning! My husband became like a lion. He had the advantage of my situation like he knew I would not take off and go to work and go on my own. So he figured, 'I can have a double life. I take off. She's in the house.'"

Rosa became more and more despondent, to the point where she would sit at home, unable to move. "All this happened in this time and this age when the kids are grown up and independent and you find yourself—how can I tell you?—you don't belong and you're not needed. I would sit home with depression above the sickness. I would just sit and do nothing. He never gave me money. I wasn't even doing the shopping like any housewife. Three years that was going on. I don't have immediate family over here so there was no one to tell my problems. Only my kids knew, so I kept everything inside. You know I felt like I was drowning. I think now I was hanging by one hair."

One day, however, something happened—one of those lucky events that can precipitate a lifelong change. Rosa was reading a city newspaper and found an article describing the Displaced Homemaker Network,* with an address in Washington, DC. She said to her daughter, "Please write. In this city of so many people, there must be a hand somewhere that can grab me and pull me out." Her daughter wrote and received the address of two local job readiness training programs designed especially for women who have been out of the job market for many years, but who must suddenly make their own way, through widowhood or divorce. Rosa hesitated about contacting a Displaced Homemaker Center by telephone because she had no confidence in her command of English, and she was afraid of her husband listening in from the basement extension, but she eventually placed a call which resulted in an interview. In spite of the fact that she had not lost her source of support, she

*See Appendix

was accepted into one of the programs because her marriage was in jeopardy and it appeared inevitable that she was going to have to support herself eventually. She did not tell her husband about her plans. In January, 1984, she began attending the program. "He wasn't working by then, but he was collecting through the union, so he had to go every morning and punch the card. I used to leave home in the morning before he was back. By then we didn't speak to each other."

The first day of classes at the Displaced Homemaker Center, every woman was asked to introduce herself. Rosa was so overcome with emotion, that she was unable to give her name. She simply wept. However, for the next eight weeks she attended classes in English, Office Procedures, and Math. She participated in group counseling sessions which enabled her to air her problems and and talk about her fears in a supportive environment, among a group composed of women like herself, suffering from the shock of facing a new single life. She was referred to an expert for legal advice and, as a result, was able to obtain some money that had been maintained in a joint savings account. It was this, her first act of rebellion, that was to provoke her husband into threatening her with violence if she did not return the money to him. Fearful for her safety, she moved temporarily to a neighboring state to stay with a friend. She was determined to finish the job readiness program and at the end of the eight week period she graduated, along with the other members of her class—fifteen women celebrating what was for many of them their very first graduation ever.

Rosa returned home and her husband berated her again over the money from their savings account. As she describes it, "He grabbed a glass and threw it at me. That was it. I was out!" In that moment she made a momentous decision. She was going to leave her husband and her home, even if it meant being without money, without security and without possessions. She went back to the Displaced Homemaker Center trembling and in tears. She was helped to find a room at the local YMCA for the night. She contacted her daughter and, through friends, her daughter found her a place to stay after that. Little by little, Rosa started to take control of her own life. She never returned home. She stayed with an older woman who

needed companionship and who provided her with a small room of her own. She approached the local Social Security Office which arranged for her to receive disability payments until such time as her arthritic condition improved. Her children brought her some of the clothing she could not collect herself, because her husband would not let her back into the house. Gradually she learned to relax somewhat, to feel safe and to appreciate the joys of being alone.

About her life and her choices she now says, "In the weeks I was in the Displaced Homemaker Program I built enough courage to get out of the house. I went to family court. I didn't even know where I was going to sleep, but people opened their homes to me. It's amazing—me without money, without anything." After two years by herself she is able to look back at her life and to say, "I wasn't in touch with myself. My life was really rotten. It was me! I can't blame him—because I couldn't say 'No.' I didn't know how! Even now, I got a friend and she count on me to do everything for her. And still it's hard to say 'No.' But I learn! I can't blame my husband and I can't blame my mother because of their doing what they did. They both got their reasons. When I became adult I had to take responsibility for myself, but I couldn't. But down deep I knew there was more to life. I know now how to separate this today, that yesterday. It's still hard for me to say 'No,' with friends, with anybody. But I know now it's okay to put *myself* first. I have to work at it! I'm doing a lot of reading. It gives you a different perspective, makes you realize different things."

When asked what advice she would give women who find themselves in a situation as unhappy as hers, she counsels, "Life is too short to feel that way. Find that little thing that is left in you. You have to find it and start working on it! No matter how impossible the situation may seem, there's always a way to get out of there!"

No midlife woman can hope to improve a painful marital situation without recognizing the imbalance and the inequalities inherent in it. If you are not receiving love, then you must begin to give it to yourself. Not receiving love does not mean that you don't deserve it, or that there is anything wrong with you. A very simple, basic exercise, something you can do for yourself, is to use an

Affirmation, a short statement that states that you are valuable. An affirmation can be as brief as, *"I am, I can, I will."* If you feel weak and insecure, if you are mistreated and unappreciated, repeat this affirmation to yourself—aloud or in silence—every morning and evening. Write it out on a piece of paper and carry it with you. It will serve as a gentle reminder that you are special, as special as the people on the list you made. Repeating it will serve to gradually reprogram your thinking and to erase old criticisms leveled at you when you were too young to defend yourself.

If you remember the opening to this book, you may have noticed that one of the first tactics we recommend is to challenge the Authority Figure in your life. By this we do not necessarily mean actively rebelling or confronting, or losing your temper, but we do mean that it is often essential to look hard at a situation that seems to put two people in unequal positions—one with all the power, one with none. What is frequently the case in situations like this, is that one of the two partners or players, whether within a marriage or a job situation, has tacitly given permission to be placed in an inferior position. It is almost as if a signal has been sent that says, "You have the right to demean me. I deserve it!" If this has occurred in your life, and if you feel angry and uncomfortable about it, cheer up! There is still hope. *In Self-Awareness Lies the Possibility for Change.* Many of us who have allowed ourselves to become inferior partners have done so out of habit, still responding to those old internalized, parental criticisms. We are, in fact, putting *ourselves* down, but by allowing someone else to do it for us, we are making use of a scapegoat, someone else who takes the blame because it is too uncomfortable for us to take the responsibility personally. The first time we allow ourselves to see this trick our behavior is playing on us, it hurts! We may deny it vehemently, but we need to realize that a healing can always follow a wounding—if we will allow it to happen.

So, look at yourself and your situation. Are you going to stay a victim for the rest of your life, angry, unhappy and resentful, or are you going to say to yourself, as Rosa did, "Find that little thing that's left in you. No matter how impossible the situation may seem, there's always a way to get out of there!"

4

What Will You Do When He Is Far Away?

Triumphing over personal loss.

If we hear a certain sentiment expressed often enough, it becomes a part of the culture and a part of our own subconscious. How many of us, having experienced widowhood, divorce or separation, feel that we are not worthy because we have been left behind, and believe that we are a Fifth Wheel? How many women have been hurt and shocked to find that, as single people, we are no longer welcome at our friends' dinner parties? Society in this country, in many ways, still reinforces the old belief that a twosome is all right, while a single individual is not. As women over forty, we grew up hearing that a woman's place was at the side of her man, and without a man, a woman had no real existence.

What we need now are some new standards! Instead of, "Without a man, a woman has no real existence," we need something more like, "With or without a partner, every person is unique." And if nobody is working on these standards for us, we'll just have to do it ourselves. Every woman you meet in these pages has created her own way.

Before we can get on with making a new life as a divorced woman or as a widow, however, we have to learn to accept the parting, no matter what form it has taken. There is no shock like the sudden shock of losing a mate. For those women who have a husband one day and no husband the next, life takes on an unreal reality. As one woman who lost her young husband one holiday, in a boating accident describes it, "The physical and emotional shock to your system is unbelievable. I felt as if someone was punching me in the stomach. I kept feeling these hard, cramping pains that made me want to keel over. A couple of times I actually passed out briefly. I was the one who had to tell my three small children that Daddy had died. I had never experienced so much pain in my life, not even as a child when my mother had died. The shock, the disbelief, the unfairness was all too much. I could hardly put one foot in front of the other when I took the baby out in his stroller, yet somehow I went on functioning, taking one day at a time. That's as much as you can do in the beginning."

It has been demonstrated that bereavement takes three predictable stages: denial, rage and acceptance. Initially, denial appears to be necessary to give us time to make some physical and emotional adjustments, in order to cushion the shock. Soon afterward comes anger—the "why me?" phase. Anger is acutely felt whether or not the one who died is young or old, formerly in good health or bad. We feel that we do not deserve to be left behind to handle all the problems, to face the loneliness and changed circumstances. Life had had a certain rhythm, a security in its sameness, and that has been destroyed, exploded forever. We look around us and all we see are couples. They may be caring and concerned for our well-being, but we sense that they are also relieved that they are not the ones facing the chasm of loss. Their routines are uninterrupted, their lives proceed as before. No wonder we feel angry!

Sooner or later, acceptance of the loss must take place. Once this has happened, mourning may be allowed to take its natural course, whether the loss has been through death or otherwise. Acceptance and mourning are both essential for our health, absolutely necessary if we are to go on living and growing. And there

is one more emotional action we must take to insure our future balance. That is forgiveness. We must forgive the one who has left, and we must forgive ourselves.

Widowhood may come as a sudden, sharp blow or as the final step in a lengthy, painful process. Separation or abandonment can occur overnight. Divorce is often the end point of a long and bitter battle, but it can also take you unawares if your partner has been deceptive. But no matter what form physical separation takes, the effects are virtually the same. Where you were once half a unit, you are now, like it or not, the whole unit. Where you once were told of, or shared in decisions, you now make the decisions. How you handle this will depend largely upon whether or not you have completely let go of your former partner. Whether that partner is dead or alive, you must accept the separation, releasing first your anger and then the relationship itself. This is why forgiveness is so important! A relationship can never be healthily released if anger or despair still exist. And those emotions will persist in obstructing your future growth if you allow them to play a part in your daily life. Do you know someone who has been divorced or widowed for many years, but who still talks about the married state as having the only reality for her? Such a woman has refused to forgive and let go. As long as the relationship exists in her mind, she has not released it. And if it is still taking up space in her mind and emotions, then nothing new can move in to take its place. We must create a vacuum before we can fill it!

So if you are a formerly married woman who feels stuck, a single individual who yearns to get on with living but doesn't know how to do it, ask yourself the following:

"Have I let my husband go?"

If your answer is No, here are some suggestions to help you release the relationship:

First, ask yourself: Why am I hanging on?
Then: What am I afraid of?
And: What am I angry about?

Write down your thoughts as they come to mind, without being self-critical. What you are aiming at here is clearing out some mental and emotional debris. Think of it as waste matter clogging a water pipe. Before clean, clear water can flow through, the blockage must be removed. For example, your answers might look something like this:

1. I'm hanging on because I am depressed and because I don't think I can make it on my own.
2. I'm afraid people will see all my weaknesses now that I am by myself. I'm afraid they won't like me. My husband was always the one they liked.
3. I'm angry because I'm in this situation. It's not fair!

Now explore your answers by expanding them. If you wrote that you do not think you can make it on your own, ask yourself, "Why can't I make it on my own? What will happen if I try?" If you wrote that you feel anger, ask yourself just what you are angry about, and at whom. Keep writing! As we have indicated before, this is a great tactic for pulling your fears out of the dark closet and shining the light of understanding on them. Only when you see what it is you are fighting, can you conquer it.

When you have finished this exercise, study it. Is there a lot of anger in your answers? If so, do you feel guilty about it? Are you angry at your husband for leaving you? It is natural for widows to feel abandoned, just as divorced or separated women do. The circumstances may differ but the feelings are the same. If you do see signs in yourself of anger and guilt, understand first of all that these are very common emotions. They are common to all human beings, even the most spiritual, loving and ethical. They serve a purpose for a brief span, but, if held too long, they become destructive to their owner. How can you get rid of them? Forgiveness cancels them out, just as love cancels out fear. So, for your next exercise, try writing down the following phrase:

I Forgive Myself.

Write it over and over again, filling one sheet of paper, two sheets of paper, as many pages as necessary, until you feel it is time to stop. You can expand the phrase if you want to. Custom tailor it:

I forgive myself for feeling guilty.
I forgive myself for feeling angry.
I forgive myself for hating my husband.
I forgive myself for being depressed.
I forgive myself for not making progress.
I forgive myself for gaining weight.
I forgive myself for being lazy.

You know the phrases you need, and as with all the other exercises we suggest, this is personal, your private homework which nobody else need ever see or share, so you can be completely honest with yourself.

Secondly, repeat these same phrases to yourself as you are falling asleep or as you are waking. Post them on your bathroom mirror as a reminder and repeat them mentally.

Thirdly, follow the same procedures, but this time focusing on your former partner:

I forgive my husband.
I forgive him for meeting someone else.
I forgive him for leaving me.
I forgive him for dying.

Whatever fits your circumstances and your feelings, put that down. Again, write these phrases over and over again. Repeat them mentally.

If you follow through on these exercises, you will find some strange things happening. You will realize that you are beginning to feel better, and you will realize that you can use these phrases whenever you fall into old habits of depression or inertia. You will know when to stop using them because you will know when you no longer need to write or repeat them. They will have served their purpose.

Think back to strategy number five, listed in Chapter One: "Always try to empower others as well as yourself. Like the successful entrepreneur, find a need and fill it." Ask yourself what you could do to help other women who are going through emotional crises of their own, perhaps similar to yours? Do you know of any other widows or divorcees, single parents or lonely grandmothers? There is something very powerful about group support. When a woman is left alone, she feels exactly that—Alone. She feels as if she is the only one to face this painful situation, the only one ever to have been abandoned to face life by herself. But the facts are that thousands of women have to cope with aloneness. In your town there must be many others. Perhaps even on your block. Look in your local paper or contact your local church or synagogue to find out if there is already a Self Help Group for single women in your neighborhood. If there is, join one. If there is not, start one! You can do this by placing a small advertisement in your local newspaper, or by putting up a notice in the supermarket. If you want to, invite men too. Men also suffer from widowhood and divorce and are often less able than women to express their fears and concerns, having been raised with the stricture that "Men don't cry!" You could hold a meeting in your home and you probably will not even need an agenda. People undergoing stress need to talk about it. We all could benefit from a supportive environment in which to air our doubts and fears. You do not need a psychologist or psychiatrist to lead the meeting. All you need is a number-greater-than-one because there is no support like peer support, as any teenager knows. To suffer in silence is not wise. To suffer in solitude is not necessary. So, take charge! Organize, open your doors, and before you know it, you will be reaping the benefits that come from offering solace and support to another, for it is still true that in giving, we receive, and in helping we are ourselves helped.

For some women, as we know, widowhood happens very suddenly. Just such a woman is Jane, whose placid, routine life as the wife of a broadcast engineer and mother of four children was shattered ten years ago when her husband died after a very brief battle with cancer. His disease had just been diagnosed and was not considered life-threatening when he unexpectedly succumbed

to it. At the time of his death, the household consisted of three lively teenage boys and a ten-year old girl. The family had always lived comfortably, supported as it was by Jane's husband's sizeable paycheck from the international corporation for which he had worked for many years, and their home was a typical, large house in a handsome suburb. As Jane says, "There was insurance and some stock, but, looking at the replacement factor and the fact that I had no job, I was really in a panic situation. My husband had always supported the kids very well. They were used to that."

Jane has a graduate degree in economics, and she had been working for two years prior to her husband's death as the director of the child care center at the local college. She describes it as a suitable arrangement at that time, because she had the summer free. She had been hired in her capacity as an economist, to find out why the center could not meet its payroll, and she had been given a mandate to make the center economically viable. She found that the program was lacking in quality and that the faculty members were choosing not to leave their children there during the day while they were teaching. The center was not meeting the state requirements regarding its staff qualifications or regarding nutrition. Jane asked for one week to bring the food up to the state's requirements. Not only did she accomplish this, but, within the two years of her directorship, she made the venture highly profitable.

One week after her husband's death, Jane called the Chairman of the Board of the center to tell him that she would be coming back to work the following week. To her amazement, he told her that she had no job! In her characteristically understated way, Jane described herself at that time as being, "Very low and very upset that I was being treated in such a callous and inappropriate manner. In retrospect, I realized how this situation might have developed. On one occasion, while my husband was still alive, I had gone with the Chairman to look at playschool equipment, and on the way back, he had said to me, 'If you'll be good to me, I'll be good to you.' So I said I would always be extremely professional in the work I was doing. I think there has to be some connection."

Because of the shock of her treatment, Jane says that she felt very insecure about finding a new job, and she decided that the best way of dealing with the situation was to go into business for herself. Her accountant had told her that within three years, all her money would be gone if she did not do something to conserve the capital she had. He suggested that she invest $7,000 in a gift business he knew of that needed a cash infusion. Five acres of land adjoining the gift shop were available for development and from that point of view, she felt it was a good investment since the land could be developed later. So, she invested—sharing responsibilities with the original owner. She describes their working relationship this way: "He did most of the buying and the work around the store. Initially we were doing reasonably well, but within one year it became apparent that he didn't really want to share the business with anyone. I had applied for a Small Business loan to develop the property, but when I discussed this with him, he was against it. Soon things deteriorated and eventually we sold off all the inventory, and this was the beginning of a very bad few months. I knew I had to find work that would bring in income for the household, and I had to do it right away."

Then began a period when every day saw Jane boarding a commuter train for the two-hour ride to the city, sneakers on her feet, and high-heeled shoes in her briefcase. "I went around to all the agencies, and I went to phone booths to find addresses of companies nearby. I would make inquiries about job openings, and make appointments whenever I could, changing my shoes in the building lobby before I went up for an interview! Finally I found an entry-level position with a bank, doing filing and cataloging, typing and other kinds of ancillary work. It's true I had a Masters in Economics, but I didn't have time for a professional job search. I had to start immediately!"

After eight months at her entry level job, Jane pursued a vacancy in the bank for the position of Assistant Comptroller. She says that her job hunting and her low-level job had created quite a strain on her children because they realized that her income was simply

going to take care of day to day necessities. When she received her promotion, her salary jumped by $6,000. Her son's comment was, "We're back in the middle class!"

Jane says that her new position was difficult at first. "The material was all new to me, but it was very good training. Out of that I learned computer skills that today happen to be highly marketable. I was commuting two hours every day, leaving home at six in the morning, and getting home between eight and ten at night. I guess because my work was of good quality, I didn't have problems with feeling that I was being treated differently than anyone else."

But then came a change in management and Jane's boss left. "The new person who came in, I don't know if he preferred having younger people around him, but he started putting pressure on me. Others in the department, obviously on his instructions, did the same. I decided that there was no way I was going to be able to function in that environment. I was moved to a location where the facilities were not nearly as good and I had to share a telephone. Then they did an internal review, and the criteria they used to rate me were totally erroneous. The review was malicious!"

Despite the shock of receiving unwarranted criticism for good work, Jane chose to stay and fight, instead of walking out. She needed the income and could not afford to quit. She responded to each item on her review, line by line, sending her comments both to the Personnel department and to her boss. "I was afraid I would lose my job! Then I was called in for an interview and asked questions about the review. I was given a few days to come up with facts and dates. I did this and responded in writing again. In the meantime, a position materialized in another department that I felt qualified for, so I applied for that and spoke to the man who was the second in charge, telling him how I felt about the whole situation."

Jane's determination paid off. She was given the new job, which she says held her together until she could update her resume and send it out. It took her three months of serious, disciplined effort to find a new job. "I dedicated every Sunday to going through the paper and sending out at least ten resumes. I contacted all the people I knew, going back ten years for leads, sending them a current copy

of my resume and asking for advice." Her activity led to her current position as Financial Analyst for a bank fifteen minutes from home, working for a boss who is purely professional and respects quality work.

Looking back, Jane says, "I had never before had to be self-sufficient. I had always had my parents, my family, my children. I think I've grown a lot in the last ten years. The experience with the first bank was particularly bad because I didn't believe people could be so vicious. I was fortunate to have a couple of really good friends to talk to. Without them it would have been much more difficult to deal with the situation." Asked for advice for the woman who finds herself widowed and who needs to make a living, she replies, "I would tell her to really hit the market, to get in by doing anything she can, no matter how menial. Take it one day at a time. It is important to develop skills, particularly any skills related to computers. And when you're in, and things go wrong, you just have to refuse to become angry to the point where you would be immobilized. Reacting on the job with tears or anger will not get you where you want. Most women in today's marketplace have to learn that. There is a new generation of young people coming into the job market who are very sure of themselves and in some cases, quite ruthless in pursuing career goals. You just can't think in terms of being older! Develop very good skills, be highly competent, and stay late if you have to. Quality of work pays off—I have absolutely no doubt about that. Get in there and get a piece of the action! Don't let anyone tramp on you, and reach out to other women in the business world because they're very familiar with what you're going through and they've probably gone through it themselves."

One other important piece of advice she offers to widows is this. "Be very careful when it comes to trusting other people with your money, no matter how well you know them. The accountant who steered me to the investment that backfired was an old friend of my husband. I trusted his recommendations without question. Much later, I discovered that my former partner had actually owed the accountant $7,000 and the only way he could pay him was by getting money from another source. Of course, the source turned out to

be me! I can't tell you how shocked and hurt I was when I found this out, but it taught me a good lesson. From now on, the only one who decides what to do with my money is me!"

Ten years after her sudden widowhood, Jane is adjusting to a single life without children, all of whom are now working or in college. She is earning a good salary, and the future looks very positive. Her oldest son has chosen to separate himself emotionally from the family, and she feels unhappiness over this, but she knows that she did the best she could under difficult circumstances and she refuses to brood over the situation. She believes that when her son has children of his own, he may begin to understand that life is unpredictable and that his mother struggled to provide for her family as best she could with the skills and experience she had at the time.

Jane has learned what is, perhaps, the hardest lesson for many midlife women to learn, that it is impossible to be all things to all people, and that the best we can do is to be true to ourselves. We can never please our children totally, no matter what route we take. We can never satisfy the demands of others totally, no matter how hard we work. Peace of mind comes from the knowledge that we have satisfied ourselves, our own expectations and our own standards. If, along the way, we have set an example or in some manner made things better for others, that is the cream in our coffee, the flourish on our parade! We may never remarry or sustain what is now called a Meaningful Relationship, but if we have adjusted to aloneness and are comfortable with ourselves, we need never be unhappy again. And if we are earning a living and paying our own way, we need answer to no one! We can cheerfully and confidently give up our need to approval, knowing that we are doing the best we can to develop a centered sense of our own wholeness.

5

How We Wish We Were in Love Again!

Dating and mating again, after forty.

One of the most common problems faced by women over forty is that of dating again. With one out of two marriages being restructured, we frequently find ourselves sharing the challenges of creating a personally satisfying social life, at the time that our daughters are attempting to do the same! But whereas daughters in their teens and twenties are surrounded by an ocean of eligible males in which to fish, their mothers seem to be encircled by something more like a dried-up moat! You have probably heard it before: "All the best men are married" or "The greatest looking guys are all gay." Add to this the comments you have heard about any children who come along with a suitable male package, and you may be tempted to quit before you begin.

Remember, however, the strategy listed as Number One in our first chapter? "Never accept other people's barriers, restrictions and negative belief system automatically. There is always a better way! Find new ways to think." This is so important when it comes to picking up the pieces of your life and starting afresh. If you do fall for all the negative beliefs with which we are surrounded, such as the myth that "all the best men are already taken," then you

may miss making some of the most exciting and rewarding contacts you could possibly make. And if you believe, on a conscious or subconscious level, that dating after forty or fifty is inappropriate because of your age, then you will certainly forego the possibility of new love or friendship.

If the last time you went out on a date was twenty or more years ago, then of course you can expect that the whole enterprise is going to feel awkward! After all, you have twenty years of responsibility, experience and growth added to the you of the nineteen fifties or sixties. This does not mean, however, that you do not have either the right or the ability to enjoy creating a new role for yourself.

How have the times changed since you were last single? Remember that old unwritten rule that he must be older, taller and successful? And the other one, he must come from the same religious background? Thankfully, both those rules have been broken over and over again in the last twenty years. Men and women are looking at each other with new eyes, looking beyond the confines of school, church and community-related edicts. The defiant rule-breaking by the renegades of the sixties caused a collapse of the formerly rigid roles that had marked all our private lives. Suddenly skin color, age and religious affiliation became less important, and differences between people less threatening and more exciting than ever before. Consequently the last decade or two have seen a rise in interfaith marriages unparalleled in the country's history. Catholics are no longer obliged to marry Catholics and Jews are no longer excoriated for marrying Gentiles.

For you, if you are in the position of dating and relating again for the first time since marriage, the first wise action may be to look at your old belief system to see if it needs updating and revising. How many of the old injunctions are still circulating in your mind? Take a look at them, as objectively as possible, and ask yourself, are these beliefs still appropriate at this stage of life? Which ones do you want to keep, and which ones can you cheerfully discard? For example, when you were a girl, would you have gone out with someone younger than you? Probably not! But today some of the most satisfying friendships, with or without a sexual component, are between older women and younger men. This may be

due to the fact that women in midlife are generally more open to new ideas and more flexible than men in the same age group. Men in their forties, fifties and sixties are usually resistant to change. They like things the way they were and see no need to alter them. And why not? The game plan was designed for the white male. If you were in his shoes, would you want to change the rules? No, it is the women in this age group who have had change forced upon them. And the wonderful thing about life situations that seem devastating when they happen is that they can always bring about new growth and new opportunities, if we will just allow this to occur. So it is that a mature woman is often more in tune with a younger man who has not been so hamstrung by the old regulations and has himself been sufficiently affected by woman's recent entrance into the career marketplace, that he views women somewhat differently than his father or older brother does.

So, what to do once you have decided to take the plunge and enter the dating arena once again? You have, we hope, used the exercises we gave you in earlier chapters to get to know and understand yourself better, and taken out and dusted off the old belief systems about socializing. Now it's time for some practical maneuvers. What about a Buddy System? Remember when, as a child, you held the hand of a companion so that neither of you would get lost? Starting your foray through the unknown territory of singlehood will be made easier if you have a friend, someone who is about to embark on a similar sortie. If you took the initiative we mentioned in the last chapter and started a self-help group, then you will have met at least one other single woman. If you do not know anyone else who is a recent widow or divorcee, ask your married friends if there is someone they know who seems to be quite alone. Then, pick up the telephone and make a contact. It is important to your new image that you be the one who makes the first move, who takes action. Call and ask if that person would like to join you for a movie, the theater or dinner. Chances are that she would be delighted to have some company, and that she has been just as shy as you about getting out of the house. That is step number one. Going out and about with a woman friend can be a lot of fun, and will get you into the habit of being responsible

for your own decisions about where to go, how to dress and how to budget for the event. Many formerly married women have been habitually led, rather than leading, so this is an opportunity to practice your new independence, one small step at a time. Many wonderful friendships develop between women who are single in midlife. There is a certain camaraderie founded upon common experiences and difficulties that cannot be as easily shared with married friends.

Take the time to discover what it is that each of you enjoys—opera, ballet, sports. You may have very different tastes so try sharing each other's interests. One week a movie, the next a lecture. You may find a whole new world out there, one which you have never experienced before. Then, when you feel ready for it, you can make a conscious decision to go where you may meet men. Singles bars may not have a good reputation, but they do serve a need and you may want to experience them at least once. A more likely way to meet a man with whom you will be comfortable, however, is to further develop interests of your own and to go to the meetings or conventions that cater to those interests. You are just as likely to meet a compatible man at an evening course or a club meeting as at a bar. As a matter of fact, if the timing is right, you may sit next to him at your local coffee shop or on the bus. One thing is certain, however, and that is that you are unlikely to meet him at home. You must get out! And if you are working and see the same people in the office day after day, then the same advice applies. It is up to you to expand your horizons and to find ways to meet new people! It takes practice, like every worthwhile endeavor, but as you become more comfortable with yourself and your role as an individual, you will grow bolder and find yourself doing things you never expected to do.

Start small! Before you sign up for flying lessons, try dining out by yourself. That seems to be a really difficult action for many midlife women to take. If it is a problem for you, first choose a local restaurant for breakfast or lunch. Somehow that is easier than dinner. After breakfasting or lunching out alone a few times, you will be able to take the plunge and take yourself out for dinner. True, it feels strange! You will look around and every table will appear to be full of couples or groups. That is all right. *You* are

all right! It is all right to be by yourself. Dining out alone is a very good exercise. If you do it more than once you will gradually feel more and more comfortable. You are not bad company, are you? Once you have conquered the dine-alone-fright, try the movies or the theater. In fact, try all those things that you were accustomed to doing on someone's arm. Don't let fear or embarrassment get in your way. Remember that while you are struggling with the aloneness, some important gains are being made.

Your self-confidence is slowly growing.

You are becoming a more interesting person by expanding your horizons.

Somewhere along the way, you will meet another single individual, male or female, who will become a new friend.

Now, when you feel redy to deliberately seek a new man in your life, you might want to try one or more of the following tactics, which are all based on the simple premise that if you want to find a man, you have to put yourself where the men are! So, if you are serious about finding a new male friend, consider the following:

- Go to bartending school.
- Join a civic or political club.
- Resign from the PTA.
- Spend a day at the races.
- Take a wine-appreciation course.
- Join a health club.
- Take up jogging, bicycling or dog-walking.
- Take flying, sailing or golf lessons.
- Vacation or travel alone—but not to Disney World.
- Learn to play bridge or chess.
- Work in a male-dominated office, such as a stock brokerage, legal, military or police environment.
- Take computer classes.
- Become a salesperson in a menswear department or an electronics store.
- Take a course in Nouvelle Cuisine.
- Offer a class or a service on a cruise ship.
- Go to law school or study for an MBA.

- Visit art exhibits or museums.
- Offer a personal-shopping service for men.
- Open a shoeshine parlor.
- Spend a day at Atlantic City or Las Vegas.
- Travel on the airline shuttle service between big cities during early morning business hours.
- Take lessons in Japanese or Chinese.

Have fun with these suggestions. Use them as a starting point to brainstorm and come up with ten of your own. Mix and match! Be as creative as you can. What about doubling your chances by opening your shoeshine parlor near a military base? Or operating a VIP only chauffeur service to and from major airports? As with any creative exercise, set your judgemental Left Brain aside and let your all-knowing, intuitive Right Brain take over.

What about personal ads? If you decide to advertise yourself as available for social engagements, realize that you are putting your address and telephone number out there for all to see, unless your ad is protected by a box number. This kind of advertising is a risky business, prone as it is to descriptions that are highly subjective. If you decide to try it, use a vehicle that is appropriate for you. If you are a literary type, see if your local book review has a classified column suitable for personal ads. There are newspapers that cater exclusively to blacks or to ethnic minorities. Be selective and narrow your search by concentrating your efforts in those areas you feel would be most likely to yield someone who has interests or background similar to your own—if this is what you want. However, be prepared for the responses you may receive! A mental health counselor who has placed and answered ads herself has this to say about the process, "My experience is that men lie! They say incredible things like, 'I'm a hunk, financially independent, looking for a woman who can match my intellectual capacity.' Then they turn out to be nerds or worse! Women placing ads will struggle with 'Can I say I'm pretty?!, while men will comfortably say whatever they think works. Here again is the double standard of women not wanting to exceed their reach, while men are keeping their eyes on the goal. Men are used to figuring out what will

work and women are used to being good girls. Women still believe that if they are nice and tell the truth and don't brag, then all good things will come to them."

Here is a less usual but effective tactic you might want to try instead of this. Let's call it a Mindercize, an exercise in creative imagination. Write down in list form exactly what you want in a male partner. Fantasize as freely as you can. If you have artistic talent, you might prefer to draw your Mr. Ideal. However, once you have comleted the drawing, add in writing those undrawable features that you are seeking, such as generosity, dependability, punctuality, sense of humor, or whatever it is that you particularly feel you need in a partner. Now go through your list and prune it to the bare essentials. Be wary of concentrating on the physical details. For example, does it really matter if he is six feet tall? Wouldn't you rather have understanding than height? It is more important that you decide what it is you want on the inside—not the outside. But, only you know your own heart, and if certain physical or externally visible properties are truly important in fulfilling your needs, then by all means, list them.

Once you have refined your list, place it where you can see it every day. The bathroom mirror is a good choice. You will look at it every morning and evening, thereby mentally reinforcing your goal, that this is the man you want to meet. The most important step of this exercise is this. Every evening, just before you drop off to sleep, say to yourself, "I am attracting my perfect partner to me."

Then either recite your list to yourself, or visualize in your mind's eye the picture you made earlier. Have confidence in the powers of your own imaginatin and willpower and in a natural law known as the Law of Attraction. Then make a point of remembering every day that you are doing this exercise! Otherwise, your Perfect Partner may come along without your being alert to the coincidence, and you may miss the opportunity of making a connection when your two paths intersect. Be open to the possibility that visualization and practical endeavor can work together to create a miracle!

Your chances of meeting someone with whom you are highly compatible increase every day that you gain in self-confidence and learn to like yourself better. As long as we feel dependent on someone else to make us happy, then we run the risk of finding someone who seems to make up for our own losses. While this feels fine initially, and is the very stuff that romances are made of, after a while the attraction loses its glamor. You may find yourself leaning too much on the other partner, or he on you. Look around you. How many marriages do you see in which one partner is shy, the other outgoing? One untidy, the other neat? One busy, the other lazy? While it is true that two people counterbalancing each other can make a marriage or relationship work for a long time, what often happens is that, sooner or later, the one who is doing most of the giving starts to feel some resentment at the other partner's lack of self-responsibility. Of course, in some relationship, the dominant partner has an unfailing need to be dominant, and the weaker partner a similar need to be weak, and, if neither want to change, the partnership can remain as it is forever. Carried to an extreme, such relationships are considered to be sadomasochistic, as in the case of the physically abused wife who is unable to leave her husband. However, what you want at this stage of your life is not an unbalanced relationship or marriage, but a partnership of comfortable and comforting equality. Once you feel complete in yourself, and without a desperate need for companionship, you are more likely to be drawn to a man who is similarly "whole." A partnership, friendship, or marriage with such a man can mean a mutually satisfying relationship in which both of you follow your own star, yet spend plenty of time star-gazing together!

Alternatively, you may decide after a certain period of being alone that you enjoy the state of singlehood so much that you will make a conscious decision to remain single. Many single people feel that there is much to be said for following one's own desires and inclinations without having to consult with or consider another person. Once we have learned to enjoy our own company and to make our own decisions on a daily basis, independence can feel very comfortable. A single life can still be shared with others, if not with one particular other. Women are particularly fortunate

in that we have the capacity to form satisfying friendships with other women in later life because we have all had similar experiences that can become the basis of new and rewarding relationships.

However you choose to define your life, it cannot be stressed enough that now is the time to reach out and to try something new. Take up that interest you left behind years ago, learn the foreign language that has always sounded so good to your ear, give some time to those less fortunate than you. If you ever feel sad and lonely, this is the ideal time to really look around and search out someone who needs your companionship. Call the local nursing home or hospital. Be persistent—somewhere there is someone in whose life you can make a difference, whether young or old, healthy or ailing. Remember, you have a lot to give, and the giving can make your life full of meaning. For example, Hannah is a career counselor, a widow who divides her working life between individuals needing help with their professional lives and groups of disadvantaged women who need to learn about the opportunities they can open up for themselves. She has an active social life, one special man, and friends of all ages. Her calendar is always full.

She is a tall, attractive British born woman in her fifities who was widowed over twenty-five years ago. Her husband, a Danish businessman seventeen years her senior, died suddenly of a massive coronary while they were on a business trip to Madrid, Spain. As Hannah says of the memory, "It was terrible. The heart attack happened in the middle of the night, I called the hotel doctor, but my husband died in the ambulance before it arrived at the hospital. I was in shock and was brought back to England by a businessman who was with us, one of my husband's staff. The whole thing seemed pretty horrendous! Ghastly! I was in deep shock for three to four weeks. Then I started to pick up and carry on—which is what you have to do. I had my own company with two partners—a small Import-Export business. This kept me busy but it took several months for me to feel myself again. Fortunately, we had some close friends who would invite me over. There were one or two couples who did not provide an extra man when they asked me to dinner parties, and I must say I felt quite uncomfortable about that at the

time—being the ninth at dinner. But basically, people were nice. I suppose that I was always more gregarious than my husband was, so after a while I just kind of continued with what I was doing.

"A year later I became consultant to the first American Trade Centre in Europe and handled three big shows. At one of the trade shows I met a Texan who was the spokesman at the conference for the textile industry. After an exhilarating two weeks, he asked me to marry him—and I said yes! It was all very romantic. . . but I think it was rebound. We were already engaged when he came back to England on a trip two months later and told friends that I only wanted to be married in England. I asked, 'How do you know that?,' and he challenged me by saying, 'Well, will you come with me to Dallas tomorrow, and we'll get married in Guatemala?' I can't resist a dare, so I said I would, and he got right on the phone and bought another ticket! Well, it was all a bit of fun! We flew to Dallas where I met his relatives and friends and he showed me the site of the house he was building for us. I had a friend in Reno who had just been divorced—that was about the only place you could get a divorce in those days—so I suggested to my Texan that, as a switch, we get married in Reno! He said, 'Okay, I'll join you in two days. Set up the wedding!' My word, it was romantic! But I got a terrible shock when I got to Reno and happened to find out that the four adopted sons he'd kept telling me about didn't exist! Can you imagine? If you find out that kind of a thing, then you know everything else must be a lie!

"Anyway, I promptly flew back to Dallas, changed planes and went straight back to England. From there I cabled an old friend and said 'I'm going to Rome for three months.' In those days, I had some money and was able to do those things. You see, people were talking, and I didn't want to have to explain that I'd been engaged to a pathological liar! So, my friend joined me and we set off two days later for Rome where we took a small apartment. My friend was keen on looking at churches but I used to drive to Naples, park the car and catch the ferry to Capri where I had some friends."

After three months, Hannah packed her bags and went back home and "carried on as usual." She decided that she wanted to emigrate to the United States where she had friends and in 1963 made the big move. Before leaving England, however, she had made a very important new boyfriend, an American, and there was talk of marriage. "Life was too busy at that time for both of us, so it drifted more into a very serious friendship instead." She moved to the United States where she and Jeffrey, after all these years, still spend a lot of time together—whenever it suits both of them. She explains their close friendship this way: "We've had a lot of fun throughout the years. And then, he's looked after me when I've had an operation, and I look after him when he's not well. We're very close. In a way it's almost a unique situation, because I still have other friends who escort me here and there and it depends who it is as to how Jeffrey feels! I encourage them all to be friends."

When asked what advice she would give women who are starting out on their own after many years in a marriage or relationship, Hannah says, "Realize that you probably have very few friends, but a lot of acquaintances. As long as you know which is which, well then, you've got your sights set okay. If you want a good social life and to stay in circulation, you must entertain, whether it's asking people for drinks, or dinner, or any other special event. When I had a job at a magazine I would give small dinner parties regularly. You must keep in touch with people."

Are women friends important in her social life? "Oh yes, yes! If they're nice! But if I get wind of anything unpleasant, I'm off! Life's too short to be putting up with people who don't have your best interests at heart. Women friends are just as important as the men. I think if you can try to lead a balanced life, one that has the minimum of competitiveness, that's the ideal. I mean just being yourself. It's very important to have couples, too, in your social life, but the essence of it is, when you're alone, then you have to reach out to people in order to have them warm up to you. It's not a one-sided thing at all. I think it's something you build by give and take. It's not exactly 'a chop for a chop,' but you have to be willing to extend yourself. I could name people who are always

going to other people's places but never give a party themselves! Even if you don't cook, invite people in for drinks, and go to the deli and buy some cheese!"

Hannah believes that location is also very important to your social life. "You have to build friendships among those who live within twenty minutes' traveling time. A lot of your social success is based on the accessibility of the people, no matter where you live. But age is not important! Develop friends of all ages—some your age, some older, some years younger. Whatever the ingredient of friendship is, that's what's important. And remember that when you get older, you have to be interesting enough in yourself to be worth two people. In other words, a married couple has to enjoy having you around enough that it's unimportant to them that it's not a foursome. A woman has to stand on her feet instead of leaning on other people! A woman has to be her own entity! Develop plenty of interests and be interested in everything, be interested in life! Especially be interested in other people's lives and not only your own. I think that's terribly important—not living in a tight little world of your own."

Hannah has a zest for living that is irrepressible. She has lived a very full life, one filled with both excitement and pain. She believes in letting go of the old and embracing the new. She is never lonely, because she has developed a wide circle of friends and acquaintances, and is always open to forming new relationships. She admits to having made some poor judgements ("plenty!") along the way but has no regrets. If she had a slogan it would probably be, "Let the good times roll!" She enjoys people of all kinds and keeps closely in touch with those she really likes. She is always making new friends while at the same time keeping the old. Regularly invited to friends' dinners or cocktail parties, she often puts on impromptu parties of her own, mixing people of all types, ages, and backgrounds.

Her own word of caution about developing a new social life is that women need to be alert to some of the hazards involved with being alone and lonely. "It's possible to be too impetuous because you miss being half of a couple but, take my advice, never go off with someone you've just met, no matter how wonderful he seems."

And she feels that there's nothing like a good sense of humor to get you out of potentially sticky situations. "If any stranger ever puts you on the spot by asking you if you'd like to have lunch or a date, and your intuition tells you this doesn't feel quite right, just say, 'Of course I'd like to have lunch with you—if you don't mind my husband joining us!' "

Hannah was offered marriage more than once, but chose to remain single at a time when society's pressures were all in favor of weddings. She feels that this was the right decision for her. She and Jeffrey are always available to each other for support, companionship and good times, but she still has the sense of independence and self-sufficiency that is so important to her. Would marriage have interfered with that? She is sure of it. She is a woman who has consistently defied traditional mores by developing her own very personal style—and is thriving on it!

6

Life As a Shadow

How to find fulfillment as a Corporate Wife.

We all know at least one. The self-effacing hostess, the slender, attractive woman in the black dress who entertains graciously, raises well-behaved, achieving children, and supports every opinion her husband expresses. She is the American corporate wife. Very similar to the American political wife. And also to the American doctor's wife. She is always over forty, because the younger models of this type of wifehood are usually of a different breed, having been raised in a changed environment where their own personhood was respected and allowed to flourish.

Do you recognize yourself as a corporate wife? Do you sometimes wonder if you are married to the man or the company? Have most of the decisions of your adult life been made by your husband, reacting in turn to the demands of his employer? Have you moved more than once, uprooting yourself and your family from familiar environment, family and friends? If so, you are certainly not alone. For three decades this has been the accepted way of life for thousands of business wives. If the company decided that its marketing executive was needed in Omaha, then you picked up and went to Omaha. If a promotion meant relocating to Atlanta, off you went to Atlanta, children and pets in tow. The company became not only your Pied Piper, but also your Santa Claus, and you better not laugh,

you better not cry, you better not pout! You surely know why! You had to keep moving in order to keep moving up. A good corporate wife has been absolutely indispensable to the good corporate man, the quintessential team-player. The smoothness of the transition from one town to another, from one professional position to another, not forgetting one school to another, depended in large part on the flexibility, good humor and coping skills of the Little Woman. Without her unpaid cooperation, her willingness to subjugate her own needs and desires to the demands of the company, American business would have had to rethink its personnel policies and politics. In fact, very little thought has been paid, until recently, to the havoc that frequent uprooting has played in the lives of so many growing families. But by now, with children's school years over, or almost so, husbands well-established within the corporate structure, and no more moves anticipated, many wives find themselves looking at their Empty Nest and wondering, "Just who am I?"

Well, today is a perfect day to start to find out just who you are, to step out of the shadows and establish your own identity. There may be absolutely no financial need to do this, but in the current climate of mergers and acquisitions in the business world, where bigger fish are daily swallowing smaller fish, it might not be unwise to look at your own skills to determine where you might put them to work. Salaried work, that is! No husband's corporate position is really secure any longer and even the most prestigious rank and title can disappear overnight.

So why not choose this time in your life to take a look at your own needs and desires and decide what you are going to do to satisfy them. Where are you going to put the energies that formerly went into child-rearing and husband-caring? What if your husband were suddenly no longer a company man? Would you be able to afford your familiar lifestyle? Could you adjust to the loss of status and financial comfort? These questions are posed not to alarm you but to alert you to the possibility of a changed scenario and to give your mind an opportunity to break out of its habitual grooves. Ask yourself a few What Ifs:

- What if my husband lost his job?
- What if he doesn't make VP within the next year?
- What if the company relocates to Dubuque?
- What if he has to choose early retirement?
- What if we lost his income?
- What if the kids come back to live with us?

Use a popular business management technique to come up with what is known as a Worst Case Scenario and then, without fear, look at the scenario and ask yourself, what woud I do to cope with it, overcome it, even benefit and grow from it? A little foresight goes a long way, as the founder of the Boy Scouts realized so many years ago. Be prepared! Today is a perfect day for looking at life and choosing whether to stay on the same path, the path of custom and familiarity, or to make a turn to the left or the right. What could you do right now to satisfy old yearnings or prepare yourself for a new role—just in case your current role ever changes?

One corporate wife who refused to allow herself to be solely and completely an adjunct instead of an individual is Sally, happily married for twenty-six years to a highly placed executive in the retail industry. Despite the fact that she is rather rare in that she claims that she loves being a corporate wife, and would have no hesitation in doing it all over again, this has not prevented her from fulfilling her own potential at the same time. She says that she was a corporate wife from the time her husband began his career as a buyer in a department store. "I loved it! I think of it as mainly advantageous to my life and I'm very happy that that's how my life has been. I really feel that a strong advantage has been my meeting very, very interesting people. A lot of other friends that I have who have not been in corporate have maybe four or five couples who are their friends and that's kind of their life. And that's fine. I'm not saying anything bad about that, but I've loved people and I've loved the opportunity to meet so many different people and not just to have a small group of friends. I love to travel and this has afforded me tremendous travel, all over Europe and to the Orient and for that I'm very, very happy and grateful. Because my husband has been in retailing and in department stores, it is very

important to go to the showings in Paris and last year we were in Korea, Taiwan and Hong Kong, and that's a tremendous perk, a tremendous opportunity. My husband was involved there with the buying offices. Stores use buying offices to help them get the merchandise in the stores and do the selection. I was with him, but during the day he has always felt very strongly that he has his work to do and I've either gone with other wives or gone off by myself. I've never really gone with him to do the things he does during the day, when we have traveled."

What else has she enjoyed as a corporate wife? "Again, I'm lucky that I do enjoy people, so I've loved the parties! We go to many formal dinners in the course of the year and I enjoy getting a pretty gown and I enjoy going to a ball! But this isn't for everyone! There are people who wouldn't enjoy these situations. I've just been fortunate that I like them and this is what my life is about."

When asked about the chief disadvantage of being a corporate wife, Sally says that she perceives only one real disadvantage. "You don't have total control of your life. In corporate life, you're more structured. The most important factor in handling this successfully is that you should view it as a challenge in your life and not as a threat. Having that up front as your attitude is going to make a very real difference. I also feel that a corporate wife should have an identity of her own. You could very easily lose your own identity in that of your husband or of the corporation itself. And it doesn't have to be a big career! It can be a job, a volunteer activity or a wonderful hobby like photography. It could be studying at the university. Your husband is out there with a lot of interesting people all day and you want to be interesting, too, when he comes home. A wife needs to grow with her husband for her marriage to stay really healthy, I believe, and for her to enjoy her life as a corporate wife. You know it's easy for the man to grow. He's out there and that's just what he's doing. You're at home and you're not exposed to all the things that he's exposed to. So just being aware that you're vulnerable makes you do certain things. It did for me! Taking special courses, reading everything that's current. I used to read the daily

and Sunday newspapers from cover to cover, every page, because I wanted to be aware, because I was home with the children and this was my way at that time of staying abreast of the news."

How did she cope with the relocations that the family went through while her husband was moving up? "It was difficult in the beginning. I'm not going to tell you it wasn't. We started in Washington, DC. Our first move was to San Francisco and after three years, we moved to St. Louis. After more than five years in St. Louis, we moved back again to DC. It's hard to uproot yourself and make new friends, but once you've done it, the reward is so tremendous, you just feel so good about yourself! You learn that you can go anywhere in the world and make friends, and I think it has given our children great confidence in themselves. It's been a growing experience for all of us. Painful in the beginning, but growing!"

What about the strain of entertaining the boss, the boss's wife, the customers? "Sure, I was scared about that too in the beginning when I had to make my first dinner parties, but you get used to it as time goes by. If you think of it as a support to someone you love, rather than being just the litle woman at home then, at least for me, it's okay. I've always viewed my life as a corporate wife as a part-time job, but I've gotten tremendous pay for it! That's how I've seen it. I've just enjoyed my life the way it's been. The secret is how you perceive things! If I know I'm going to a formal, I look forward to getting dressed up, having my hair done, and going out. So it's not stressful to me. If another woman was going and she was not happy about the way she looked, and if she didn't want to go anyway, then, yes, she would perceive it as stressful. So it's how you perceive the event, whether it be a dinner party, a cocktail party, or a big move, that makes all the difference."

Sally learned early in her marriage how to develop a positive attitude toward events that have caused great stress to many other wives of corporate men who have felt that they were definitely not in the driver's seat. Her tactic was to take as much control as possible of any situation by approaching it from a viewpoint of personal growth. "How can I use this situation to my advantage? What can I do about this situation to make myself happy?" Instead of seeing

her cup as half empty, she always saw it as half full and resolved to fill it to the brim. Events that many wives might have resented, she used as reasons for her own satisfcation. Where some women might have resisted the pressures of dressing up and being well-groomed, she developed an attitude that enabled her to enjoy the experience. Where some women might have experienced feelings of inadequacy and frustrations at a husband's advancement, along with a fear of being left behind, she determined to keep up with his pace through self-education. Her behavioral pattern has consistently been one of support for her husband's growth, but never at the expense of her own.

As for Sally's husband, during the course of his career, he encouraged his wife to branch out on her own. Twice, in different cities, she established a small retail business, but now back in Washington, she is developing a new professional area for herself. Understanding so well the challenges and strains that today's women face, she has developed a relocation counseling practice which enables her to work with individuals or with groups of corporate employees.

Undoubtedly, her own experiences led her into this new career. As she says, "A man's main focus is on his identity within the organization, knowing just where he stands with his job. For women, the biggest problem is managing her time. She may or may not have a paid job, but typically these days a woman has multiple roles. If she has a career, she seems to feel that she has to work twice as hard as a man to get to the same place. Often the same woman is working hard at her job, and then coming home to handle her house, her children and her husband."

What does Sally feel is most important to the understanding of a situation like this? "It is very important to know that too many women try to be perfectionists. There is no such thing as a perfect person! Lower your expectations! Now I do believe that we can do almost anything that we really want to, but some persons set expectations that are just too high and are unrealistic. Still they keep out there, trying to do all these things, and feeling very down on themselves. I think you should set goals that are reasonable. A reasonable goal within a reasonable time frame. Set priorities,

make lists, and ask for help when you need it! If you can afford help, pay for it. If not, enlist the help of your husband, your children, your mother, or your friends. You don't have to be everything to everybody. You really don't! If you don't realize that, before long you'll be burned out."

Sally also advises that, as part of your new consciousness, you learn deep breathing techniques. "When you exhale, get rid of all the emotions within that are troubling you. Learn to tighten all your muscle groups so that you know what it feels like to be really tight, and then just let it all go. Learn to take time for yourself to relax. You can actually take a mini-vacation by imagining yourself at the beach, at the mountains, surrounded by wildflowers, whatever you really like, and it's amazing how far that can really take you. People sometimes feel foolish doing this, but my advice is that you should never feel foolish! You're doing this just for you! And, most important of all, have positive thoughts around and about you all the time. If you feel negative about something, try to look at it from a different perspective. There's always something there to be positive about. Replace worry thoughts with positive thoughts! It takes discipline and it takes time, but it's so much worth it. Learn the techniques, change the beliefs that are harmful and practice, practice, practice!"

If, like Sally, you are a corporate wife and want to stay a corporate wife, what service could you provide for other women in your position? What have you learned in the years of moving, adjusting and growing that could be of benefit to younger wives who are choosing to stay at home? What could you do to ease the path of young wives who are attempting to follow their own careers? Could you set up a business or consultancy of your own which would tackle some of the problems that arise for women wedded to corporation men? There might be need for a relocation service if you live in a large city on the corporate circuit. You know the area, the school districts, the price of Real Estate. Newcomers may not. Perhaps you could write a newsletter or establish a professional childcare service for working mothers. Could you do something to assist the growing number of foreigners who are being sent to this country on trade missions or assignments? Whatever your

experiences have been, they have value to others. Remember when you were new in town—what did you need to know, what did you lack? Contact the director of Human Resources or the Personnel Manager of the large corporations in your town. Ask them if any services to executives or transferred employees are missing that you might be able to provide with the know-how gained from your own experiences. You might decide to start an enterprise in a small way, volunteering your time and talents. If it goes well and has promise, you could allow it to evolve later into your own small business.

If you have tired of lunches, cocktail parties and shopping expeditions, this is the time to think back to your early dreams and resolve to make them come true. Time has a habit of slipping by without our noticing it, like ice-cream melting in a summer hot-fudge sundae. One year becomes five, and five, ten. Children speed through grades and suddenly you're a mother-in-law. One day you turn around and realize that you are forty, or fifty. If you are still in love, if your marriage is still intact, if you and your husband still have plenty to talk over, then you are a lucky woman. But, if there is any room in your life for expansion, for fulfillment, for curiosity, for caring or daring, for service or for dream-achieving, then this is the time for you. Don't let it slip away!

7

Was There a Tavern in Your Town?

Drugs, alcohol and the addicted woman.

It used to be that drinking was considered a man's problem. It still is—but not exclusively. We all know now that women drink too, and for the same reasons: for escape, for solace, and for companionship. We may drink to escape our feelings of fear or inadequacy. We may drink when we're depressed or angry. We may drink when we feel all alone in the world and that nobody cares. Whatever the reasons, women today are reaching for a glass of wine, a bottle of beer, or a gin and tonic just as readily as men.

But there is a difference in our society as to how drinking is perceived. It is still thought of as a manly thing to do. It is still acceptable for a man among men. And even though there are campaigns from time to time against "one for the road," the perception persists that a drunken woman, on the other hand, is seen as an embarrassment and a disgrace. No wonder that most women who become accustomed to a daily pick-me-up become closet drinkers, reaching for that comforting companion, the wine glass or the bottle, in the privacy and security of the home after their husbands leave for work and their children for school. No wonder that it is harder

for a woman to acknowledge her addiction, her dependency, and to seek help. More often than not, she is unable to acknowledge it even to herself, and will be left alone, caught in an inexorably descending spiral of self abuse until someone close enough, brave enough, and loving enough, confronts her with her situation.

Alcohol and the lonely woman. And now, drugs and the lonely woman. How and why does it happen? And just how common is it? Statistics from the National Council on Alcoholism indicate that 30% of those who join Alcoholics Anonymous are female. But such statistics relate only to those women who seek help. If we make an educated guess at the number of women who are too embarrassed or unwilling to admit their addiction, then the percentage rises substantially. According to a report issued by the National Clearinghouse for Alcohol Information, based upon a 1981 survey, "More middle-aged women are drinking." Another report, from a hospital Department of Psychology, states that, "Middle-aged women are felt to be especially at risk because of the nature of the events that they are likely to experience, e.g. divorce, bereavement, departure of children from home."

And a university report adds, "It is noted that new societal and family pressures, plus the lessening of taboos against female drinking, may be causing more women to become problem drinkers." Another interesting comment comes from an article in a European journal on psychology: "The theory of learned helplessness is applied to explain how social insecurity leads to alcoholism among women. The empty-nest syndrome and disharmonious relationships with partners and family are believed to be the uppermost causes of female alcoholism."

Is there a typical female alcoholic? Not really, although we might say that a midlife woman who feels herself to be under undue stress and who feels that she has not achieved in her life what she had somehow expected to achieve, is a typical candidate for the role. So is the woman who had depended on her beauty for her identity and feels that her looks are fading. If she had parents who drank, she may unthinkingly turn to alcohol for problem relief. For many women, the trouble begins with the pressures of raising children and being a wife. Trying to cope with the demands made by others

for their satisfaction, whether in the form of a spotless house, a hot meal, clean shirts, paid bills, filled lunchboxes, or a lift to the game. Trying to be all things to all people: cook, housekeeper, chauffeur, gardener, nanny, maid, laundress, accountant, lover. For some women the demands are too many and too onerous. Certainly, if they are repaid with love and appreciation, thay can be satisfying and fulfilling. If, on the other hand, those unpaid services are not only expected but unrewarded, than the toll on the energy and self-esteem of the giver begins to mount until it reaches a crisis point at which the woman reaches out for some form of relief. This search for relief often results in a quick fix of some kind, anything from a love affair, a brief escape or even marital separation, to a drink or a pill. And since it is usually easier and faster to find a drink than a lover, this can be the point at which the habit begins.

While alcohol is the choice of the majority of what are now known as "substance abusers," there are many other, readily available means of quick relief. One of the most common addictive drugs and one which has not been recognized until recently for its dangers, is the mild tranquilizer. For many years these innocuous-looking little pills were not only readily dispensed by doctors to their female patients who were showing signs of mental and emotional distress, but they were routinely advertised to physicians by the drug manufacturers in medical journals, in ads complete with illustrations of the manufacturers' idea of the patient most likely to benefit from the drugs' use. Which patient? The dutiful housewife, of course! There she was in the vibrantly colored illustration, hand to forehead, eyes rolled to heaven, surrounded by all the litter and clutter of everyday life, chaos all around her. The preferred answer? A mild tranquilizer.

As with so many other aspects of life, a little may be fine, but a lot is disatrous. Before long, mild tranquilizers were being offered to women as a cure-all. Menstrual pain? You're just upset. Take two of these every four hours until you feel better. Overwhelmed with the amount of work you have to do? Two tranquilizers. Giving a big party and don't know how to cope? Two tranquilizers. And on and on. The pills worked, and women loved them! Before too long, what had been prescribed as a stop-gap measure became the

routine cure for just about any situation. It helped to take the edge off anxiety, it helped to dull the ache, and it helped to ease the unhappiness. In fact, women found that if they took the pill on a regular basis, they could get a head start on the tension that kept creeping up and attacking them.

In fairness, it must be said that when mild tranquilizers first hit the market, the medical profession did not realize that they were addictive. Nevertheless, they represented an easy way out when the physican did not want to take the time or the energy to discover what was troubling his female patient. After a check-up seemed to prove that there was no physical cause for the patient's complaints, prescribing a tranquilizer "for your nerves" was a very acceptable way to satisfy both the patient and the doctor. Tranquilizers became women's medication. Most doctors are still men and most patients in doctors' offices are still women, and since many men truly believe that women are prone to emotional excess and that their behavior is negatively affected by their menstrual cycles, tranquilizers appeared to be a harmless way to keep their patients happy—or quiet.

Meanwhile, what were the tranquilizers really doing for the woman taking them? Basically they were preventing her from taking a serious look at her problems. They were a form of escape. If she felt apprehensive, the pill took away the apprehension so that she did not need to examine it to find the cause. If she felt edgy, the pill made her feel calm. Why then bother to question the edginess? If she felt exhausted, the pill provided an easy way to fall asleep. Why wonder about the exhaustion? And so it went, until the mild tranquilizer lost its potency and a stronger pill was needed, and the need escalated slowly, invisibly sometimes, into a severe addiction. Many women, unaware of the potentially lethal combination, and needing more and stronger antidotes to their emotional pain, started to drink at the same time that they were swallowing pills. We have all heard stories of the celebrities whose lives were ruined or even ended by such a fatal combination, but for every celebrity whose escapades became front page news for a few days, there were hundreds of ordinary women leading ordinary lives

whose stories were just as painful. Does anyone you know seem to be reaching into her bag for a couple of pills every time you have lunch together?

There is such a wide range of addictive substances around us today. This year, the drug of choice, the "sexy" or "in" drug is cocaine and tomorrow it will undoubtedly be something else, something we have not even heard of yet. Drugs are available on every street corner and at every party in America, and it is always going to be simple to take what seems to be the easy way out whenever you are feeling angry, frustrated or depressed. The first step, that routine drink or pill, may go unnoticed. The second or third step, the gradual slide, may also be ignored, perhaps for years. However, when you have knowingly or unwittingly succumbed to a drug or alcohol addiction, when you have tumbled deep into such a morass, just how do you climb out? Is recovery possible?

Betty's addiction to both drinking and drugs began innocuously enough when she was in her teens. Going out on weekends, dating and socializing were occasions to have a sociable drink or two, as was the custom in the upper middle class area of New Jersey in which she grew up. The drug use began when she paid her first visit to a diet doctor at the age of sixteen. He prescribed an amphetamine for weight control, and she discovered that , "I liked the way it made me feel!" She continued to use amphetamines or other forms of speed (so-called because the drugs give the user a "high" or a feeling of elation and quickened responses, rather than the low and calming responses of a tranquilizer) for twenty-five years. Her drinking also continued. She grew up and married, and by the age of twenty-four had given birth to two children. She did not realize that she had become addicted, either to alcohol or to drugs. As she says, "Not realizing it was unusual, I drank on a daily basis. With me it was generally controlled because I didn't like to lose control, but I did have black-outs. Everyone I knew was doing the same thing. Women and men. It was a lot more common and accepted than was believed at the time. I saw it on so many different levels. At the same time that this was going on, I was having trouble with my son at school. He was heavily into pot. At twelve years old, he became a heroin addict."

Betty became emotionally involved with a therapist who introduced her to recreational drugs—marijuana, Quaaludes, and other street drugs. Asked if she realized at the time that she was trying to escape from her marital problems, she says, "I was unhappy and it wasn't that I had such a terrible life at all! I was just unhappy. I was bottoming out on lack of faith. It was more than just unhappiness. I felt different from other people. I was trying to find out what was my purpose for being here, what was my life all about? There had to be more to life than I was experiencing right now. I didn't feel like I fit in anywhere. I wasn't prepared for marriage. I wasn't prepared for raising children. I certainly didn't know the first thing about what I was doing. I felt totally inadequate! My feelings of self-worth and self-esteem were zero. I developed narcolepsy. I had intense migraine headaches. I had ulcers. I used sickness to escape. I used drugs to escape. And I was a totally dependent person who had simply gone from father to husband."

Betty divorced when here children were ten and twelve, and found that she was going to have to go out to work. "I had always had money. The problem came after I got the divorce because I didn't get any money. And I had the habit of drinking. But I also had the habit of surviving! I knew I would have to do something. I had to figure out what to do. I knew I couldn't work for anyone else. I knew that much about myself! Through a friend I got the opportunity to become a manufacturer's rep, so I began a little company of my own and repped a lot of products. But I found out this was not for me, so that didn't last very long. Then another friend had a shoe manufacturing company and offered me a job as a fashion coordinator. I traveled with him and the job provided me with what I needed. That lasted for seven years and then I knew I had to find another business and not depend on a friend any more."

Fortunately for Betty, family connections led her into the stock brokerage business. She jumped at the opportunity to go to school and become registered as a broker. She made up her mind to specialize in bonds, focused on that aspect of the business and is now earning a six-figure income as a partner in the company.

She says that without this career, she might simply have married again. "My only knowledge was survival through a man." However, as successful as she was becoming in her new career, she describes her personal, private life as "totally unmanageable. I had become unbelievably lonely. Cocaine really brought me to my knees—I had such incredible highs and lows. I used it on a daily basis. Still I didn't think I had a problem. I thought I had it all under control. I'd buy my vodka by the case, my pot by the pound and my coke by the ounce. I always had to have a backup supply of whatever it was I was using, and that's the way I lived. But to me, because it was controlled, I didn't go crazy with it. I doled it out to myself in what I considered to be acceptable quantities. Every day I had two vodkas, a gram of cocaine—and a joint to go to sleep. My son was a heroin addict and I was in a life threatening situation. I sobbed and prayed for someone to come into my life."

It was during this period of intense aloneness, that Betty began locking herself in her room. She would put on an eye mask and listen to audiotapes on meditation and self-improvement, and says that she slowly began to get a sense of something else, "A sense of who I was." Raised without any formal religious training, she began watching religious television programs, and purchased several inspirational books that revived her dormant sense of self. An emotional spritual experience one night when she was alone in her room led her to begin an intensely personal search for meaning to her life. She heard from a friend about a private rehabilitation center in Minnesota and went there to undergo a twenty-eight day program of detoxification and education. She describes this as an intense peer group educational experience combined with individual and group counseling, lectures, and "qualifications" or personal stories. After completing the program, she then became involved with Alcoholics Anonymous.*

The success of Alcoholics Anonymous is well documented. Although the focus is upon adult drinkers, programs also exist for the Adult Children of Acoholics and for children who drink. While

*See Appendix

non-sectarian, the organization takes a spiritual approach in its teachings. It was founded in 1935 by a physician, and has since become known as the foremost association for the successful treatment of alcoholism. The program of recovery is based upon a concept of Twelve Steps, the first of which is the acknowledgement of personal powerlessness over alcohol, and the second a belief in a power greater than oneself. Peer support is an essential ingredient in the success of the AA program, and help is always available from one individual to another.

For the last two years Betty has been entirely free of both alcohol and drug dependencies, and followed up those successes by giving up smoking—after thirty-five years. Her advice for anyone caught in any addiction is, "Be willing to look at yourself and be willing to accept that your life is unmanageable. Accept that you are not a victim. All my life I was a victim, but there really are no victims. I was creating that for myself, and until I realized what I was doing and became willing to take responsibility for my actions, I simply denied the addiction. There's a lot of denial, a lot of escapism and an unwillingness to give up what you think works. But addiction is about attitudes. Think of AA as Attitude Adjustment! And think of "HOW." Honesty, Openness and Willingness. You need honesty and openness and willingness to change your life, and a support group is essential in those early stages."

When asked how someone would take the first step in reaching out for help and a supportive group of people who have had similar experiences with addiction, she says, "Begin by looking for AA in the phone book. Or call Intergroup. There's a program for you wherever you are, whatever you are addicted to. In one large city alone there are forty-six different "twelve-step" programs for people with addictions of some sort. Most insurance plans cover alcohol rehabilitation programs. Once you can admit to the addiction, there are people to help you. But you have to be the one to reach out, to stop denying!" Betty still attends group meetings routinely and is working with drug addicts and alcoholics on a regular basis.

From a situation of complete dependency and lack of self-esteem, she has encouraged herself, through spiritual growth, to bring about major changes in her life, reeducating herself and learning to love

who she is. From this new position of self-love, rather than self-pity, she can now reach out to help others—by example and through one-on-one counseling. There is no trace on her face of the years of drinking, as she happily anticipates the excitement of her daughter's forthcoming big wedding celebration, knowing that she has successfully overcome the challenges involved in what seemed for so many years to be the easy way out.

8

We've All Got Lots of Living to Do!

The challenge of passing years.

How do you feel about being an older woman? How does the term, Mature Woman compare to Mature Man? As we mentioned earlier, as long as television news teams are routinely composed of gray-haired men and daughterly-looking women, the message midlife women receive is that it is somewhat gauche to be caught with more than forty years on our personal calendar. And, of course, as long as advertisements for cars or other tangible objects are adorned with young women in various stages of undress, then we will continue to absorb the message that a young and shapely female is okay, but a white-haired and wise one is not.

This sort of unsubtle message delivery has been going on in our culture for far too long. What can we do to change it? First of all, remember our original strategy, listed on top of all the others in Chapter One: "Never accept other people's barriers, restrictions and negative belief systems automatically!" Granted, this is not particularly easy when we are living our lives. However, it is not impossible! We can fully expect to feel like salmon battling our way upstream. Now, if we look at the salmon's task unemotionally, we would say that the foolish fish doesn't understand the odds

against successfully vaulting over the powerful, onrushing waters. Yet we all know that the salmon population is not diminishing, so the mother fish must know what she is up to—and against! Think back to Strategy Number Three: "Remember that every rule can be broken and every platitude repealed. Become the reformer in your own life." It is indeed a platitude that "After thirty it's all downhill!" Stop and think about that one and ask yourself how such a negative expression ever gained any credence and found its way into common circulation. The answer is that for many people, it is simply a habit to think and express negativity. How many people do you know who are constantly critical of their friends, their bosses, their coworkers, their parents, their children, their teachers, the government, the salesperson, the bus driver, the homeless, or the racially different? Any or all of the above! On the other hand, how many people do you know who are absolutely non-judgemental or who express a positive attitude or expectancy most of the time? Unfortunately, most of us know more of Group A than Group B. And not surprisingly, since negative thinking has become far more common in our society than the positive variety. If we consider the content of the newspapers and the television news programs, we can certainly see that the bulk of the news is given over to disasters. We see this on the screen, absorb it into our systems, and day by day unwittingly assume that all of life is bad news. If, in fact, there were no national or international news broadcasts, or if we were living in a rural environment in which we did not have access to a television or radio set, then we would see a far smaller proportion of unhappy circumstances, and watching the flowers bloom, we would be led to believe that life was really pretty good. What happens to us when we watch the daily parade of disaster is that we instinctively say to ourselves, "That might have happened to me!", and we take on the stress of a situation that actually has absolutely nothing to do with our personal lives.

What does all this have to do with growing older gracefully and happily? It has to do with attitudes and expectations, and it has to do, above all, with fear. If we decide to believe the advertisements, the movies, and the television specials which all deliver a similar message—that youth and beauty bring wealth, power, glamour,

romance and success—then, when we reach forty without having achieved all those wonderful attributes, we feel not only that we have failed but also, and more importantly, that it is now too late for us to do anything about it. We might as well throw in the towel and pass the boxing gloves on to the next generation.

Take heart! Changes are in the air and you now have the opportunity of joining the pioneers who are reshaping the image of the older woman. Certain prominent women in the entertainment industry, whose every move is closely watched by the press have, in their own ways, taken up the challenge of establishing forty-plus and fifty-plus as a sexy satisfying time of life, a time of fulfillment, growth and fun. Think of Shirley MacLaine, whose enthusiastic venturing into the little-known realms of metaphysics and spirituality has increased her appeal as a woman of multiple talents and interests, without decreasing her appeal as a vital, vibrant performer. Think of Jane Fonda, whose passion for excercise equals her zest for political action. Or Gloria Steinem, who combines feminist teachings with a style all her own, and who is said to have originated the now classic retort to "You don't look like forty!" with "This is what forty looks like!" In the media-related industries, which for years have relegated stars to the back of the bus once the bloom of youth has ripened, these women and others like them are leading the way for the rest of us stating publicly how old they are, and behaving so energetically, enthusiastically and winningly that, sooner or later, everyone will realize what a myth we have been internalizing for so many years.

In addition, other changing aspects of life in the eighties and nineties will force a different awareness of midlife. Take the beautiful title, Grandmother, for example. The word, as such, evokes the image of a gray-haired, elderly woman in a rocking chair. Definitely a Whistler's Mother archetype. But look around! In an age when most families need two paychecks, and many families are being shepherded along by a single, female parent, most grannies are out there working. They are slim, well dressed, active, and just as likely to be found doing floor exercises in the gym in their spare time as baking apple pies in the kitchen. If you ask them what their concerns are about growing older, they are most likely

to reply that financial security is the number one issue for them, and in order to stay in fighting trim for promotions and recognition on the job, they keep active, keep interested, and keep up to date. Obviously, this does not mean that they are less interested in their grandchildren than earlier generations were, but times and the cost of living are bringing about changes in the relationships. This, in turn, may cause friction between the grown children of these women, children who expected mother to be always available, and the women themselves. However, as one woman put it, "If you are an apple, you can try to be the very best apple you can—red, round, firm and sweet. However, you have to realize that there will always be someone who wants a banana. Or an orange!"

The number one secret to successful aging is the absence of fear. If you are afraid of growing older, the first step to take is to ask yourself why. Just what is it that you are afraid of? Take a pen and a piece of paper and write down what you fear about the aging process. For example, Maria, a married social worker in her early fifties who was asked to make such a list wrote the following:

1. Loss of mental faculties. I get anxious at every instance of poor short term memory or words being jumbled. Fear of living as a mental cripple.
2. Loss of eyesight and secondarily other possible instances of physical decline.
3. How to continue to lead an active, productive life, being aware that older people are scorned or ignored.
4. How to cope with depressing losses of loved ones and friends if one lives long.
5. Financial planning and concern about managing our resources so that we are independent.
6. My husband's health and his lack of good care—my hope that he keeps himself alive!

Let us look at these concerns one by one. First, the possible lack of mental faculties and memory. The brain is like any other part of the body. It will serve us well as long as we take care of it and give it plenty of exercise. A working woman in her fifties need have no fear of losing her mental faculties. It just will not

happen as long as she is interacting with others in her profession and keeping up to date with her reading and research. If she is busily engaged in counseling patients five days a week, what chance is her brain going to have of becoming rusty? Perhaps the fear is more that her abilities will suddenly decline as soon as she retires. Again, there is no need to fear that. Any individual who has maintained an interest in areas outside her professional life will simply expand those interests once her paid working life ends. And as for memory loss and word jumbling, we all have times when it seems that the brain suffers from an overload and short circuits temporarily. This is not so much a function of age as it is of too much input into our personal computer. We need to be kinder to ourselves and allow our brain a few seconds to analyze, compute and come up with the information we are seeking.

Notice this woman's choice of words: "Fear of becoming a mental cripple." If she continues to harbor this fear, she may eventually cause it to happen. In her own profession, this is known as a Self-fulfilling Prophecy. There is a wonderful phrase in the Bible, attributed to Job: "That which I most fear has come upon me." Which means that, *if you develop consistently fearful thoughts, you run the risk of bringing them into physical reality!* It seems to follow the scientific principle that for every action there is an equal and opposite reaction. If you fear mental incapacity, you are in some strange way, inviting it into your life experience. If you doubt this concept, think of someone you know who is constantly worrying about the state of her health. Isn't it true that whenever there is a virus about, she will catch it? Think about another friend who is too busy to worry about her health at all. Isn't she healthier than the worrier? It is not easy in this day and age, in this society, to be positive about our health. We are bombarded daily with news about the latest Designer Diseases and it is all too easy to succumb to the pressures, much as medical students are known to do as they go through medical school learning the symptoms of hundreds of diseases and worrying that they may have each and every one.

Maria's second concern is loss of eyesight and other physical abilities. Contrary to what we have been told, vision decline is not an inevitable factor in aging. There are eye exercises we can do

to help our eye muscles remain strong, but they are not well known in a country that has a large optical industry. In a later chapter, we will go into this idea of taking control of our own health in more detail.

Maria's third comment refers to her desire to lead a productive life in spite of what she perceives as society's scorn and neglect of older people. Many Americans fear the aging process because they have heard and perhaps seen treatment of the elderly that is abhorrent to them. What's to be done? We can either become politically active on behalf of the elderly, lobbying our elected representatives for more support and more money, or we can decide to take charge of our own lives in our own way, thereby gradually changing the society in which we live. Our population is aging and everyone will be old at one time or another, just as we were all young once. What can you do, as an individual or as one of a group to bring about constructive change? How do you want to live when you are older? Do you want to be segregated from other age groups in an artificial, golden-years community? What about planning a new form of retirement community yourself? Don't let things just happen to you! You are not a helpless bystander, but you may become one if you do not take charge of your own future.

Maria's next concern, coping with the loss of those we love, is a very real aspect of growing older, and can be unbearable unless we have come to terms with our own mortality. If we fear death, we will find the loss of the ones who are dear to us to be almost unendurable. And the losses will be even more pronounced if we decide to live in warm, sunny retirement areas filled primarily with older people. The deck is stacked! On the other hand, if we surround ourselves with children, teenagers, and young couples, then we will be less likely to be devastated by loss because we can see that life goes on all around us. If we believe in a religious or esoteric philosophy of ongoing life, then loss is less unacceptable, perceived as a natural event in a natural cycle of birth and rebirth, rather than as an affront to our control of our circumstances.

Frequently after forty, individuals begin to look for a real meaning to life, just as Shirley MacLaine has done in her books, *Out On a Limb* and *Dancing In the Light*. After forty it is time to inquire,

to search, and to formulate a personal philosophy of life. If you have a fear of death, and don't know where to start in your personal search for a larger meaning to your life and your position in the universe, you might begin by studying nature and observing its natural cycles and rhythms. "To everything there is a season." Without any books or gurus you can simply be an onlooker, and you are as likely to discover something of value, something that makes sense to you, as you would if you were to devour libraries of esoteric literature. However, if you want to try just one book to begin with, you might want to look again at the Bible. Or the Koran. Or the Baghavad Gita. *On Walden Pond* by Thoreau, *Jonathon Livingston Seagull* by Richard Bach, or *The Little Prince* by Antoine de St. Exupery might be just right for you. The world is full of wonderful books. After forty, when there are fewer demands made on you by others, is a perfect time for beginning a journey within, seeking answers to questions you have been too busy to ask yourself until now.

Maria's next expressed concern, relating to financial planning, is a very common one among midlife and older women and will be discussed in some detail in a later chapter. Just remember that planning is one thing, and worrying is another! Planning is a good, logical, left-brain activity, appropriate in its own time and place, whereas concern, fear, worry or anxiety have not yet been shown to be of any value to anybody—except perhaps psychiatrists and psychologists!

Maria mentions next her husband's health and his lack of good care, along with her hope that he keeps himself alive. There is just so much that we can do for any other person. Can Maria keep her husband healthy? Can she keep him alive? We are not so powerful that we can extend a partner's life span, and furthermore, our only responsibility really and truly is to ourselves—our own health, our own well-being and our own longevity. Maria's husband is an adult. He will take care of himself to the extent that he himself chooses, and he will live his life the way he chooses to live it. Her unexpressed fear, of course, is that she will not be able to manage without him. This seems to indicate that she feels incomplete without him and, if this is the case, then this is an area that she might

well consider. If you are married and if you recognize this fear in yourself, pull out your pencil and paper again and write down your fears about widowhood. Why do you feel incomplete?

While it is true that in a good marriage, two partners complement each other, it is even more true that the finest marriages are between two complete individuals, two wholes coming together to form a greater whole. What do you feel is missing in yourself that would be threatened by the loss of your partner?

Try to understand that at the root of such a fear is a lack of love for yourself. In reality, you are perfect as you are. You do not need any other to make you complete because each one of us is complete in ourselves. If you can learn to love your own company and not feel alone, then you will never fear the loss of a loved one, nor will you feel the need to hang onto a love relationship that has died. This does not mean that you are not capable of loving another, but rather that you actually love him enough to let him go, and that you love yourself enough to know that you can make it on your own. If we feel totally dependent upon one other person, then we may be neglecting our ties to all the others with whom we interact daily and to whom we reach out through our words, our actions and our friendship. In reality, we are all in some way part of each other's lives, each one of us a unique and beautiful tile in some grand and colorful mosaic.

Staying young is a state of mind much more than it is a physical condition. All of us have met people in their twenties and thirties who are already set in their ways and know all the answers. They don't ask questions, and they never seek anyone else's opinion about anything. They are no fun to be with, even though youth is on their side. Youth without vigor and enthusiasm is simply existence without growth. On the other hand, we have all met certain old folk, those in their seventies and eighties, to whom every new day is still a delight, and who radiate energy to everyone they meet. Just such a one is eighty-five year old television commercial actress, Margaretta.

Margaretta is a petite, wiry, energetic dynamo of a woman. She was born soon after the turn of the century to an American mother and an English father. As she tells it, the auspicious but accidental

meeting of her parents in Paris was an indicator of her own rather unorthodox life. Her father, in training for a bicycle race in the Bois de Boulogne, collided with her mother's horse, knocking the young woman to the ground. Her mother was from a socially prominent, wealthy Philadelphia family, while her father came from a middle-class English background. Despite the disparity in class, her mother persuaded her father to stay at her side, when she leaned over the railing of the steamer carrying her from France back to America and asked him to come with her. According to Margaretta, her future father leaped, penniless, onto the ship and sailed for America!

Margaretta was subsequently raised in England, being educated at a prestigious school for girls, and then at the Royal Academy of Dramatic Art in London, which she attended, she claims, in order to "get rid of self-consciousness." Depsite the fact that singlehood, or spinsterhood as it was then known, was much less popular at that time than it is now, she decided that she did not want to marry. She describes her decision in this way:

"I simply did not want to lose my freedom and I felt that if I married a man, I was not prepared to do what he had every right to expect me, as a matter of course, to do. I couldn't live a life of absolutely never coming up to scratch! If I had a house and a husband, he would expect children, and I wasn't awfully keen about that. That wasn't the life I wanted to live." Margaretta adds, with a chuckle, "Everybody was getting married and it did prick every now and again when you would hear people say, 'She doesn't look *that* bad!' If I had wanted to get married, I would have done it! There were opportunities all over the place and I probably would have had a completely different personality. I didn't feel I could bear the thought of marrying for money, so I stayed single and did what I wanted to do!

"It's not easy! Whoever said it was going to be? I'm asked so often, 'Aren't you ever lonely?' And I say, 'Of course I am? Who isn't?' There isn't a living soul alive who isn't lonely sometimes—no matter what they've done! I learned the hard way to live successfully

alone. And when you've done that, you get the reward! The reward is truly a sense of well-being, that you are in the driver's seat. And then you're beautifully free to flirt and have a good time!"

Her career in the theater was interrupted by the second World War, when she joined the A.R.P., the Air Raids Precaution unit of England's civil defense. She tells of being assigned to an information center deep underground in the bowels of London, wearing a steel helmet, with a cage down over her ears. "It was non-stop vigilance down below. The bombs came down day and night for five and a half years, and you were there. You had achieved your objective if, in the morning, your head was still on your neck! I learned what matters and what doesn't and, of course, people are at their best when things are at their worst. Every bomb that fell was catalogued as to the place, the time and assessment of damage. There was almost no panic all the way through. We wore these things over our heads and as soon as we got a message about a bomb falling, we put it all down in shorthand and passed the message on. Someone else gave the orders as to where the equipment should go. They would send teams and equipment immediately to clean up the streets so the next day it didn't look a terrible mess. It was a morale thing. But, you know, the war went on for five and a half years. It was a tremendous strain."

After the war, she came to the United States and has lived here since then. She joined a theater troupe and toured from Newfoundland to the Caribbean. She loved the traveling and she loved the theater, but she became frightened about stage acting because she suffered from memory lapses, brought about, she believes, by her wartime experiences. She was very upset and told herself, "You've got to come to some conclusions about this! You've got to deal with it along certain lines or give it up altogether." She says that she needed the money, but, more than that, she knew that acting was where she belonged. She decided to try to get into radio. Although it was next to impossible to break into "the fortress," she was eventually given a role in a soap opera. She speaks of the waning heyday of radio with great affection. Radio work was ideal for her, unaffected by her memory problem, because she was reading from a script. But then she says that she felt a sense of something

happening to her. That something was the brand new communications system called television. She says, "Television came my way and I pushed it away. But they kept coming after me. The more I didn't want it, the more they pursued me! And then the thing was offered to me right in New York. I went with a sort of anger because I loved radio, but I was able to cope with it."

So began her career as a television performer, which she maintains to this day. Two years ago, at the age of eighty-three, she was being recalled for 80% of her auditions, when the average rate is ten percent. "I couldn't fail, and I said to myself, Don't think about it! Let it do its work and just don't mess about. You can kill things by wanting to know why! The butterfly is beautiful flitting from flower to flower. You want to know what makes it tick, so you stretch it out on the blotter where you know all about it—and it never flits again!"

Margaretta loves her work. As she says, "I like the crazy hours we keep, the all-night sessions, the glamour! *And* the awful drudgery and the disappointments and the fury when somebody who you know can do half of what you can do, gets the job! You have to deal with that in a certain way, too. If you feel the slightest jealousy or animosity, then get out of it! It's no place for you. And there are no nicer people in the world than the ones we have in show business. They'll do anything for you—except the current job! Then, everybody's strictly on their own!"

This year her career is at a low point, with few auditions and she says that she is sad because, for the first time in her life, she is not earning a living. She does not need the money now, but says that she needs the work all the more because she misses her colleagues and all the fun. She is not, however, contemplating retiring, and at eighty-five claims that, "If it weren't for my memory, I would go straight to the top!"

The secret of Margaretta's success lies in her attitude. She used winning tactics of her own to fight an established order that told women to get married and stay in their place. As she says, "The only thing a woman is considered good for, even in this day and

age when women are coming to the top and doing extremely well, is sex! We're always fighting this inferiority thing that's handed out to us all the time, and it's worse today than it was in my day."

It would have been easy for her to give in to her memory loss years ago by finding a job that did not require a good memory. Instead, she kept to her dream of being an actress and adapted her skills to an entertainment medium that was less demanding of a trained memory than the classical stage. She faced discrimination for jobs because of her distinctive accent, but she learned to use it to her advantage in character roles. Her adivce, in a situation where you feel at a personal disadvantage, is, "Do your own thing. Do something that's entirely yours. You're not going to get anywhere if you don't. Don't care if people say 'No.' You've got to get rid of your fears of everybody, and you must be able to rely on yourself. Otherwise you have nothing to offer. Don't be afraid of the person who is interviewing you. Laugh occasionally, and, even if you trip over something, don't be afraid to speak up for yourself! You can't get in a rut if you've had a life like mine. A good deal of what happened to me is because I have strong religious faith. You have to be bold and step out, which you cannot do unless your faith stands up to it. I met with success when I stood up quite clearly to what I felt I had to do. I addressed myself to what I believed in. I'm at a tremendous age now, and I'm still thrilled by new things—and I'm not afraid of anybody!"

Eighty-five and still going strong! Eighty-five and still excited about daily life and current events. Eight-five and irritated that she is not being called for auditions. Margaretta proves that mental attitude is the most effective tool we have with which to challenge the aging process.

9

Facing Those Blues in the Night

Conquering depression.

Some of us have spent at least a part of life in a mild state of depression or what used to be called melancholia—not really miserable, but definitely not happy. We wander through our days in a gray fog of feelings in which one day seems very much like the previous one or the one before that. If we don't turn to drink or drugs for relief, then we may use anger or self criticism to vent our sense of dissatisfaction. Our families suffer, our friendships dwindle and our self-esteem can barely bubble up through the density of our unhappiness. Why does this happen to women?

Part of the problem stems from the way we have been socialized. When we were small, we were taught, in a variety of ways, that to survive we must be sweet, obliging, good and kind. Implicit in this training was the notion that, as long as we behaved this way, there would be a reward. Whether we really believed in Prince Charming or not didn't matter. What we did believe was that being good was going to bring results—happiness, success, wealth, power. Many of us were sustained by this belief for years—years during which we married (absorbing a sense of identity from a husband) and had one, two, or more children. Then, at some point, somewhere

in between the diapers and dinner, we started to feel that something, some subtle, undefined something, was missing. A sense of unease began to develop within us, a dismay that was slowly reflected in our diminishing capacity to perform happily the role of capable wife and nurturing mother. And we wondered what was going on! After all, we had a nice home, smart children and a husband who paid the bills. We were not starving and the children were well dressed. A lot of us put the depression down to post-partum blues, a popular item at the time, and we waited for it to go away. The children got taller, and went off to ball games and the orthodontist. Our husbands got raises, and our houses got bigger. And still we waited for this cloud to lift, for the sun to come shining through. But it didn't. With seemingly everything going our way, we remained unsatisfied with life. Where had all that early promise gone? Why weren't we happy?

If you recognize some of these feelings, be assured that you are not alone. Therapists' offices are filled with female patients trying to come to terms with their anxiety and anger, and we now understand, thanks to research and revealing writings by prominent feminists, that society did not quite have the story right! Being sweet, kind, nice, and even beautiful, has not brought us the pot of gold, nor the satisfaction of a fulfilled life. In spite of our accomplishments as mothers or wives, it has not been enough. Why? Because we are human beings and human beings, whether they be male or female, have a drive to succeed and a need to be recognized and appreciated on their own merits. In this society, such recognition and reward takes the form of a pay check. If we don't receive a pay check, then how do we know we have any value? That basically, is at the root of a great deal of unhappiness among women, especially those who are now in mid-life and who were not expected to develop careers but were instead expected to sublimate their natural drives for power in the numbing routine of unpaid domestic work. This has been said before, of course, but can not be repeated often enough, because so many women still do not understand what has happened to them—why they feel that yesterday they were twenty and the world was at their feet, and today they are fifty and the world has passed them by.

How do you begin to break out of a state of chronic unhappiness? As with any other form of addiction or distress, admitting that there is a problem is the first step toward making constructive change. We can spend a whole lifetime refusing to admit to ourselves that we are not happy. We rationalize our insecurities and convince ourselves that we are just imagining things. If we express our fears to another, often we are told that it is "all in your mind." The truth is, it is indeed all in the mind, but that mind of ours is having its effect on our body, and on other functions of mind such as ambition and the need for personal fulfillment. For many years, women's physical ailments were dismissed as being merely psychosomatic. But that is no reason for their dismissal. Psychosomatic illness is just as real as organic illness. In fact, a case could be made for one being the same as the other, except in name. The Biblical phrase, "As a man thinketh, so is he," applies to our daily state of mind and well-being or health. *Out thoughts determine our state of happiness.* So, we must first understand and acknowledge that our thinking about ourselves and our daily existence may need some constructive change in order for us to begin to enjoy life more.

You can begin this process for yourself by making note of two extremely personal aspects of you and of what makes you the person you are. Let's imagine that your life is divided into only two areas: speaking and thinking. To really understand what goes on in your private world, and what stems from it, undertake the following exercise. (This is one that really demands discipline and concentration from you, as well as a willingness to be completely open and honest with yourself.) Take two pieces of paper and head one, *Words*, and the other, *Thoughts*. Limiting yourself initially to a period of half an hour, pay attention to the words you speak out loud and your thoughts—those words you speak silently to yourself. Write them down on one of the pieces of paper, depending upon where they belong.

This is a very tricky exercise, in the sense that you must act as the objective observer of your subjective self. For example, let us imagine that for the first five minutes of the selected half hour, you are vacuuming the carpet in your living room. As you are using the cleaner, thoughts pop into your head. As soon as you are aware

of one, turn off the machine and write the thought down. Another will pop up to take the first one's place. Write that one down too. Then a family member comes into the room and asks you a question. What is your response? Write it down. Write down the content (exact words) of everything you say to this family member. After that, perhaps you will decide to organize the contents of a closet. While you are doing this, what are you thinking about? Write it down.

Another way to do this exercise would be to sit down for a quiet half hour, deciding to deliberately relax. Immediately, your mind will be flooded with thoughts. Write them down. Or, if you meet someone you have not seen for a while, notice what you talk about, what you say, and how you say it. As soon as you can, pull out the sheet of paper headed words and write as much as you can remember about your side of the conversation.

If you are honest and serious about this exercise, you will have two full sheets of paper. Take a look at them and ask the following questions of yourself:

- On a scale of Plus One to Plus Ten, how positive are my thoughts and words?
- On a scale of Minus One to Minus Ten, how negative are my thoughts and words? (If you have trouble with this, think of an expression such as "That's great!" as a Plus Ten, and "That always happens to me!" as a Minus Ten.)
- Count all the phrases. How many are positive, cheerful or optimistic in some way, and how many are negative, sad, worried or fearful?
- Look to see if there is one particular subject that is dominating your thoughts and your conversation.
- Is there any one person who is the subject of much of your thinking?

Doing this exercise will help you start to pay attention to the words you speak to others and the thoughts which you speak to yourself. Notice whether you habitually express fears and worries. Notice whether you are obsessed with one particular person or problem. Do you often use certain phrases, such as:

- "I can't stand"
- "I hate to"
- "I always"
- "I never"
- "I can't"

This is simply an exercise in self-awareness. There are no rights or wrongs. What you will notice is that you have a particular style of your own, expressed first in your thoughts and words, and subsequently in your actions. Study your style objectively. Are you happy with it? Did you realize that you function this way? Is there anything you would want to change?

If you discover that perhaps you have become addicted to worry thoughts, ask yourself what purpose they serve. We all believe we act for our own greatest benefit and therefore we speak and think in a manner that seems to be best for us, so ask yourself, "What am I getting out of this? Why do I worry so much? Do I do it for attention and support from other people? If I stop expressing my fears, am I really afraid that their support will disappear? Is that one elemental fear of being abandoned and alone underneath all these other fears? And does my continued expression of anxiety really endear me to the people I love?"

If you find that a lot of your thinking and speaking is negative, either toward yourself or others, and filled with criticism, sarcasm or pain, ask yourself why you are doing this. What is the pay-off? Does it make you feel superior? Or does the sense of superiority really cover feelings of inferiority or inadequacy? Do you think you are out of your depth? This takes a lot of honesty and is not an easy exercise to do. Only if you feel that you really want to understand yourself better and want to spend life after forty in a happier state of mind will you stick with this one.

It will be easier to get at the answers if you handle it in a loose, free-flowing, intuitive way. For example, as you ask yourself a question, write down the first answer that comes into your head. Don't be a judge! If no answers come to you, it simply means that you have tightened up and your logical, often critical, Left Brain, is

not allowing your feeling, intuitive Right Brain to release its information. To overcome this, settle yourself in a comfortable chair, put some relaxing background music on, close your eyes and ask yourself the questions again. Without reaching for pen and paper this time, just allow the answers to float up out of your subconscious and tell yourself that you will remember to write them down once this nice period of relaxation is over.

The key to happiness is in knowing yourself, your hopes, your anxieties, your dreams and your goals. The exercise above is designed, as are many of those you will find in this book, to help you discover more about yourself and to help you set out on a path of greater enjoyment of life.

If you are prone to depression, there are several strategies available to you if you want to conquer the sadness. The most difficult is paradoxically the easiest and the most effective. That is to get yourself moving! Depression idles us. It slows us down, sometimes to a point where we park in a rocking chair and slip into a near catatonic state of immobility. Do you remember when you were a child, the joy and the freedom that you felt in movement? Children run, climb, jump and dance quite naturally and without any thought as to how their uninhibited movement appears to others because as far as they are concerned, others are not involved. They move to please themselves, because this is an inborn desire. Too often, as adults, we get out of the habit of physical movement. We ride in cars instead of walking. We ride in elevators instead of climbing stairs. The results of our inactivity can be a combination of overweight, poor circulation and lethargy. Think back to your childhood. What did you enjoy? Running, dancing, playing ball? What could you do today, as an adult, that you used to do as a child? You may not like the idea of jogging, but walking is now catching on as a popular form of exercise and not just a method of getting from here to there. It has many advantages: you don't need to learn how to do it; you don't need a partner; you don't need special equipment; you don't need a special area to do it in.

If walking sounds like a good idea, but you don't know how to start, then start small. As soon as you have finished reading this chapter, put on a pair of sneakers, leave your home, and walk around

the block. The key is repetition. Tomorrow, walk two blocks, and the next day, three. As soon as you begin to do this on a daily basis, you will realize that you are feeling better, that your energy level is increasing and, most important of all, you feel less tired and less depressed! Exercise actually counteracts lethargy! It also diminishes the appetite, while increasing the supply of oxygen to your system. It brings you nothing but benefits and all you have to do to avail yourself of this munificence, is to get up, get out and do it!

Perhaps as a child you loved to dance. Dancing is once again a popular past-time. Ballroom dancing is back in favor, and folk dancing never went out. You do not need a partner to join a ballroom dancing class, and courses are offered in many towns, through school or college adult education departments. People who take up folk dancing become addicted to it as an outlet for both physical fitness and social interaction. For a few dollars a week you can learn just about any dance, from polka to flamenco.

If your talents were always more in the area of hand and eye dexterity, then consider taking up tennis or racquetball. Equipment, lessons and indoor court rental may be fairly expensive, but on the other hand, what could be better than calling a friend, hauling your old racquet out of the attic, and going off to the park for a couple of hours?

We are very fortunate that we live in a society where so much is available to us. If we do not take advantage of all that is offered, then we run the risk of missing a lot of pleasure, and staying in the doldrums. Once you get over the initial hurdle of habit, that easy-chair and television set, then you will find that your energy is increasing, your waist is slimming, your eyes are brightening, and your worries diminishing. Make an attitude adjustment—Movement is Freedom!

Another useful strategy to use whenever you feel down in the dumps, is to turn on the radio and spin the dial until you find some upbeat music, whether it be rock and roll, country and western or jazz. Whatever you choose, make sure it has a lively tempo, something that sets your toes tapping or fingers snapping. It is very difficult to feel downcast when you are surrounded by lighthearted music, because the vibrations have an effect on your mood.

Humor is now known to make a physical difference in the healing process. Author Norman Cousins documented his recovery from serious illnesses in his books, *Anatomy of an Illness* and *The Healing Heart*. He chose to watch reruns of old television comedies while confined to a hospital bed. Laughter is indeed the best medicine. One of the very cheapest and quickest remedies for the blues is to take yourself off to the nearest card shop and simply browse through the birthday cards. There are complete sections devoted to humorous cards that are guaranteed to make you smile.

Writing can also serve as a release. Many people now keep a personal journal in which they document their feelings. If you take this approach, forget all the rules of grammar and don't edit! A journal is a personal and private record that you can embellish with poems, illustrations or doodles. Art is, of course, wonderful therapy and guaranteed to take your mind off your problems. Sketching, painting, sculpture, pottery or jewelry making can provide the outlet you need. You can begin by taking a class in your local adult education department. There you will not only learn a craft, but you will also find people who are compatible with you.

Think back briefly to our original C^3I: Command, Control, Communications and Intelligence. If you are suffering from chronic depression, your emotions are in command of you, and you need to deliberately exert your willpower to reverse the situation. To conquer depression, you must take control of what is happening, no matter how helpless it seems. Depression can be more easily combated if you understand the cause, and if you communicate your anxieties to someone you trust. A State of The Blues indicates that you have allowed your emotions to take temporary command of your intelligence, and your thinking may be skewed to the point where you require some objectivity—especially if you are the type of person who normally tries to handle all her problems by herself.

If, after trying some tactics, such as those recommended above, you are still trapped in depression's snare, and if this is a condition that seems to be more and more habitual, force yourself to reach out for professional help. This need not mean expensive and time consuming therapy. Look in your local telephone book for a Self-help listing and follow through to find others who are fighting a

similar battle. If there is no listing, call your local church or temple to ask about support groups or pastoral counseling. If neither is available, try your local college. Most colleges have Women's Centers which will either sponsor a group or be able to make an appropriate referral. Above all, don't suffer alone! If your problem seems too big to handle, know that help is available somewhere. Some women feel that they have no right to feel unhappy or in need of comfort. In that case, what you must do is to acknowledge to yourself that you have a need, that you are entitled to help, and then take the first step toward finding it. Allow yourself to be helped. Don't be embarassed. Don't be too proud. Know that you are never truly isolated and that, in a group structure, you will not only receive assistance but you will also, out of your own experience, be able to provide it to others.

A woman whose personal story exemplifies what willpower can do is Cynthia, who is divorced and lives in Florida, where she works for a travel agency. She has fully overcome serious and long-lasting attacks of depression and anxiety which began some years ago, after several years of marriage. The attacks were connected in a mysterious way solely with her personal life, never interfering with her ability to function well in her working life.

She describes her problem this way: "Mostly it was in the form of terrible anxiety attacks. I would be afraid constantly. I was afraid to take the bus and I was afraid to go to the supermarket. I was afraid of everything, basically. I would have these out-of-body experiences also, and I had no idea what was happening to me! It just seemed like everything in my world was going wrong, except at work. At work I never had anxiety attacks. At work I was a normal functioning human being. I don't know if somehow, at work, that's where I felt self esteem, but whatever my problems were, they never seemed to touch my work.

"The anxiety attacks started way after I was married—maybe nine years. It seems like it all came together at one time. I think it was a warning signal that things were all wrong. They lasted most of the day and they were constant. Constant! When I eventually did go for help, even my therapist told me that he had no idea how I had existed for as long as I did."

Cynthia had suffered from enervating anxiety attacks and out-of-body experiences for eight months before she felt compelled to seek help for herself, and she describes those months as being almost unbearable. "It was just a horrible existence. I talk about it now and I think about it, and I can't believe it was me." Asked to describe the strange feelings associated with being separated from her body, she says, "The out-of-body experiences happened at the same time as the attacks. It was like there were two of me—the one who existed inside my body and the other me who watched my body! That's the only way I can describe it. There was a part of me that was going through the motions, cooking dinner, making the bed, and then there was another me that was sitting on the shelf kind of watching my life. A lot of people still don't know about this. I don't even know if my husband knew the depths of what I was in. I don't think we were communicating. Our marriage was falling apart at that time, but I don't know what came first—the chicken or the egg."

After months of suffering from debilitating anxiety, what made her decide to take action about her deteriorating situation? She says, "I really thought it would get my husband back. We were on the verge of separating. Nothing I could do at this time could make him see that I wanted to change, so it was really almost a last ditch effort. I thought, 'I'll go to the shrink, the shrink will tell him I'm sick and my husband will be willing to wait it out until I feel better again!' But I think that wasn't really the case. I think that might have provoked me into actually doing something, but I was really on the verge of committing suicide, I think. I didn't know *how* I was going to do it. I was basically afraid to do it—the act itself—but I spent too much time thinking about it or wishing that something would happen, to not look at it as a very real possibility. I think my life was slipping away from me and I was losing control. I didn't have a grip on it any more and I didn't know how to get a grip back again. And I think that basically that's what it was. I think wanting everything to be okay with my husband gave me the nerve to go for help, but I think that, underneath, there was something bascially very, very wrong. At the time, I was approximately 140 pounds overweight. It's hard to understand, but I think

I had been eating my way through my marriage and I think I was eating because it was all I knew! I don't know how to describe it any better."

Cynthia took command of her situation by calling the American Medical Association* and asking for a referral. She described her problem and was given a list of our or five places to contact. She says that she was strong-minded and had definite ideas about what she wanted, but that, in the end, she was told what she needed, and she respected the professional judgement.

She began her therapy with a male psychologist by visiting his office twice each week. She never missed a day of work, and six months into the therapy her anxiety attacks started to ease up. She and her husband separated during this period. She describes the first year of therapy as being very difficult, yet she lost a total of 120 pounds in just over seven months. She says that she "seemed to blossom" then, so that by the time the second year of therapy began, she felt herself to be on a different road.

Asked what was the most important factor in getting rid of the anxiety attacks, she replied, "Desperation, I think! *Wanting* to get better so desperately and being willing to keep an open mind as far as the therapy was concerned. Something inside of me knew it was my last hope. I would go in to the therapist's office and there would be times that I would be belligerent and I would swear that I was never going in there again. But there was never, ever, a time when I missed going to the doctor. I think what it was, was that at some point, trust set in. I think he was the first man in my life that I felt I could really trust. I learned that my marriage was not the most important thing in the world. Getting my life in order was the most important thing. And as that started to happen, I got my life on an even keel and there were no more anxiety attacks."

Cynthia was being treated by a psychologist trained in traditional clinical techniques, but she says that she believes he saw a uniqueness to her situation and worked creatively with it. As she puts it, " I could see that there were times when he was a little bit

*See Appendix

stumped by me! He was so shocked by the out-of-body experience, but he knew that it was really happening and that it wasn't some kind of a fabrication. I needed this man the same way that if I had a cold, I would need a penicillin shot. I feel that I'm real open and honest, and I don't feel like I've really got much to hide. I just felt like I needed help from a doctor, and instead of looking at my anxiety attacks as some kind of a mental illness, I looked at them as just another form of sickness. If my tooth hurt, I went to the dentist. If I had a bad cold, I went to the doctor. It was just being in that mode that I think got me started. Everyone who knew me knew I was going to a therapist. I never saw anything wrong with it. People even now look at me a little bit startled that I could be so candid, but I didn't see it was any more than that there was a part of me that needed healing, and that this was the doctor to go to for the healing!"

Cynthia went on to explain further, "There were two of me. There was the one of me that was married, the one of me that had existed on the surface for thirty years, and then there was the underneath part of me—the part that had been 'suppressed,' I think, is a good word—but that I somehow knew existed. And that's the part that drove me to eat and needed to be recognized. That was the positive part, but I think it didn't work because I was in such conflict on the surface. I had the best husband in the world, but I didn't really want to be married. But I couldn't tell him that I didn't want to be married! Everybody thought we had the ideal life, the ideal existence, so why was I so unhappy all the time? Why couldn't I make him happy? Why couldn't we get along?"

As Cynthia's therapy progressed, her anxieties lessened and the out-of-body experiences stopped. She says that as she became more contented with her life, they just disappeared. She comments that, "While they were happening, I used to think that this was the worst possible thing a human being could go through. I didn't think that there was even any physical illness that could have been as bad as that, because I kept thinking that they would give you a pain killer, there would be something you could take to make them go away! And my therapist told me that he was not going to give me any drugs. I went through this without having to get addicted to

anything. I think he felt, since I was so overweight, that I probably had a natural predisposition toward an addictive personality. And it would probably have been real easy for me, if he had started to give me any medication, that I would never have gotten off of it. I've never taken drugs and I'm not a drinker, so I don't know for sure, but I don't think that a compulsive personality just affects one area."

Cynthia's treatment gradually brought her to an understanding of how she had been consistently suppressing vital aspects of herself. Her therapy lasted for two and one half years, and at the end of that time she moved from the northern state in which she had been living, to Florida. She is now happily occupied with her travel agency job, and has resumed her college education. She describes her life now as "real happy and real secure. I couldn't ask for a better life than I've got right now. I'm not in a relationship, so it's not like some man has come along! Two years ago I picked myself up and I started going to college, and I'm working on my education. Last summer, I was accepted into the summer school program at Cambridge University, over in England. My job isn't maybe completely fulfilling, but it pays my bills and I have a new car. Materially, I'm doing all right. Emotionally, I'm doing all right. I just wake up in the morning and can't believe how lucky I am and it's all with things that nobody can take away from me ever again."

Cynthia regained her sense of self and a feeling of healthy balance by using her personal C^3I, taking charge of a very frightening situation and taking intelligent action to make it better. She communicated her needs to an impersonal organization in a big city far from home, yet someone in that organization proved to be the conduit to the therapist who eventually helped her work through her difficulties.

She says of her experiences, "It sounds like such a cliché, when you tell people that you've got to love yourself before you can give anything to anybody. When I was sitting there weighing 260 pounds, five feet tall, feeling so weird that I didn't know how I was going to make it, if somebody had come up to me and said, 'Well, if you liked yourself, it would all be better,' I would probably have wanted to shoot them! I mean, it's very hard for somebody at Point

"A" to ever think of Point "C," because the road seems so long—but its really not! If you plan on being alive in a year, you might as well try to help yourself! A lot can be accomplished to make you feel a lot better right away if you're receptive to the fact that help is out there if you need it, and there's a better life if you just work toward it."

When asked what advice, in light of her own experience, she would offer any woman who is suffering from depression, anxiety or any form of panic, Cythia suggests, "Try to wait it out a little bit. Try to give yourself a little bit of time. Get involved with things. If you don't work, get a job. If you don't want to work, do volunteer work, something that takes up your day. And if you see, after a while, that you're just not getting along, that you're just not getting adjusted, and you're in a constant state of depression or you're not functioning, go and talk to somebody! Now they've even made it so easy—there are people who will talk to displaced homemakers, people that deal only with the problems of women at a certain age having to start all over again. You know, I just can't stress that enough, because running to a shrink is not the worst thing you can do for yourself!"

She adds, "Try to be patient. I have never known anybody who ever took her separation or divorce as hard as I did. It's been five years, and I'm only now being able to deal with my husband the way he deserves to be treated. But time makes even all that clearer. Nobody is obligated to spend a lifetime with somebody if they don't want to, and they can't be blamed for that, you know? And just try to wait it out. There really is something better around the corner, and that doesn't necessarily mean being with somebody. I don't want anybody to get the impression that I left my husband and I was miserable and six months later, Mr. Right came along! I haven't had a steady relationship since we separated. It just hasn't been anything I wanted or needed even when the opportunity arose.

"My therapist said that the best thanks I could give him was to never be afraid to tell my story, because it just might make a difference to one person between going to get help and not getting help."

That is Cynthia's story. Are you that one person? If you suffer from chronic feelings of depression or anxiety, or if you ever contemplate ending your own life, gather your energies together and pick up your telephone. On the other end of a phone line you will find someone who wants to hear your story and wants to help. Call a friend, a close relative, a mental health clinic, a hospital, a Displaced Homemaker program, a women's center, a suicide hot line, a church or a temple. Out there, beyond your own unhappiness, is another human being *who wants to help you.* It may take more than one call, but the first call will lead you to the second, and the second to the third. There is no glory in suffering and no long-term gain in being a victim. Take command of your own life because, as you can see from the women you are meeting in these chapters, there is no problem that has no solution.

10

Beyond the Rainbow

Making your dreams come true.

What are you going to do with the rest of your life? Now that the time has arrived when other people need you less than they did, are you ready to take a look at where you have been, where you are now, and where you are going? Midlife is such a wonderful opportunity for taking stock and deciding which path is right for you, now. It is a time for weighing options and making choices. It is a perfect time for summoning all your energies and setting out to achieve whatever it is that makes for a fulfilling life for *you*.

Most of us do not take time out to glance over our shoulders to see where life has led us, and then to peer forward to the far horizon and plan for where we are going. We sort of drift along, like a twig in a river current, being sent this way and that by the vicissitudes of flowing time and circumstance. But right now, today, is a great day for pulling yourself out of this undirected stream and taking charge of your own progress. It is the right time to look at what it was you always wanted to do with your life, and deciding just how you are going to go about doing it before another week, month or year passes by.

What did you want to be when you grew up? Don't give it too much thought, but just let the old memory resurface—and when it does, jot it down in your notebook or on a sheet of paper. There is always a reason, very valid and worth observing, for the choice you made as a young child, as to what you were going to do with your life. For most of us, that intuitive choice has been set aside in favor of more practical, *realistic* decisions. Perhaps now is the time to look at it once again! Underneath your old fantasy, write down the reasons why you chose that particular role. For example, if your dream was to become a ballerina, ask yourself what it was about the role that was thrilling and meaningful for you? Was it the desire to be applauded or was it the excitement of movement? The wearing of pretty, feminine costumes, or the emotional tie to the music? Was it the uniqueness of being a star, or the dedication to being part of something greater than yourself? Was it a sense of liberation, of freedom? Many young girls may want to be ballerinas, but they will not all have the same reasons. What reasons are unique to you, to your personality, your individuality?

Of course, you may not have seen yourself in such a traditionally female role at all. Perhaps you wanted to be a cowboy or a soldier. Whatever your childhood choice was, remember it now. Write it down and then list all the elements you can think of that went into that choice. At that time, at a very early age, you did not analyze your dream, but now is a good time to accept the innate wisdom of your youth and to define just what went into that intuitive role selection. Try to remember as far back as you can, because sometimes even our early choices were conditioned by our environment, so that many young girls might have chosen the role of nurse, rather than doctor, because it was already obvious that most doctors were male. If you have trouble remembering your choice, use the relaxation technique that we have suggested before and seat yourself in a comfortable chair. Quiet your restless mind, close your eyes and mentally ask the question, "What did I want to be when I grew up?" The answer will come to you from the encyclopedia of your own memory bank.

Once you have looked at that early goal, next think about all those times in your life when you felt really happy and fulfilled. A very effective way to do this is by drawing a line across the middle of a horizontal page and labeling it your Lifeline, with your birth on the left margin and your present age on the right. Then, as you remember high points of your life, mark them with a check on the lifeline, corresponding to your age at the time, and writing in what each event was. You could also grade them on a scale of One to Ten for the sake of comparison. You may be surprised to find that some seemingly insignificant event in your life actually has more importance for you than your marriage or divorce! Once you have completed your lifeline or have simply made a list, then analyze each high point as you did the childhood choice. About each highlight, ask yourself, "What was it about that event that made it so special for me?"

If you take the time to do this seriously, you will find that you will finish with a combined long list of elements that are very important to your happiness. The most important part of the exercise is the next step which is extracting from your combined list those factors which are common to all the events you noted. As a brief example, let us imagine that one of your early highlights was a trip somewhere, by yourself. When you ask yourself just what it was about the trip that gave you so much pleasure, you may come up with a list that looks like this:

- Seeing new places.
- Hearing a new language.
- Traveling alone.
- Meeting new people.
- Eating different foods.

Now take a later event, such as planning your daughter's Sweet Sixteen party. Suppose your analysis reads,

- Choosing the location.
- Selecting the menu.
- Organizing all the details—invitations, etc.
- Planning the seating.
- Hiring the musicians.

Looking at these two lists, we can already see common characteristics between the two, even though the events themselves have little surface similarity. They were obviously written by someone who likes to be independent and to make decisions, a take-charge, unafraid kind of person, someone who is vitalized by action and by the stimulation of places and people.

Similarly, if you analyze six or seven highlights in your life, you will see just what essential factors you need for your enjoyment, and you may be very surprised at what you discover! You will learn from this exercise what you need to have in your life now to make you feel complete. You will realize, perhaps for the first time, what has been missing. Later we will discuss using this type of analysis to determine where you might best fit in the job market, but for now, ask yourself what you can do to bring these fulfilling elements into your life? What can you do, in a small way, to be sure that something is always going on in your life that will bring you joy? This is the time to make these decisions, so that you can spend the next forty years of your life as a cheerful and satisfied individual.

Once you have done this, your next step will be to establish some personal goals—for today, next week, next month and next year! As we have mentioned before, there is nothing like putting something down in black and white to make it real.

If you are like most people, getting this far was relatively easy. The difficulties begin once those lists are made and the need comes for you to act upon them. And here we come upon one of the most common of human problems, that of procrastination. By now you have a good idea of how you want to tackle the rest of your life and you have written down some essential goals. You may even have posted the list in some prominent position, to be sure that you cannot overlook it. What happens next? Somehow you forget to take action on it, neglect to make that phone call, set up that date. In this respect, we are all alike! Just what is procrastination all about?

Again, as with so many other things, it is necessary to take procrastination and shake it about, to get at what it is that underlies our inability at times to make the moves we know we must in order to change our lives into what we want them to be. The following

is a list that a mature woman made, of reasons why she was unable to make a particular phone call to a male contact. She felt so much frustration and so much annoyance over this that she decided to hold a two-way, one-person conversation with herself to get at the hidden reasons behind her self-defeating behavior. Her questions and answers were these:

"*Why can't you pick up the phone?*
— *Because I might be interrupting him.*
What would happen then?
— *He might be annoyed.*
How do you feel about that?
— *Scared!*
Why?
— *I would feel guilty and I wouldn't know what to say.*
Why?
— *I feel shy. He doesn't know me.*
What are you afraid of?
— *Looking like a fool.*
What would be the worst thing that could happen?
— *I would say something stupid.*
How would you feel about that?
— *Very small, very insignificant, like an ant.*
Are you really an ant?
— *No!*
Is he also an ant?
— *No, he's a giant!*
Is he really a giant?
— *No, but he feels like one to me!*
What do giants do to ants?
— *They step on them!*
You don't want to be stepped on?
— *No!*
If you don't make the call, are you still an ant?
— *Yes, a frightened ant!*

If you do make the call, are you an ant?
— No, not really. In fact, once I dial the number, I won't be an ant at all.
— Okay. Dial the number right now!"

The last command to herself was the all important one. It is the act of putting something off that causes the Giant-and-the-Ant syndrome to develop. The longer you put off a phone call you are afraid to make, the smaller you shrink and the larger the person at the other end of the line, male or female, grows. It is a strange phenomenon that is brought about by fear—the fear of being found a little less than perfect; the fear of being in the spotlight; the fear of being responsible for your thoughts and words; the fear of failing. But the fear of failing is really a disguise! Because if we fear to fail enough, then we will never take the steps that might expose us to success. So what we are really afraid of, paradoxically enough, is succeeding! And along with that is the unspoken fear, "If I succeed, will they still love me?"

This is a tough one for women over forty who have not had as much experience in putting themselves on the line as men their age, or as their younger sisters. Like everything else, it takes practice! And the only way to learn how to handle procrastination (which keeps us feeling less than grown-up) is by deliberately tackling the most difficult tasks first and getting them out of the way, just like a child eating spinach before the hamburger. The secret to succeeding in this area, as in all others, is first to recognize the difficulty, and then to acknowledge your own resistance. Forgive yourself for not being perfect! Next, affirm that you are on a path to adulthood and will not be deterred, and move right ahead by doing what you had promised yourself you would do. If it helps, create and use a private, silent battlecry that you repeat to yourself whenever you find yourself procrastinating. You will be surprised to find that those obstacles you have built up in your mind will crumble before the onslaught of your determination and your ever-increasing self confidence.

Always remember to use the power of your imagination to combat feelings of doubt and fear. Visualize the obstacle in your mind's eye. For example, if you imagine procrastination as a brick wall, picture it in every detail—from the height and length of it to the shape and color of each brick—and then see yourself dismantling it, piece by piece. If a burden feels like a yoke around your neck, imagine that you are slipping it off and letting the weight fall away from your shoulders. You will really feel a difference, because giving shape and form to our amorphous anxieties gives them a manageable reality which enables us to conquer them.

What does this have to do with the title of this chapter, "Beyond the Rainbow"? We all have dreams. Some of us forget them in the day to day busy-ness of home and family, or career/home/family, but somewhere around the age of forty, the dream can start haunting us, bringing with it the feeling that there was a mission we wanted to accomplish so long ago. We used to know what it was, but now we have forgotten. As we left childhood and adolescence behind, and became caught up in the chores and routine of daily living, our fantasies about life and all the wonderful things we were going to accomplish, were relegated to the back of our consciousness, only to surface now and then during sleep. But here they are again, popping up from time to time as if to say, "Remember Me?"

If we have forgotten who we are, or if we really don't know ourselves at all, or if we have constantly put ourselves in second place to the extent that we fear making phone calls or even going out of the house, then those dreams can become more and more insistent. The reason for this is that a vital part of ourselves is being neglected, and often it is our intuitive aspect, the essential factor that is most in touch with what we might call our Real Self. If we have managed, over the years, to move too far away from our Real Self, we may find ourselves in unhappy situations, jobs or marriages that are just not right for us. Recognizing that something is amiss means listening to the Inner Voice that speaks to us in dreams or quiet moments, or that occasionally precipitates an action on our part that is unplanned or even unpremeditated. If we find ourselves procrastinating too often, watching too many soap operas, drinking too many glasses of wine, indulging in too many affairs,

wasting money, shopping incessantly for new clothes, and feeling generally aimless, it means that we have temporarily lost our dream. And in that case, how do we get beyond the Rainbow?

Pamela is a Washington woman who had been working for several years as the administrative manager of a prestigious firm, and had lately found herself dreaming about traveling to Ireland in search of her roots. Although she had never been out of the United States, and had never traveled alone, she found that her thoughts kept returning to the land of her ancestors.

In her forties and recently divorced, she owned a very comfortable townhouse which she shared with her poodle. Her children were grown and, for the first time in her life, she had no obligations to anyone other than herself. Her career, which had been very stimulating, filled as it was with powerful, political people, had begun to pall. Quite suddenly one day, she decided that she was going to leave her job, sell her house and go on a voyage of discovery to Ireland. This is her story:

"I left my job because I was very unhappy. In fact, I was terrified! I had spent about a year realizing I was extremely unhappy and very, very agitated. I did a lot of pacing, finding I was angry about a lot of things that had never bothered me before. I found I couldn't do jobs that were absolutely simple. I just couldn't remember how to do them! I had been in the job for two years and absolutely loved it, and all of a sudden, I was anxious. I did not know if I was angry with the people in the organization or if I was tired of working in administration. I just didn't know what it was. Finally, after about a year, I decided the only thing I knew how to do was to take a rest. Obviously I was experiencing burnout of some sort, and I had no energy left to put into a new position. I didn't even know where to look. I had to quit, and the only way I could do that was to give up the job and sell my house so that I could live off the proceeds of the sale of the house.

So that's what I did, and first I was terrified of it and I had to talk to myself and tell myself I could do anything, I could always find another job, even if I had to wait tables. I had to have a lot of faith in myself.

At the same time, I thought one thing I had always wanted to do was to travel, especially to Ireland, so I decided that was what I was going to do. I had never traveled before, except for very short trips. I didn't want a companion. I knew this was going to be a very difficult time for me, very emotional. I had a lot of things that I knew were buried inside me, but I didn't know what they were and I wanted to be by myself because I'm normally a very positive person and I was in a negative state. I didn't want to pass that on to anyone. It was something I had to deal with myself, and I wanted to be alone where nobody knew me. I had to be by myself and, in the meantime, have a little adventure. My family had mixed emotions about my decision. They were happy for me, especially since I was going to Ireland. However, they feared my being alone. Plus, they were a bit concerned that I had lost some of my marbles!"

During her marriage, her husband had been constantly on the road, but she traveled with him only once, and she had never been exposed to the necessity of making her own arrangements for airline tickets, car rentals or hotel rooms. Deciding to visit another country alone was to be a voyage of discovery. For several months she explored not only Ireland, but also England and France. She rented a car, adjusted to the differences in European vehicles and rules of the road, and traveled around without prior reservations, staying at Bed and Breakfast places or small hotels. Being alone a great deal of the time allowed her room for introspection. She kept a daily journal and also wrote some poetry.

Asked what she learned about herself from this personal quest, she replies, "I learned that I can't live any longer by traditional rules nor be controlled by the American concept of success and security. I've learned that I've always been too much of a perfectionist. I'm learning to listen only to myself, because the majority of the people I've known and loved are too controlled by fear of failure and what other people might think. My perceptions of success and security have changed and I've reached a new level of freedom that has brought me great inner peace and outer joy.

It took me a while to get to this point, but I think I have learned to live for the moment. I was always getting into a situation that I had wanted, but I never could calm myself down enough to enjoy

it. I was always thinking of the next situation! I've learned to take each day as it comes, and realize that there really are no accidents. I am more aware, more conscious of the people I meet and the incidents that happen because I feel they are there for a reason and they are helping me to find the carrot at the end of the stick, or the pot of gold at the end of the rainbow. It's all there waiting for me, and I don't have to rush around trying to find it!"

Pamela is now living very inexpensively in a midwestern state, in a simple cabin on a lake. Two days of each week she works in a local bookshop, meeting and conversing with new people and enjoying the relaxed pace of her life. The rest of her time is entirely her own. She spends time writing and meditating and allowing life to take care of itself for the time being, in the belief that she will be guided by her intuition to take the next step, whatever it may be. She says that she would advise any woman who wants to find out who she is and where she belongs to, "Get away from everyone you know for as long as you need to. Live simply—rent a cabin in the woods and by the water. Sleep in if you like, or stay up late. Just do whatever you want and set no goals or limits on yourself. Just be! Be open and free to chance encounters and absolutely love yourself!"

Somewhere beyond Pamela's rainbow lay a cabin on a mountain lake and a small bookstore. What about *your* rainbow?

11

Your Body, Your Soul

Here's to your very good health!

Just about the most important thing a woman over forty can do for herself is to take charge of her own health. For too many years we have allowed ourselves to be dependent upon the medical establishment. Most doctors are honest, knowledgeable professionals dedicated to the health and well-being of their patients, but the practice of medicine has changed drastically over the last two decades, to the point where physicians now have to practice defensive medicine, replete with an overwhelming number of x-rays and other invasive procedures designed to protect them from the growing incidence of malpractice suits. The old image of the family doctor applying his bedside manner may still have some validity in the rural areas of this country, but, for most of us, the gentle hand-hold has given way to the sterile, cold and impersonal touch of high technology. Western medicine, for many and varied reasons, has become a system of referrals, in which a patient is moved along a conveyor belt of specialists, and the value of the healing touch has lost its meaning.

In addition to the depersonalization of medical practice, the costs have soared so high that a visit to the doctor's office is rapidly

becoming a luxury many of us cannot afford. We are in a time of change, and we must learn how to move with the times, to our own healthful benefit.

As in so many other areas of our life experience, we can have a tremendous effect on our own existence by making a choice. Let us choose good health! That may sound very simplistic, but it is of inestimable value to be able to say and to mean, "I choose good health!" It has been proved over and over again that the mind is in control of the physical body which it inhabits. "Mens Sana in Corpore Sano," a Healthy Mind in a Healthy Body, has just as much validity today as it did thousands of years ago. Fear, anxiety, and worry do more to bring about disease than any other cause. In fact, it has been proved that chronic, unrelenting fear actually weakens the body's immune system. Today, we live in a social environment in which we must fight to maintain a sense of balance despite the onslaught of fears that the news media and even the government promote or endorse. The hot topic as we write is AIDS. AIDS gets more press and television coverage than any other topic. The destruction that it brings to the physical body is documented time and time again in newspapers, magazines and on the screen. If we manage to remove our attention from AIDS, before long we will pick up another paper that tells us the statistical likelihood we have of dying from heart disease, lung cancer or smoking. What does all this coverage lead to, depend on, and profit from? Fear! Fear is induced in us of illnesses we had not even heard of yesterday.

There is a fable of a traveler on his way from Baghdad, who meets the Plague, traveling in the other direction. "Where are you going?" he asks the Plague.

"To Baghdad, to kill four thousand!" replies the Plague. A few days later, returning to the city, the traveler again passes the Plague, on his way back.

"You told me you would kill four thousand," the traveler says, "but I heard that forty thousand died!"

"In truth," replied the Plague, "I did kill four thousand. The others died of fear!"

What all the publicity about AIDS and other diseases does is not simply to alert us to the dangers (its proclaimed focus), but

rather to incur fear among us that we will succumb. Our attention becomes focused upon ill health, and not upon good health. You may remember that in an earlier chapter we concentrated upon the importance of thoughts in determining our actions and their results. The same holds true regarding health. We can either see ourselves as well, active and happy, or we can assume that now that we have reached midlife, sickness and debilitation are the inevitable results. Which do we choose?

Two people of equal strength and fitness, one choosing to think of good health, the other of disease, reach the same older age. Which one will be in better shape, physically and emotionally? We know the answer, but it is not easy to believe that we have so much control over our own destiny when we are continually bombarded over the airwaves and through the press with so much negativity. What about menopause, for example? If we believe what we have been told, that menopause brings inevitable hot flashes, discomfort, irrationality and depression, than our minds will oblige us by rolling out the symptoms just as soon as we anticipate them. Menopause is nature's signal that our child-bearing years are over. If we get out of our own way, the physical body which is pre-programmed to cease the menstrual cycle at the right time, just as it began it at the right time, will do so. Many women have undergone menopause without any overt discomfort. If we were all told that menopause is nothing to be concerned about, our belief system would change accordingly and we would all welcome the freedom from monthly awareness. Certainly, there are hormonal changes that occur around the time of menopause, just as there are prior to each menstrual period. The secret in coping successfully with these changes is recognizing that they are happening and understanding the temporary mood swings that may accompany them.

How many people do you know who worry about the possibility of developing cancer? Whole industries have grown up around our fear of cancer! We must begin to learn that what the mind dwells on, the body will provide. Our thoughts condition our lives. If we want to be healthy, we must think healthy thoughts! The medical profession has, without harmful intent, increased the anxiety about cancer by the very frequency and nature of the surgical techniques

and other treatments used. We know about the trauma of radical mastectomy, and we have heard of the difficulty patients have experienced in attempting to discuss alternative forms of treatment of breast cancer with their physicians. Do you know that some enterprising surgeons are now considering a procedure called a prophylactic mastectomy, an operation which is performed on a woman with no sign of breast cancer, but who has a history of cancer in her family? Always remember that if your doctor recommends surgery for you or someone you love, you have the right to request a second opinion. Be aware that the number of hysterectomies performed on women in the United States in 1986 was at an all time high, and now a new trend is developing toward an operation called Pelvic Clearance, in which all the reproductive organs are removed at the same time, on the grounds that if they are all removed, cancer is less likely to develop! Ask yourself how it was that for generations women did very well without such surgery! If you are told that you need a hysterectomy, ask your doctor why he believes that this surgery is essential. If you or your daughter are pregnant, ask why it is that one third of all deliveries these days are by Caesarian section! American medical practice emphasizes surgery and drugs, and is being drastically affected in many ways by the constant threat of litigation, which is altering the choices doctors make regarding procedures. You, however, do not have to be led like a lamb to the slaughter. You, as a fee-paying adult, have the right to ask questions, or to obtain a second or third opinion about your doctor's recommendation. Any caring physician will welcome a well-informed patient. Did you know, for example, that if a drug is prescribed for you, you have the right to ask about its side effects? Every drug has an effect beside the one for which you are ingesting it! If you cannot get the information you want in the doctor's office, you can find it for yourself in the research section of your local public library. Realize that when you take any drug, you are putting chemicals into your body. We have become so accustomed to taking pills that we don't even stop to ask just why we are doing it, or if there are any other choices. The time is right for you to stop accepting medication, surgery or other invasive procedures without question.

Remember that the practice of medicine, just like fashion, is subject to trends and fads. We have been conditioned to believe that doctors know everything. This is just not possible, and they and we all suffer from the priest-like status to which they have been elevated in our society. For example, very few medical schools offer any training in nutrition, and yet we all know how important a balanced diet is to our health. If you are interested in exploring your options in more depth, you may want to read *Confessions of a Medical Heretic*, by Robert Mendelssohn, M.D.

Health concepts are changing, and you may want to look around to see what is happening where you live. The concept of holistic health treatments is gaining ground rapidly and will continue to grow as long as the costs of traditional Western medicine remain as high as they are currently. Holistic health may include the uses of herbal or other natural remedies, therapeutic massage, and good nutrition, and practitioners may include chiropractors, acupuncturists, nurses and homeopathic physicians. Acupuncture and acupressure are drug-free medical techniques that have been commonly and successfully practiced in the Orient for centuries, and are gradually becoming accepted in this country. Some members of the nursing profession are now being taught a system of healing known as Therapeutic Touch, pioneered at New York Hospital by Dr. Dolores Krieger. Therapeutic Touch might be called a form of laying-on-of-hands healing and involves no medication. If we think back to the old general practitioner who cared about his patient and sat at the bedside asking about the family and the job, then we can appreciate this return to the exchange of caring and affection between practitioner and patient that so often results in healing.

Meditation or simple relaxation has gained acceptance as a highly beneficial method of self-care that brings about a refreshed mental attitude which, in turn, promotes the well being of the physical body. Next time you come down with a headache, instead of automatically chugging down a couple of pain-killers, take five minutes to relax completely, asking yourself why you have the headache. Almost every headache has its root in tension. If you can understand and ease the tension, you will cure the headache. If you take two

pain-killers, you will cure the headache too—temporarily! But it will recur as soon as the chemical effect wears off and tension makes itself known again.

Be aware, as you turn to the management of your own health, that for many of us, a doctor-patient dependency has been fostered over the years because of society's view of the status and prestige of the medical profession. Not only is this an unhealthy position for a patient to be in, but it has also been discovered that a doctor-patient dependency, (especially between psychiatrists or psychologists and their clients) sometimes works in reverse, with the doctor becoming dependent upon the patient. It always takes two to form a dependency, although it may not seem that is the case. Just as a victim needs a bully, or masochist needs a sadist, so someone who is dependent needs someone who needs to be needed! Anyone who sincerely wants to help another, will focus upon that person's own ability to become self-sufficient as soon as possible, and will not suggest that the problems are so unique that they will require years of therapy. There are new styles developing in the treatment of mental and emotional stress which emphasize peer counseling rather than a doctor-patient relationship.

You may initially feel threatened at the thought of taking responsibility for your own health, but as you take small steps toward this end, perhaps by not calling the doctor at the first sign of an ache or pain, you will begin to realize that your body does know best and can handle some illness or distress by itself. If you are in pain, particularly from a headache or lower back ache, realize that your body is sending you a signal. Instead of immediately making an appointment to see the doctor or the psychologist, ask yourself, "Why do I have this pain?" Often, physical pain is primarily an indication that a mental dis-ease, such as tension, anxiety, anger or frustration, is being reflected in the body. If you can begin to understand what it is that is worrying you, what it is that is angering or frustrating you, then you may be able to relieve your own pain.

You can even practice eye exercises that will help you avoid the seemingly inevitable vision decline of midlife. Earlier this century, a physician named Bates discovered that weakening of the eyes was

not inevitable and he developed a series of eye exercises that helped eyesight substantially. The most likely reason that these exercises have not been widely publicized is that they might have a potentially disastrous effect on the sales of prescription glasses, but in fact, that first pair of reading glasses become all too soon a crutch, and but the first of many pairs of increasingly strong lenses. These days, wearing 'Designer' frames has become yet another status symbol, so there might well be resistance to the maintenance of perfect eyesight from many quarters, from stylists to opticians.

If you want to strengthen your eyes, try the following exercise. The next time you are sitting on a bus or train, keep your head still but allow your eyes to move as far to the left and then the right as possible. Next move them way up and way down. Then, holding a newspaper or magazine in front of you, use your eyes to outline first the whole picture and then every item or figure in it. This is called contouring and should be done with the head held steady in one position. These simple maneuvers are designed to strengthen the eye muscles, because it is muscle fatigue that is the major contributing factor to eye strain. Blink rapidly from time to time to lubricate the eyes, and splash the eyes every morning with ice-cold water. There are also acupressure techniques that an individual can use to strengthen vision. All such techniques can be self-taught and practiced privately, at no cost. If you are interested in exploring self-care for your eyes, there are books on the market, generally available in health food stores, which detail those exercises which are of most benefit.

Then, of course, there are physical exercises and good nutritional practices for your body's future well-being. Swimming, walking and cycling are some of the most pleasant past-times to decrease tension while improving health and fitness. A routine of fresh air and regular exercise can not only keep you in good shape, but also restore you to good health if you have been neglectful. It is never too late to start. Good health and a youthful attitude—two inexpensive, sure-fire components of happiness after forty!

Here is a winning tactic you can use that harms no-one, costs nothing and takes maybe one minute of your time every day. When you wake up, before you get out of bed, say to yourself, or aloud,

"Today is a wonderful day! I choose health and happiness!" Doing this on a daily basis reconditions your subconscious—that part of you that has unwittingly become filled with so many fears and apprehensions, beginning with your parents' warnings and continuing with your exposure to the Daily Bad News. You know that to dispose of an old tape recording, you record over it, thereby making a new one. That is just what this affirmation does. Repeating it means making a new mental tape recording to be played in your subconscious every day. Instead of the *AIDS-cancer-heart disease-osteoporosis* tape, you will play the *I choose health and happiness* tape instead. It may feel strange at first, but try it anyway! You will be able to see your attitude changing after a while. When you start to notice how often poor health is the subject of so many people's conversations, you will realize how your own thinking is changing for the better. Then, perhaps, you can do something with your new-found knowledge and changed attitude to help others lose *their* fears.

Of course, using an affirmation like this does not mean ignoring potential environmental hazards. Toxic waste is real. Acid rain is real. Pay attention to the environment in which you live and work. Few of us work in asbestos factories, but do you spend many hours at a machine such as a word processor? Prolonged use of such a machine may cause dehydration of your skin, as well as neck ache and eye strain. Do you smoke? Sometimes a simple change can make a major difference in the quality of your life. If you are concerned about local, national or global environmental health hazards, become an activist by joining a group and lobbying for constructive and healthy changes which will benefit everybody.

In urging you to take control over your own health and well-being, we are, of course, not advocating the discontinuation of your relationship with your physician. Any severe pain or other persistent unusual symptom should, of course, be checked by a professional. However, physicians' offices and hospital emergency rooms are crammed with women (seven times the number of men) suffering from minor ailments they could cure by themselves. Many women are sick because they feel afraid or depressed. Many women are sick because they are not happily busy. Many people are sick

because they feel unloved. Many people are sick because they do not love themselves. *Next time you feel unwell, ask yourself what your body is trying to tell you.* Is it signaling you to take care of a problem, to slow down or speed up, or to rest and revitalize?

Your body is a marvellous instrument, controlled by your mind. When the mind is preoccupied, the body may have an accident. When the mind is depressed, the body may experience a headache. When the mind is angry, the body may produce acid and create an ulcer. You owe it to yourself to choose happiness, and good health will follow. If you are not receiving enough love in your life, look for someone else who is not receiving enough either, and give some of yours away. If you have any free time, volunteer some of it to help in a babies' ward at your local hospital. How many times have you heard a woman say, "It's not the sex I miss, it's the cuddling!"? If you miss being cuddled, find someone else who needs it as much as you do. Many sick infants are not held and cuddled enough, and busy nurses often do not have enough time to spend on this essential task.

If your hospital does not use volunteers in this way, call your local hospice or retirement home to find someone who has no visitors. The world is full of people who need an extra dose of care and affection, and you can never give love away without receiving more in return. Once you have found your place in the world, doing something that satisfies you emotionally, so that you know you are needed, valued and loved, then your physical ailments will tend to disappear. Your concentration will no longer be focused on what might happen tomorrow, but will be fully absorbed in what is happening right here, right now, today. Allow the future to take care of itself by taking each day as it comes and filling it with meaning. Have you ever heard a busy person say, "I don't have time to get sick!"? We do have a choice. We can either buy into the current atmosphere of fear, or we can fight it by ignoring it and giving it no weight. Let us not repeat the mistake of the citizens of Baghdad, but rather resolve to trust our own potential for healthy, happy living.

12

Say, Look Us Over!

Looking your best after forty.

Gloria Lintermans is an internationally syndicated health and beauty columnist who lives in the very heart of glamour-country, Hollywood, California. Interviewed on the sunny patio of the Los Angeles Press Club, Gloria, slim and beautiful, was dressed in a loosely fitting white silk dress, and appeared to be wearing no makeup. Her dark hair was pulled back, simply, from her face. She spoke enthusiastically and lovingly about women, their achievements and their support for one another, and offered the following beauty tips for women over forty:

"The most common mistake women over forty make is that they do their makeup the same way they did when they were twenty-five. 'If I wear my makeup the same way I did when I was twenty-five, I'll look twenty-five forever.' Instead, you don't! You will look dated when you can and should look fresh at any age. After forty, you must use less makeup, not more. Absolutely less! Once your skin matures, a very heavy foundation can get caught in wrinkles and make them look more pronounced. You want to stay away from things like metallic eyeshadow, because if your skin is the least bit crinkly around the eyes, it will make them look worse, not better. We want to update and soften our makeup as we mature, to use it to define—not to camouflage.

"There are several fallacies that go along with this age group. Number One is that we should be gentler to our skin as it matures. The opposite is true! The dead skin cells do not turn over as quickly, so to keep our skin moist and looking as young as possible, we have to keep those dead cells sloughing off. All you need to do is to use a terry washcloth and scrub your face every day, so that, as you mature, you work that skin. Don't let it become lazy! Soap and water is fine! The only time you might want to avoid a particular type of soap is during the summer when a deodorant soap can be a photosensitizer, causing a serious burn. Especially if you're going to the beach or the pool, don't use those soaps—and leave your perfumes at home. If you're still taking birth control pills, be extra careful, because they too are photosensitizers. And if you're taking antibiotics, stay out of the sun!

"Unprotected exposure to the sun is the largest single contributor to premature aging. The best way to prevent premature wrinkling of the skin is to give up tanning and protect your skin with a sunscreen all year round. Don't just wait for summer! If you're going to participate in outdoor activities, you're going to need extra protection applied often. After cleansing your skin, apply a moisturizer that already contains a sunscreen. Or apply a sunscreen on top of your moisturizer. Then you can put on your foundation or loose powder.

"I love the fashion and beauty industry! Clothes and beauty products can make us feel wonderful, but according to the advertising campaigns we see, it seems necessary to first find flaws, and this is very intimidating to most women. Industries that are essentially about making us feel better about ourselves, can do exactly the opposite and find fault just so they can sell us something to 'make it better.' An example of this is a product that is called anything from a toner to an astringent, depending upon how harsh it is or how much alcohol is in it. Basically, I think it is an unnecessary product for most skin types and should never have been put on the shelves in the first place. If your cleanser will not come off completely with water, it is too heavy. Cleansers which must be tissued off are not necessary for most women, and therefore, neither is the astringent or toner that is needed to remove them.

"More expensive doesn't mean a better, more effective product. A very good moisturizer for the skin is petroleum jelly. Cleanse your skin and dry it. Then, take some petroleum jelly and smooth it on, avoiding the eye area. Take a wash cloth, wring it out with hot water and put it on top of the petroleum jelly on your face. This will open up those pores so that your skin can drink in the jelly, and it will remove the excess so that you don't feel oily. Simply pat your face dry and you will love how soft and smooth your skin looks. Tiny wrinkles will vanish."

What about the best way to use makeup? "If you use an oil base or water base foundation, take a little in the palm of your hand and mix it with mineral water, thinning it out considerably. Then apply it with a makeup sponge. Find the softest sponge you can. If you wash it with soap and water after each use, it should last you for years. The reason you should us a sponge rather than your fingers, is that the foundation will spread a lot thinner and smoother and look a lot softer. As you mature, you want a finer film of foundation on your skin, so it is important to start thinning whatever brand you are used to wearing. Also, powdered blush is a lot easier to use than cream. Select a very soft color and blend it all the way, up and out, into the hairline, using a big, fat, soft makeup brush."

Asked about hair and hair coloring, Gloria advised, "As you mature, your hair color should become lighter, not darker. Darker will make you look older, not younger. In fact, if you have a lot of gray coming in, and you hate it, the way to find your best color is to go back to a photograph of yourself as a child. Go to that color, but one or two shades lighter. It's important to be aware, however, that gray is a very flattering color and very softening for the face.

"There are so many different types of hair coloring available, everything from a semipermanent rinse to add highlights, to a permanent color. A one-process color can only add color. It tends to look rather harsh because you're not lifting color, you are just depositing it. You can't go lighter, so obviously, you have to go darker. I believe that a one-process color doesn't usually work as well as the two-process for this particular age group. If you go into the two-process, which is a lifting of the color with a bleach or

peroxide, then depositing color which is lighter than your original color, that works. The problem is that you must be prepared for touch-ups, sometimes as often as every three weeks, because roots are absolutely unattractive. So I would avoid this, unless you are prepared to maintain it. I think a lot of looking your best is understanding the kind of time that you are willing to give and the kind of investment you are prepared to make regarding cost. Better to do nothing than to do something that isn't quite right!

"As for hair styles, again, you do not want a style that is going to date you! You want something soft. As a woman gets older, her hair may thin somewhat, but the softer and shorter the hairstyle, the less that is going to be obvious. Best styles are shampooed every day and air dried to stay fluffy. There is no reason not to shampoo your hair every day. Hair should feel comfortable, loose and clean. You can whip up a hair thickener at home by dissolving a little plain gelatin in water and adding it to the shampoo in the palm of your hand. Do not add it to your shampoo bottle, but mix it as you need it. Henna works very well both as a thickener and oil controller. Use a colorless, natural henna by mixing it with hot water, sectioning your hair, applying it and leaving it on for up to one hour before rinsing it out thoroughly. A coating of natural henna on blond hair will protect it from turning brassy in the sun.

"Permanents are no longer a problem, because there are some very gentle formulas on the market. If you are going to do your own at home, the most important tip I can give you is to time the neutralizer as carefully as the wave solution, because the neutralizer can damage the hair. If you want to color and perm your hair, remember that you must first perm and then color, because otherwise the perm will destroy the color. Even if your hair color is natural, the perm may lighten it."

Asked it if would make a difference if more women felt that gray or white hair was something that can be very attractive and not something to be afraid of, Gloria responded, "I think women are afraid of aging in general. I think it is changing slowly, but women are afraid of looking in the mirror and honestly evaluating themselves by saying, 'This I like, this I don't like, and this I want to change.' We have to stop running after a Godlike image that no

one attains! Accentuate the positive! Each woman is unique, and all a woman really needs to do to look wonderful is to care for and honor her very best self.

"I think that a woman should be stylish all her life, but that means not being *fashionable*, because being In Fashion doesn't necessarily work for every woman. You have to develop your own sense of style according to your own figure and lifestyle and then, every season, you can pull a fad or two—whatever works for you—and you'll have fun with it. But you won't throw out your wardrobe each season. Once you have developed a sense of your own style it will transcend all fads and you will be very stylish or 'in style' your entire life. It's a matter of being comfortable with who you are."

How can a woman who has not paid very much attention to her appearance, or not changed it for many years, develop her own sense of personal style? Gloria says that, "Number one, you have to be really brave. Stand in front of a three way mirror and take a good look at yourself. Really come to grips with the issues of your weight and general physical condition. I do not think you should think in terms of 'I'll just run off and get a face lift!' Plastic surgery is very accessible, but consider your motives carefully and choose your surgeon wisely. Plastic surgery might not be the right answer, for now. It's just like the issue of money. More money will not automatically make a happy person out of an unhappy one. And neither will looking ten years younger. I think a woman must first look within, at her general health, energy level and attitudes, before concentrating on the outside. If she is feeling worn out and tired, that is wrong, and should be changed with proper exercises and diet. Then go for the outside. Once you *feel* young again, then all you have to do is to match the outside with the inside! But it can't start with the outside. It has to start from within. If you're feeling sluggish, if you're feeling unhappy, go out and do something about your energy level and psyche—then everything else will flow. After that, when you're ready to start working on the outside, your attitude will be positive, and you'll have fun. It's playtime! No one ever died of split ends!

"I receive letters from women who say, 'Find me a good plastic surgeon—my husband has left me for a twenty year old!' And I say, 'No, this is not the time. You have to mend first, You are in pain. Unfortunately, growth does not come from the good times, it comes from the difficult ones. You must go through this hard part. Get your diet in order, start exercising, seek counseling. Then reconsider a face lift, if that's what you still want."

Gloria was asked what she would recommend for the woman who is too depressed to do this for herself. What about the woman who is feeling lost, as if everything seems to be happening at once?

She replied, "Find an appropriate support group. If your problem is your weight, find a support group. If your problem is depression, find a support group. If your problem is drugs or alcohol, find a support group. Call your local public health service for a referral. Open your heart to let other women help you, because this may be a time when you're feeling so very alone. You may have gone through a divorce, your children may have moved away, or you may be depressed because you're sure that at your age you will never marry or have children. Look hard and you will find a support group. Allow other people to nurture you. That doesn't mean calling your best friends every afternoon and complaining the day away. It means finding a support group whose goal is helping *you* to *solve your* problems. Women are out there to help other women now. It is the climate, so take advantage of it!"

Having a high energy level is a goal that sometimes seems elusive, especially during some of the crises that we may go through after forty, when we are feeling particularly vulnerable. What is Gloria's recommendation for keeping one's energy up?

"Energy level is a combination, I believe, of exercise and a proper diet—and that's different for everyone. Listen to your body and it will talk to you. Exercise doesn't have to be aerobics. It can be a good forty-five minute walk every morning. Instead of being angry at yourself for what you can't do, do something that you can. This can be a time of finally learning to appreciate yourself. And when I say look to your energy level and look to your weight, I don't mean that you have to be a size 6. I mean that you have to be in good shape, whether you are a size 6 or a size 16. You want

to feel good about the way you look, because when you're feeling fit and healthy, your energy level is high. Any dress size you wear is fine, unless you're trying to wear one size smaller!

"The fashion industry can be a very intimidating industry. It should represent a very nurturing image but, for the woman over forty, it can be just the opposite, and that's very wrong. The crusader in me says that I don't have to intimidate women or shame women into taking my advice seriously. You're important enough to look your best, and you don't have to be embarrassed into doing something about it. You are worth it! All you need to do is agree to take the first step."

What about stress and the effects it can have on our health and our looks? Gloria remarked, "Every age, and this one is no exception, can have its problems. To deal with stress, you have to take a real good look at what is creating the stress, and if you can alter the situation, do so. If you can't, exercise a whole lot. Work it out physically. Check with a physician or a nutritionist regarding vitamin supplements. In my opinion, yeast is terrific. Mix it in with your orange juice every morning. Not only will it make you feel good, but it can be very beneficial to your skin, helping you to look great."

Gloria was asked about the most common concerns that she sees among women over forty. Weight and the advisability of cosmetic surgery headed the list. She comments, "Overweight? Start making a list of everything that goes into your mouth, because I bet you don't know! Do this for two weeks. Then, circle the things which are unnecessary and you'll know which ones are causing the problem. If I were to sit you down and ask you to evaluate your list, you would be able to tell me what's wrong with your diet. Just use common sense. Do it as if you were doing this for a friend. If you're eating because you are unhappy, find a support group. If you weren't born into a nurturing environment, it's not your fault, and you have every right to find a replacement through a support group. Examine not only what you're eating—but why? Is it emotional? Allow a friend to hold your hand. Generally speaking, you should eat more early in the day, and less as the day goes by. Speak to a nutritionist for specifics."

Asked if she believes that some women overeat in order to compensate for a lack of love in childhood and are trying to give themselves love through feeding themselves, Gloria replied, "Yes, but there's another issue a woman may be dealing with through food. In this age group, we are talking about women who may not have wanted an outside career, but who were forced into it through a divorce, or who feel, because their children have left, that they ought to be doing something. For the first time, such a woman may feel compelled to perform professionally. There's more pressure now to be successful. If you didn't come from a family that encouraged you to compete, you're out in the marketplace lacking the inner confidence that is needed to compete within the normal range of day to day stress, and it may be overwhelming. Eating may be the way you are handling that abnormal stress. Weight is often an emotional issue."

As for cosmetic surgery, she said, "If you do elect to go for any plastic surgery, you must look for a plastic and reconstructive surgeon in your area, call the American Board of Plastic and Reconstructive Surgeons in Chicago, and they will refer you to three surgeons in your area. Or check with your personal physician or local teaching hospital.

"There is always scarring after surgery. The amount is determined by three things—how you heal, the skill of your surgeon, and the way in which you take care of yourself after surgery. You can't expect to have surgery, not take care of yourself according to your surgeon's instructions, and show the best results possible. For example, if you have just had a chemical peel to lessen skin wrinkling, and your doctor tells you to stay out of the sun for six months, don't cheat!

"There are several procedures to get rid of wrinkling. One is Zyderm Implant Therapy, which is collagen injected right into the wrinkle to plump it up. You must have an allergy test before the series of injections, to find out if you have a sensitivity to this product. It's rare, but it can happen. The downside of this procedure is that the results may not last for more than six months to a year before additional injections are necessary. The newest technique of injecting wrinkles to plump them out is a procedure where your

physician will take fat from one part of the body to be injected into the wrinkle. The results from this technique seem to be permanent. Then there is the chemical peel where superficial layers of the skin are chemically burnt away. Chemical peels are also used in isolated areas, such as around the mouth. The best candidates for a chemical peel are women with a very fair skin. Darker skins may have a problem with pigment changes.

"The newest face lift techniques are wonderful. The incision is made right inside the ear so that the scar is potentially hidden, and there is very little, if any, visual scarring. Underlying muscles are tightened so that the lift lasts longer, yet is more natural looking. But, as with any cosmetic surgery, be prepared to look worse before you look better. Healing takes time. It is very important to go into surgery for the right reason. If depression is your motivation, you might be making your situation worse instead of better. The average age for a face lift for a woman today is between the ages of forty-five and fifty. The eyes are one of the least complicated procedures. Again, there is some scarring, although on bottom lid you really can't see the scar."

As for other problems common to the woman over forty. Gloria had the following advice. "Spider veins on the legs are easily treated. Medication is injected by a physician right into the vein, and many veins can be done in one session. It is so simple, and there are no side effects or recuperative period. Spider veins on the face can be zapped with an electric needle, and they're gone! Facial veins are taken care of by a dermatologist. Problem veins on the leg are treated by a dermatologist or internist. There are specialists who do nothing but veins. Varicose veins have to be surgically removed."

Upper arms: "Exercise will help, but you have to be patient. You cannot spot reduce through exercise alone. The only way to reduce is all over, and that is through diet. You can firm specific areas through exercise, but you cannot spot reduce—that is a fallacy. There are exercises for the arms, but it is a very difficult area to firm. Exercising with appropriate free-weights will help."

Waistline: "It will thicken! Your waist will not be at forty what it was at twenty, but remember that you're still a terrific person! Don't attach the size of your waistline to the worth of your person, and it will be okay. Again, exercise will help, but you have to be realistic about that."

Bustline: "It will fall! If it really bothers you, you can have it surgically lifted, but the tradeoff is scarring."

Nails: "They become more brittle, so treat yourself to a hot oil soak once a week. Heat up some oil, dip your fingers in and let them soak. Make sure the oil is warm, not hot, and put your nails in all the way up to the cuticles. And don't change your nail polish more than once a week, because the remover can dry the nail."

Enlarged pores: "The size of your pores is genetically programmed and you can only shrink their size temporarily. If you have skin that tends to break out, you probably have large pores which trap oil. If you do have large pores, camouflage them with a light film of foundation and a dusting with transluscent powder."

Lines above the lips: "Cosmetics can help minimize the appearance of these lines. After cleansing and moisturizing, apply a thin film of one of the new 'lip fix' products. Apply your foundation over this, including the lips. Line your lips with a lip-liner pencil close in color to your lipstick, and complete by applying a matte lipstick, highlighting the lower lip with a small dot of petroleum jelly for shine. Remember that the more shine a lipstick has, the less holding power, and the more it can creep into those lines."

Gloria summed up her philosophy about health and beauty at any age by saying "When I was a little girl, I used to do everyone's hair and makeup, anyone I could get my hands on! I was very artistic, but more than that, I loved what happened when people started to like the way they looked. They were nicer to themselves and everyone around them. When people like the way they look, they're nicer and happier—it's that simple! If we all were comfortable with the way we look, think what a nicer world it would be.

"I want to see women blossom, surrounded by a nurturing environment. It goes beyond putting makeup on to hide a bad complexion. If your attitude is sour or you're unhappy or depressed, I don't care how beautiful you are, you're not reaching your potential as

a person. You want to look great as a beginning, as a starting point, so that you can go out and do things with your life. You don't want to look great so that you can hibernate! You want to look great so doors open for you.

"I think every person in this world has the ability to be attractive. I don't care what canvas you were born with. It's only that—a canvas. Everyone can and should enjoy the confidence that comes from looking your best. It has nothing to do with the size of your dress, or the size of your nose, the size of your ears or your waistline. It has everything to do with loving yourself, and loving the world around you. Understand that makeup isn't to hide behind, it's just a tool for telling the world, 'Here I am and I like who I am!'

"True beauty is simple. It's one part style, one part taste, and one part grooming. In other words, courage, trust and discipline."

Economic and Financial Challenges

13

What If We Don't Have a Barrel of Money?

Taking care of your financial situation.

Do you, as a woman over forty, feel financially insecure and afraid of your future? If you do, then think of the information in this chapter as leading away from the empty barrel mentality and toward a new prosperity.

Women over forty who have spent most of their working years as homemakers have often had no need to learn or understand financial planning. Budgeting for food and clothing has been our province, but not the overall planning of the family income. This has traditionally been left to the male provider. For many, the first indication of the necessity for reeducation in money matters occurs either at the time of separation, divorce or widowhood, or upon the decision to return to the job market. Women who are single parents, responsible for the care and support of children, and who find themselves in receipt of reduced income, supplemented sometimes by sporadic support payments, are particularly vulnerable. Sudden responsibility for payment of fixed monthly bills such as rent, electricity, gas and oil, along with fluctuating charges for necessities like food and clothing—combined with the costs of miscellaneous items—has caused many an intelligent woman to panic.

Since, for many of us, our best abilities seem to lie in the areas of intuition and creativity, we feel put upon and sorely offended by the needs for discipline inherent in matters of money management.

Before long, however, we realize that to function efficiently and without anxiety, we must take control over our personal finances. We must learn exactly how much money we receive every month, how much we have invested in savings, and how much it costs us to live in the manner to which we are accustomed or in which we wish to live.

The day of the piggybank is long gone. Today's financial picture appears highly complicated, even somewhat schizophrenic, filled as it is on the one hand with stern abbreviations such as IRA and CD and on the other with whimsical names like Junk Bonds and Fannie Maes. We may yearn for the solidity of the old bank, with its wood-paneled hush and its air of sacred obligation toward our passbook savings account, but today's banks are big business— marketing institutions, each vying for a larger share of the corporate pie, more interested in companies than individuals and offering a dizzying barrage of advertising aimed at emptying our pockets into theirs. As for the income tax system, the mere format and appearance of the annual federal and state forms are forbidding enough to cause a flutter of fear in even the stoutest taxpayer's heart. In spite of recent reforms, completing our own tax forms, secure in the knowledge that all legal deductions have been taken, and that we are paying our true and fair share, no more and no less, is a challenge for which most of us feel sadly ill equipped.

However, once we get down to it, women are excellent record keepers. Perhaps because we are so accustomed to keeping a host of facts, appointments and other odds and ends, in our heads, it is easy to learn to transfer it all to paper. Barbara Phillips, a Certified Financial Planner, says that the most important element in drawing up your own financial plan is to set your goals down *in writing*. "By having a goal, you can turn every day tedium into a step on the road toward that goal. Instead of regarding a job you don't like as just a dreary way to pass the day, you can see it as a means to get to where you want to be financially."

It is well known that most women earn roughly sixty cents to the male dollar. What is less well known is that the majority of women in the United States are reaching old age at the poverty level. However, with the increasing numbers of bag ladies on our streets, the fact of the feminization of poverty is becoming much more obvious, and few of us feel immune to the fear that it could happen to us. Ms. Phillips explains just what the sixty cents to the dollar ratio has meant in terms of women's financial insecurity. "Let's say that a man brings home from work one thousand dollars. A woman with a comparable job brings home six hundred. Out of the thousand, the man spends six hundred dollars on the standard overhead of rent and other bills. He then has four hundred dollars left with which to speculate, by buying stocks, investing in Real Estate or playing poker. The four hundred dollars is known as discretionary income. The woman, however, has used her six hundred dollars on the same overhead costs, and is left with nothing! Part of a man's pay has traditionally been used for speculation, but when a woman's pay has been used to cover essentials, she's broke!"

Ms. Phillips, a divorced woman in her forties, teaches women how to handle their money so that they can calculate their net worth and learn how to provide for their old age through savings or investments. She says, "In order to manage your money and provide yourself with discretionary income, you need to budget and plan very carefully. Then, once you have set up a plan, you have to examine the results. This is what men do better than women, but we must learn to examine the results, too, and look at the whole picture. Stand back from your records and say, 'This is working and this is not working.' You have to *use* this information." As a first step, Ms. Phillips recommends finding out where you are now by calculating your net worth. This becomes a personal balance sheet, a statement of your assets and liabilities as of one particular day. It is a snapshot of your financial affairs. Draw up this balance sheet by taking an inventory of your assets, everything tangible that you *own*—home, furnishings, antiques, investments, money in the bank and collectibles. Next, make a list of your liabilities, everything you *owe*—mortgage, loans, etc. The amount of money calculated by deducting your liabilities from your assets equals your net worth.

Your net worth statement can be a very useful tool, because it measures from year to year (or period to period) where you are going. It is essential as a barometer to gauge your progress.

Step Two is to find out where your money goes. List all sources of income—salary, alimony, child support, income on savings and investments. Next list your expenses—everything from rent, food and clothing to loans, entertainment and vacations. Your list should look similar to this one:

Monthly Income and Expenses

 Income:
Salary	$ _____
Investment income	$ _____
Child Support	$ _____
Rental of upstairs room	$ _____
= *Total Fixed Income:*	$ _____

 Expenses:
(a) Rent	$ _____
Utilities	$ _____
= *Total fixed expenses:*	$ _____
(b) Food	$ _____
Clothing	$ _____
Medical	$ _____
Miscellaneous	$ _____
= *Total variable expenses:*	$ _____
Total (a) + (b) =	$ _____
(Total Monthly Costs)	

This will give you a clear picture of your monthly financial picture. Obviously, you cannot allow the total of (a) and (b), your fixed and estimated expenses, to exceed your montly income—without incurring debt.

Step Three is to draw up a budget and to discipline yourself to keep exact records. Remember, the money you save from following a strict budget becomes the discretionary income that you invest in order to increase your assets and improve your net worth.

It will take firm self-discipline on your part to keep track of all your expenses, particularly miscellaneous ones such as travel, entertainment, health and beauty care, lunches and gifts. Start by carrying a notebook or small expense account book with you everywhere you go, and remember to write in it every item that costs you anything at all, including bus and subway fares, newspapers and magazines, coffee and donuts. Total your expenses by the week, and then total the four weeks of each month. If the first month you do this is fairly typical, you can then multiply your monthly total by twelve and see what you can expect to spend in the course of a year. (Expect to be horrified!) Once you are in the habit of doing this, it will become much less of a chore and simply another small routine discipline, like doing the weekly wash. Decide at this time to save ten percent of your weekly income. It may sound impossible, but make up your mind that you can do it. There is something about tithing that has almost a mystical aspect to it. Once you can successfully save ten percent, you will approach the rest of your financial planning with confidence.

What about credit cards? Every woman must establish credit in her own name. If you are married, are the family credit cards in your name as well as your husband's? If not, you are entitled to apply for a card with your own name on it. Check the literature that comes with the monthly bill for information about applying for your own card. It is very important that you do this so that you begin to create your own credit record. At some time you may want to borrow money. If you have been accustomed to doing this (purchasing a new family car, for example) through your husband's credit standing, realize that this will not help you if you are ever alone and no longer backed up by a spouse's earning and credit power.

These days, the entire economy is operating on credit! The federal government, in referring to the annual deficit, is talking about just that—how much in debt it is. If you grew up with a pay-as-you-go ethic, as many of our generation did, it may be difficult to accept the idea that cash carries less weight than credit. However, to be part of today's society, it is mandatory that you develop a credit rating of your own. Are you aware that there are companies that

exist solely to pass judgement on you—not by virtue of your accomplishments and integrity, but on the basis of your ability to repay debt? One such company is TRW* in Parsippany, New Jersey, which routinely answers requests from lending institutions and others as to an individual's credit worthiness. Your name may be in their computer! If you have made consistently late payments on a credit card, it is recorded in their computer! Any organization from which you request a loan is entitled to approach this company, or a similar one, to ask about your credit worthiness. If you would like to know what is being printed about you, you may write to TRW yourself, enclose a ten dollar fee, and request a print-out. You need only cite your name, address and social security number, or for an annual fee, you may subscribe to their new service which enables you, the consumer, to keep on top of your credit report.

In order to begin to generate a credit rating of your own, if you do not have one already, it is wise to make a purchase (or several) with your credit card and then to pay off the monthly bills promptly. Obviously, we are not suggesting that you buy something you do not need—rather, that the next time you are in the market for a fairly large item that, instead of paying by check, you deliberately use credit. If you are a new card owner, your line of credit is likely to be quite limited. If you pay your bills on time, your line of credit will be increased because the lending institution will regard you as a good risk, someone who will indeed repay a loan. Not having a credit card in your own name these days is similar to not having a driver's license. It is positively un-American! You may live in a big city and have no need to drive, but without a license you are a sort of non-person since a driver's license appears to have more validity than a birth certificate! Similarly, you may not want to run up large bills on credit, but being given the privilege of a credit card indicates to lending institutions and other organizations that you are a reliable, trustworthy citizen.

If you are on the point of taking out your first credit card, be aware that all cards are not created equal. We are referring to interest rates, the amount of money you will be charged each month

*See Appendix

that you do not pay your bill in full. Different lending institutions charge different rates of interest. Shop around by calling the banks and asking what their current rate of interest is, and apply for your card from the institution with the lowest rate. If you have an outstanding loan somewhere, you should also keep an alert eye on interest rates. Often, it is worth while refinancing a loan in order to obtain a lower rate, especially now that interest payments will no longer be deductible from income taxes.

If you feel a resistance to becoming involved with finances, realize that this is just a hangover from your old dependency days and the idea that money was a dirty subject, something that nice women didn't talk about. Many women who have taken a somewhat late interest in their finances and the economy in general have developed such an avid interest in the movement of money that they have begun careers in the financial world. Stock brokerage, for instance, is a business area that combines analytical thinking with intuitive skills, and the rewards for success are substantial. The banking industry has also opened up for women over the last decade, as it has moved away from its traditional stance into the competitive marketing arena. Women are also becoming registered as certified financial planners and are guiding others to an understanding of their economic situation.

What about investment? If you are already in a comfortable economic situation, how do you go about making your money grow? Ms. Phillips is an advocate of Real Estate as the best financial investment for women. She and many other knowledgeable women in finance believe that only when women own a piece of land or property are they taken seriously. Men have always been the property owners, but women are beginning to catch on to the significance of owning something tangible and relatively permanent. According to Ms. Phillips, "Your first Real Estate investment should be your own home, with the very rare exception of the woman who lives in a rent-controlled or rent-stabilized apartment. Despite recent tax changes, mortgage interest is still tax deductible and your home appreciates in value in line with inflation so that you are usually kept on top of the bubble." The home you own can also be used

as collateral against a loan, although Ms. Phillips does not recommend indiscriminate use of this procedure. On a more emotional level, owning your own home can give you the sense of stability and security that so many women feel they need.

What about other financial investments? Look for tax-free Government Bonds. The next least risky investment is generally thought to be a Mutual Fund, a package of selected stocks watched over by professionals. Playing the stock market as a beginner is very difficult. If you want to try it, practice first by choosing one stock and tracking its progress in the financial pages of your newspaper every morning when you have your first cup of coffee. Every morning! Do not actually invest in it until you really develop a feel for what you are doing.

If you have received a bequest, or if you are a recent widow, be extremely cautious as to who advises you about your investments. There are many unscrupulous people who deliberately prey upon women who have little or no experience in handling money. Do not give power of attorney (allowing someone else to write checks on your account) over to anyone, not even the family lawyer! Instead, take a course in financial planning at your local college. Follow that up with a course in investing. Become sophisticated about money matters, and take responsibility for your own financial affairs. As Ms. Phillips says, "Nobody looks after your money as well as you can. Don't use the easy way out! Don't be talked into giving someone else power over your finances. Find yourself a reliable banker, insurance broker and financial planner. Listen to their recommendations, but make your own decisions. Living is money. Take control of your own life!"

In these days of automated, electronic equipment, it is easy to be lulled into the belief that everything between you and your bank takes place through a wall, between you and a wide-mouthed, talking machine. If you do not personally know a banker, we suggest that you take some money and open a savings or checking account at your local bank. When you make that initial deposit, ask to meet the bank manager. Even if your deposit is relatively small, don't be too shy to make that personal contact! Every banker knows that today's small customer may become tomorrow's super account, and

will welcome that personal touch. Whenever you make deposits into your new account, make the effort to have a brief word with *your* banker. It is in your best interest to develop such a relationship, because the day may come when you want to take out a loan and a personal history can make the difference between your loan application being approved or denied.

One last word, and that is about attitude. Women have been taught, subtly and overtly, that it is not nice to want money. Money is a symbol. Money has always represented power and, until recently, women were not considered worthy of power. Times have changed, but not very substantially. Perhaps our daughters will not be tracked into low-paying jobs and anonymity in the job market. Perhaps we will soon see more women in government and other leadership positions. Perhaps we will become aware of more role models, women of means who use money and power easily and wisely. Perhaps. Our generation must work, however, at developing a prosperity consciousness. We must develop in ourselves the belief that it is all right for us to earn, spend, invest and save our own money; that a woman of wealth is an okay woman; that having abundance does not diminish our sex appeal or threaten a man's sense of self. Only when we have convinced *ourselves*, can we move forward and take charge of this important area of life, with comfort and ease.

14

Should We Call the Whole Thing Off?

What you need to know about separation and divorce.

One of the hardest decisions any woman can make is to end her marriage. Often the choice is forced upon her, and this brings its own dilemmas. In either case, whether you are the one initiating a separation or the one who has to react to a husband's decision, this is one time when you must have legal representation. This country is afloat with lawyers, and we are living in a highly litigious environment, with everyone seemingly suing everyone else at the slightest provocation, and insurance companies benefiting handsomely from the current atmosphere of fear and mistrust. Recently, the general reputation of the legal profession has been in danger of becoming tarnished as we hear of more and more Members of the Bar using their privileged positions to act on insider stock trading information or otherwise enrich themselves at the expense of others. No matter how we may long for the mythic trustworthy and avuncular lawyer, banker, or doctor, we must face the fact of changing times and adapt accordingly by choosing our professional representatives with the greatest care.

Since there are so very many lawyers around, how should you go about selecting the best one to represent you in a separation or divorce case? Probably the one basic rule is—do not allow your husband to choose a lawyer for you! This is one time when you need a professional who does not know your husband and who can be objective about the issues. Never agree to one lawyer being used as the referee for both sides. You may know someone who is a friend of the family. Do this friend a favor by not involving him or her in the marriage dispute. He or she may have conflicting loyalties and find it hard to separate him/herself as a professional from the marital issues of friends. In fact, it is generally not advisable to retain anyone you know personally to represent you in drawing up a separation or divorce agreement. The reason is that lawyers often have their own hidden agendas when they are in any way personally acquainted with you. They have formed their own opinions as to your personality, your needs, and your intentions. For example, Anne retained the services of a male member of her country club when she decided that her marriage was not salvageable. She did not know it at the time, but the lawyer's own marriage was on shaky ground. How does the conflict of a client's marriage affect the thinking of a lawyer who is considering the termination of his own? In this particular case, the lawyer found his client attractive and entertained fantasies regarding the outcome of her divorce. She reports, "I realized much later, from various remarks that he made, that he had expected me to team up with him afterwards! I liked him, of course, but had never considered him anything other than a friend. I was preparing to get on with my life. I was going to graduate school and making plans to go out and get a job. I definitely wasn't planning on getting married again—to him or anyone else!" Anne's financial settlement was adequate, but not generous. She was the one who took on the responsibility of caring for the children in addition to trying to establish herself in a career. Eight years later, she is still struggling with finances while her former husband, an executive, still lives in the style to which they were both accustomed.

If you are considering divorce, realize that it is possible for a lawyer to be too subjective about your future. His or her unspoken

assumption may be that you will remarry before long, and that you do not need much recompense for the years of unpaid work you performed as a homemaker. What you must also realize is that if you have been home for many years caring for a family, you have not earned nothing, you have contributed nothing to any pension or retirement plan. You will definitely need an advocate who will appreciate your situation and not be affected by any personal ties to you or to your husband.

Should you retain a male or a female lawyer? The sex of the lawyer should be immaterial. You should retain a lawyer who is particularly experienced in divorce litigation. However, if you have a strong inclination toward one sex or the other, let your feelings be your guide. There have been many instances reported of male lawyers expecting or receiving sexual favors from female clients, and, while this is not true of the majority, it is easy to understand that any about-to-be-divorced wife is in a very vulnerable frame of mind at the time of separation, feeling herself to be unwanted or undesirable. Do not hesitate to shop around for the right lawyer. It is essential that you feel comfortable with the person you choose to represent you. After all, you are putting your future in his or her hands at this point. If you don't know where to turn initially, ask friends to recommend a lawyer they know to be reliable and honest, or call a local Women's Center for a referral. Your local branch of N.O.W., the National Organization for Women,* can probably recommend someone in your area. you can also call your state Bar Association for a referral.

Unfortunately, divorce is expensive, except in those rare cases where the divorce is amicable and uncontested. Finding free or low-cost services is extremely difficult, but you might try your local law school, a young lawyer, or a paralegal for advice if you have little or no money. Whichever route you choose, be sure to take advantage of professional advice. Don't try to handle everything by yourself, and don't let your husband do it for you. There are divorce kits on the market for those individuals who are prepared

*See Appendix

to handle their own cases. Even with a kit, however, it would be wise to seek help from a law student or paralegal. Separation and divorce are fraught with emotion, and it is difficult to be detached enough to proceed without professional help, even if you feel intelligent enough to handle all the details.

Lois Brenner is a matrimonial and family lawyer. When asked about women and their options at a time of family break-up, she offered the following advice regarding legal separation and divorce. She agrees that it is essential for every woman to understand the importance of choosing her own legal representative by interviewing more than one attorney and then making a selection. In addition to the state Bar Association Family Law Committee, she recommends the American Academy of Matrimonial Lawyers,* in Chicago, as an excellent source of professional referrals. A telephone call to their offices will provide you with the names of several well-qualified matrimonial lawyers in your area. Once you have the names of several local attorneys, you should make appointments for consultations. At the time of your call, ask what cost, if any, is involved in an initial consultation. The fees are likely to vary from a low of $75 to a high of $300 per hour. Ask each attorney if the consultation fee may be waived or applied against future fees.

Once you have made your appointments, interview each lawyer in turn, and make a choice based upon the attorney's knowledgeability and trial experience, and your sense of compatibility with him or her. Consideration must also be given to affordability and your perception of the attorney's ability to successfully represent your interests. In other words, does this lawyer feel right to you?

Don't forget that you have the right to make a selection, to actually choose the person you want on your side. You need not simply accept someone else's advice, whether friend or family, regarding a professional who is going to become vitally involved with your future well-being. You also need feel no obligation to commit yourself to the first attorney you meet. *You* are interviewing the attorney, as much as *the attorney* is interviewing you!

*See Appendix

If your funds are severely limited, try looking for a legal clinic in your area, where you may be able to obtain a consultation for as little as $25. If you cannot find a legal clinic, call a local college and ask if there is a law school anywhere near your home town. When you have located the nearest school, call its main office and ask to be transferred to a law professor or to someone else who would have knowledge of local legal services. It will take some research, but your determination to find affordable legal representation will pay off.

It is important to understand that you must have acceptable grounds for a legal separation or divorce. These are similar in most states, and include "cruel and inhuman treatment," adultery, abandonment, or "constructive abandonment" (meaning that you and your spouse have not slept together for one year or more). If a divorce is contested, you can expect to be required to testify in order to convince the court of your grounds. Some states merely require incompatibility or irreconcilable differences as grounds for divorce.

When a separation or divorce is contemplated, many women wonder whether they should leave their homes, or stay in an uncomfortable situation. Most lawyers recommend that you stay put, because leaving a home seems to lessen the idea of need. In cases, where physical abuse is occurring, however, this over-rides the wisdom of staying.

Do lawyers recommend that a homemaker/wife who is involved in divorce proceedings go out to find a job? They do not. Ms. Brenner says, "If a wife has not worked outside the home during her marriage, she should keep on doing what she has been doing in order to demonstrate need. Homemakers are at a definite disadvantage. Women in a traditional role have become trusting, and it is a very tough problem. The law does not really do enough to protect them, so I think they must be very careful to do something during their marriage to enable them to have marketable skills. Almost half of all marriages end in divorce, and as much as we hate to think about it, we do have to protect ourselves."

As we know, many divorces are not amicable. If either party is hurt or angry, a divorce is usually contested before it is settled. If there is agreement that both individuals want to end the marriage, it is, of course, less hostile. Often a divorce starts out being contested, and Ms. Brenner feels that an essential part of any lawyer's job is to try to help clients be realistic. She comments, "You have to deal with the reality that a divorce may actually happen. Rather than spending $10,000 running up fees, going back and forth to court, not paying support, being physically abusive, or locking people out of houses, you may just want to look at what the court is going to do eventually and save yourself grief, aggravation and money by trying to be reasonable at the beginning."

Equitable distribution has been in the news since it was introduced in many states several years ago as an effort to award the wife a fair share of community property. Is it working? It appears to be less helpful to women than was originally anticipated, because while courts do evaluate marital property, supposedly making a division of assets that is fair and equitable, they seem not always to make an equal split. Sometimes judges undervalue the contributions of a woman as a wife and mother. Neither do they seem to value home-based contribution to a husband's career with the same weight that they value a husband's contribution in the business world. Divorcing women sometimes find themselves with only 30% of the joint assets. At the same time, however, while women once received long-term alimony, the awards are currently less than they were, the focus now being more in terms of short-term rehabilitative maintenance to enable a wife to enter the marketplace and become self-supportive. Women with children, or women who have been married for many years and who have had little opportunity to develop skills, are often at a great disadvantage because they are being awarded less property and less support than they would have received prior to the adoption of the concept of equitable distribution.

We hear a lot these days about fathers being granted child custody, but in the majority of cases, it appears that children still stay with their mothers. Children over the age of thirteen or fourteen are often asked by the court about their own wishes regarding custody. As to the economic after-effects of divorce, women need to realize

that during marriage a wife is entitled to a share in her spouse's estate, but upon divorce that right is given up. During a legal separation, if a women has substantial assets, she may be well advised to rewrite her will in order to set up a trust before the divorce goes through. After the divorce, another will is in order that would dispose of assets as a single individual, and naming an executor. Whatever the final legal arrangements, after a divorce, most women do experience a decline in their standard of living.

Asked for general advice for any woman who is contemplating the possibility of separating from her husband, Ms. Breener says that most women tend to be too trusting. "I have seen women whose husbands have treated them with a great lack of respect, yet the tendency is still to trust the spouse. For your own best interests, see a lawyer! You really need to find out how to protect yourself before you get into a separation or divorce."

Myra Terry is the director of the Divorce Support Center* in Mountainside, New Jersey. Her organization offers telephone and personal consultation, referrals to lawyers and other professionals, and supportive group therapy. She believes that the Center's services of advice, support, advocacy and referral fill the gap between a divorce client's attorney and her therapist. She initially became involved in divorce issues and homemakers' rights through staffing a hotline more than ten years ago. As she answered questions from women in crisis situations, she began to research information and provide referrals. This led to speaking engagements and eventually to the founding of the Divorce Support Center. Asked if women's questions have changed very much over the last ten years, she replies, "No, but the answers have changed. So much has changed because of the political climate. As women, we're more aware of our rights—politically, socially and economically. However, when it comes to divorce, no one ever thinks it's going to happen to her!"

She says that the national average for divorce is about one out of three marriages, and, in big cities, one out of two, but that if the subject of divorce is brought up, wives deny the possibility,

*See Appendix

saying, "My husband would never do that to me!" Myra agrees that the reality is that most husbands would never do that to their wives—while they're married! She feels, however, that the loving, caring and bonding that exist during a marriage disappear when a separation or divorce occurs because the allegiance and family orientation changes. She believes that this is true not only for men, but also for women who leave. She comments, "More and more women are leaving marriages, but what I still see is that in the vast majority of cases, husbands are going through some kind of midlife crisis and are coming home saying, 'I don't love you any more—I want out!' There's usually another woman involved, and it's very traumatic whether you are leaving or being left. Every dream you've ever had for the future comes to an end. The difference is that if someone's leaving you, there's a heavy piece of rejection to get over. No one is ever prepared for divorce. It's a terrible shock and the fear is, 'what am I going to do with my life?' "

Regarding attorneys, Myra Terry's experience has been that most women do not know how to stand up for themselves, preferring to allow the attorney to make all the decisions. She warns, "Attorneys are not there to take care of you *as a woman*. This is where a woman can get into trouble. She can assume that the attorney is going to do all the right things for her. Attorneys have good intentions, but they see very many clients and they're very busy. I always tell clients, 'You need to know that the attorney is working *for you!* You have to tell that person what to do!' And women tend not to do that."

She feels that fear of loneliness and the fear of becoming destitute are the two most common emotions among divorcing women. She finds that the older a woman is, the harder it is for her to adjust to divorce, because of her fears connected with growing older. She says, "Women believe too much of what society wants to put out. We have women thinking they're over the hill, and that they'll never have a good social relationship, but I don't find that to be true at all. When women are secure and feel good about themselves, there are no limits to what they can do and what they can achieve. They can have relationships—if they want them." She says that one of the most exciting changes she has noted is that many women are

in fact not looking for new relationships any more, and that their focus has changed. They are socializing with other women and going on vacations with women friends. She sees women beginning to take vacations alone, and feels that this is the biggest step of all. "That takes time to get used to. People don't necessarily want to meet members of the opposite sex, they just want to go away and have a good time."

As for the group support concept, Myra says, "A support group is terrific, because women know they're going to get together and laugh! They'll laugh about themselves, speak up about what's bothering them, and they'll leave feeling that they've just gotten that shot they need!" Her advice for any woman who has a friend going through a divorce is, "Be a good listener. And if you're going through the process yourself, pick up the phone and call a local Women's Organization for referral to a support group or similar center. You don't have to battle this one out alone."

If you have decided to separate from your husband because of physical abuse, contact the local office of the Victims' Service Agency* or the local Women's Shelter for immediate advice and assistance. Many wives hesitate to take the first step toward ending an abusive relationship because of feelings of shame or self-imposed guilt. What must be recognized if you are a battered wife, whether the abuse is physical or psychological, is that the situation will not change by itself. Neither will tearful apologies or promises of better behavior make any difference to someone with an abusive personality. Behavior of this type does not just go away, as so many wives and girlfriends hope it will, and the victim is the one who must be determined enough to take action to improve her situation. If you feel that the abuse derives from a spouse's drinking problem, call the local chapter of Alanon for immediate assistance. Above all, whatever the reason, don't continue to allow it to happen to you! If there is no intervention, not only will the danger to your health and safety continue to exist and to affect every aspect of your life, but it may develop as a way of life for your children and

*See Appendix

their future families. Abusive behavior tends to repeat itself from generation to generation, until one wife one time takes the initiative and claims her rights as the equal of those of her husband. Slowly, society is becoming more aware of abuses perpetrated in the name of love, and police departments, which formerly refrained from interfering in domestic violence, are now more alert to the potential dangers inherent in spouse abuse. If you are afraid of speaking up, speak to a friend and ask for help. If there is no Victims' Service Agency near you, check your phone listings or call the telephone operator for the number of the nearest hotline. Above all, put away false pride. Help is available if you will be courageous enough to seek it out.

15

It's Back to Work We Go!

Getting back into the job market.

Midlife is a wonderful time to start a new career. The childbearing years are over for most of us, and the day has dawned when we can make our dreams for ourselves come true. Employers, especially those in big business, haven't quite realized yet what a bargain a mature woman is as an employee. A mature women is highly motivated to get on with her life, she has had enough experience in the real world of home management to know what it takes to run an office or department efficiently, and she is not caught up in the social scene to the detriment of her work. She does not need to take time off to care for sick children, and she is unlikely to become pregnant and require maternity leave. She is reliable and responsible, and less likely to job-hop than a younger woman. These days, a woman of forty who returns to the job market may be expected to contribute as much as twenty-five years to the growth of business.

There is a slow change underway on the part of companies looking for good, capable people, and it is in our favor. The myth about older people being unable to learn is being demolished daily as more and more midlife women, often with business skills that younger women are loath to learn, find their way back into offices, retail establishments and even their own businesses. Undoubtedly,

the more midlife women there are reentering the work force and doing well, the easier it will be for other late bloomers to fight their way back into the job market. A very real problem for many women wanting to return to paid work has been a lack of role models. How many women do you know who have raised a family and then gone on to become president of the corporation? However, look around! The last ten years have brought many changes to the workplace. There are now a good number of your neighbors who have elected to confront the difficulties and get back to work, and you can see their success in action. Knowing that they can do it, will help you understand that you can do it, too.

What are the satisfactions of returning to work? For most women it is an essential step to take for their own and their children's financial security. For others it is more of a personal growth situation, one in which an individual can be tested and challenged. As we have said before, there is nothing like a pay check to make someone feel worthwhile in this society. While some women feel that they are entitled, after raising a family, to take time for themselves and to spend it on the golf course, in restaurants and in stores, many others either do not have this opportunity or tire of this type of lifestyle before long. It is good to be active, to have a structure to life and to be rewarded for our efforts. It is stimulating to be around other adults, those from different backgrounds, living in different neighborhoods, but combining with you to form a working family.

If you haven't worked for pay for many years, you can expect to find big changes in the workplace. Offices, for example, are now fully automated, and carbon paper has gone the way of the clay tablet and stylus. Every task that can be speeded up by electronic means, from copying to pencil sharpening, is now carried out by a gently whirring piece of equipmment. If you haven't been in a corporate office for some time and plan on returning to work in some form of secretarial or other office capacity, ask a working friend if you could meet her for lunch one day — and meet her in her office. You need a quick overview of the latest automated equipment, from the telephone to the computer, otherwise you will be shocked when you set foot inside a future employer's office door.

Remember that electronic equipment looks more forbidding than it is. Computers and word processors are actually making office life easier and the work-flow more rapid. Many women who have had no exposure to word processing equipment find the new systems intriguing once they understand their operation and capabilities. If you are interested in brushing up your old skills and returning to work as a secretary, start by taking refresher courses at your local adult education center. Old fashioned business skills, such as speed in typing and shorthand, are still in demand and with them you will have no trouble in becoming employed. Do not shy away from computers if you have never used one. Take a course to familiarize yourself with what a computer can do and to learn some of the terms associated with its use so that you understand the language. Pre-planning of this kind will bring you as up to date as it is possible to be without actually being on the job, and will demonstrate to a prospective employer that you are moving with the times and are willing to learn. While shorthand is not as much in demand as it was twenty years ago, it is still a marketable skill. In spite of the fact that most managers now have a personal computer on the desk, many bosses still do not want to write their own correspondence and prefer to turn for help to a skilled support staff. You may have an edge over younger competitors for a job if you can spell and punctuate well. As you may have learned from your children's passage through school, the old basics are no longer taught the way they used to be!

If you are accustomed to a certain status by virtue of your social standing, your husband's profession, or the neighborhood in which you live, be prepared for a bit of a let-down when you first go back to work. No woman who has been out of the job market for several years can expect to go back on a senior level, unless she has a great deal of specialized experience—or a friend or relative in the business. Don't be too proud to accept an entry level position when you reenter. It is the first step that is the most difficult. Getting back in is what is most important. Where you go from there is up to you, and the only limits are those you set upon yourself.

When looking for a job, tell everyone you know that you are back in the job market. Everyone—from the mail carrier to your

friends' husbands! Women who have taken time out to raise a family have lost access to the network that exists among working people. Very few jobs these days are filled by means of newspaper advertisements. Most go to someone recommended by someone else who has a job in the same office or the same industry. "How did she get her job? Oh, she knew someone!" is no longer somewhat pejorative. It is standard and it is acceptable. If you were a busy employer, would you want to spend time advertising, receiving stacks of resumes and interviewing? Wouldn't you rather put out the word that a position was open and then have someone recommended to you? This is the way it is done now, in an age when many people work for many employers in the course of a lifetime, rather than staying with one company as it was in the "old days" of a couple of decades ago. So, it is essential for you to put the word out that you are going back to work. This does not mean that you should stop looking in the paper of going to employment agencies. Jobs are still found this way, but what is known as the Hidden Job Market is a larger and more likely source once you find your way in! This is no time to be shy. Speak up and tell friends and acquaintances what you can do. Be as open as possible, with as few set ideas and demands as possible. Be willing to try something new. An openness to new areas, new roles and new ideas is appealing in an employee of any age.

We are moving from a heavily industrialized nation to a service economy. This is good news for women, because we have traditionally been involved with service of one kind or another. Certain business areas have grown tremendously in the last ten years, including fast food, catering and other food-service-related industries. The reason for this has been, of course, women's influx into the job market. Fewer and fewer women are preparing meals at home on a seven-days per week basis. If mother is working outside the home, then new arrangements must come into being, and that is just what has happened. There continues to be a wealth of opportunities in areas such as these and, if you use your imagination in conjunction with your own particular talents, you can probably come up with some new ideas of your own.

If you have, as many women do, an interest in food selection or preparation, look into the possibilities of doing some novel type of catering and begin by joining a local caterer. If you can't obtain a paid position, ask for an internship so that you can learn the business—and then take that knowledge and use it either to gain paid employment somewhere else, or to start your own small business. What have you noticed to be missing from your neighborhood, in the way of restaurants? You have seen the recent establishment of successful Thai, Vietnamese and Indian restaurants with each successive wave of immigration. What could you offer that is different? These days, anyone who comes up with a new idea and cashes in on it quickly, before everyone else, has the opportunity to do very well. What have you ever had a fancy for, but not found? Chances are, you are not the only one to have had this yearning. What could you do to fulfill it? Let's say you have the idea for an Irish pastry and tea shop, or a German sausage and beer cellar, what could you do to bring it into being? Call a friend and brainstorm! Many women have started their own catering business or restaurant on the basis of one good idea. If you are interested in food, but not necessarily its preparation, perhaps you would like to write a column for your local paper, rating the restaurants in town.

As we mentioned in a previous chapter, health care is changing. If you have experience or interest in medicine, in nursing or other aspects of health care, take a survey in your local area to see what shape the care-giving industry is taking. Health Maintenance Organizations are relatively new and need staff, from physicians and administrators to file clerks. Hospital administration is a specialized field which is attracting women. The hospice idea was imported from Europe some years ago. If you want to be involved in a service capacity to those who perhaps need it most, call your local hospice and make an appointment to visit. If you do not require a salary, you may find working as a hospice volunteer extremely fulfilling.

If you are interested in the healing professions but feel that you do not want to undertake many years of training in the traditional fields, then do some research to find out what is going on in the non-traditional areas. Many women are, by nature, caring, touching individuals. What better way to use these talents than by studying

therapeutic massage or physiotherapy? Licensing requirements and length of training vary from state to state, but such a license can be well worthwhile in that you can determine for yourself how much time you want to spend in your official capacity. If you want to work less than a forty-hour week, you can do so with this type of Your Own Business, working as much or as little as you choose.

There are many careers you might want to consider that were not listed in the vocational books when you were in school. For example, some people make a living from astrology or from palm-reading. Something that starts out as a hobby can often become a source of serious income once you have become expert at it. There are various ventures which, if you are enterprising, you might want to think about as a change of pace. For example, do you have talents that could be used on board a cruise ship? The transatlantic liner, the Queen Elizabeth 2, hires shipboard lecturers who are expert in financial affairs, arts and crafts, beauty and fashion, computers, golf, bridge—even Tarot cards—as well as experts in the fields of politics, science and history. Cunard Line supplies five of its seven ships with lecturers, year round. Lectureships are available on a space-available basis and are given in return for transportation. If you are interested in applying for this type of position, contact the Passenger Services division of a shipping line that operates out of the port nearest your home, and ask for the name of the agency* that handles the line's lecture talent. There are no age or sex specifications for lectureship positions and an agency may be open to new ideas. Prepare a resume before you contact the agency, so that you are ready to respond immediately if interest is shown in your letter of inquiry.

Shipboard entertainers are always professionals, and are screened by an entertainment booking agency, so opportunities in that area are very limited. However, if shipboard life really appeals to you, you might want to investigate the possibilities of joining the cruise staff as a children's counselor or hostess, or Social Host. To work as a hostess, you need to be able to interview lecturers, to supervise

*See Appendix

counselors, to speak over the ship's Public Announcement system, to organize parties and other functions and to handle receptions, among other duties. Typing skills and knowledge of a foreign language are an asset, as is former hotel experience. Cruise and Social staff qualifications may include sound and lighting experience and the ability to ballroom dance with passengers! Positions are limited, but do not let this deter you. If you are interested in learning more about Cruise Staff, hostess, steward or purser positions, contact the shipping line's Personnel Manager for On-Board Staff.

The concept of free-lancing, as in the role of a shipboard lecturer, is growing and will continue to do so as long as companies continue to balk at spending increasingly large amounts of money on pension plans, medical benefits, vacations and other perks for their employees. Free-lancers and consultants are becoming increasingly desirable to firms because they do not require as much in the way of bookkeeping and other incidentals of time, money and energy that are necessary for full-time staff members. If you have the desire to work independently and you possess a skill such as writing or graphics' design, you can put together a sample portfolio of your work and go after assignments from local businesses. Women who are self-motivated and self-disciplined make excellent consultants. If you decide that this way of life sounds right for you, be sure to speak to other consultants to determine a suitable price range for your work before you start your rounds. Women have a tendency to underestimate the value of their work, so practice saying "I charge one hundred dollars an hour" well before you go into any prospect's office!

There are thousands of ways to earn money for yourself. At this stage of life, we all need to learn how to expand our horizons by asking questions, reading, exploring, questioning old values and beliefs, and opening up to new ways of thinking and acting. For example, in your wildest dreams, have you ever thought about appearing on television? Have you noticed how many television commercials these feature Real People? Have you ever wondered how those Real People were chosen for the commercials? Chances are that they were not picked up off the street, discovered by an alert talent scout. It is much more likely that they looked at a television

commercial one day and said to themselves, "I could do that!" If you can imagine yourself performing a part on the television screen, selling anything from automobiles to washing machines, you can, with sufficient determination, probably make that dream come true. Frank Spencer, an actor and teacher of aspiring television commercial actors in New York says, "It pays to have a thick skin. This is a rejection business. Take the rejections and keep coming back so that you show you're serious. You have to be a hustler, and in this field, the major payoffs are extremely large, but the numbers who get there are not. However, you can make a decent living without being a star. If you can walk and talk and remember your lines, you've go a job!"

The cost of training at a school which specializes in teaching the art of television commercial acting is roughly $500.00 for a thirty-hour course. If you live in a small town, Frank Spencer suggests that you contact your local drama coach or the local chapter of SAG-AFTRA*, and ask for referral to an appropriate instructor. The next step is to prepare a resume and to have a professional photograph taken, one that will become your selling tools to agents or producers. Frank recommends that you find a photographer who knows what "commercial head shots" are. A commercial head shot is a very special look. "It must be warm, friendly and look like you. Not glamour, but personality must pop out of the picture." As for resumes, he adds, "Most people will say, 'I don't have anything to put down!' There's an art to creating a resume where material is thin. Don't undersell yourself! Let's say you're from Cedar Rapids, Iowa and you were once on a cable show. On your resume, under the heading of TV, give the title of the program. List the title only—don't embellish. Let them ask you questions later, once they see you. Don't reject yourself!"

After sending out your resume and head-shot, he advises that you follow up with phone calls periodically and, sooner or later, you will land an audition, where you will work either from cue cards or a script. In addition to the television commercials with

*See Appendix

which we are so familiar, there are also "industrial," organizational or corporate films made for training or sales purposes, which are growing in popularity and require believable people. Frank suggests that you "get experience on your feet" through your local Toastmasters' Club, where you can get the practice you need in speaking before a group or before a camera.

If you are interested in this field, speak to as many actors as you can find, check local theatres for producers and directors, and subscribe to a monthly bulletin called Ross Reports* which will keep you up to date regarding the television business. More and more movies are being made in towns and cities throughout the country, instead of on studio lots. You might want to consider becoming an extra, a non-speaking actor. If you live in Los Angeles, contact the Screen Extras Guild. In other big cities, check the local casting agencies.

What if you are one of those talented women who has always dabbled in music or in writing poetry? Have you ever thought about writing a hit tune? If this appeals to you, listen to what is being played on the radio today. Check the listings of the Top Ten to discover what is popular now. Try to be analytical. The same emotions still hold true—"I love you", "I miss you", "I need you", "Where are you?"—but the styles vary. To write a successful song or to write a successful book, you must do some research first. You need to know what is selling, and then try to determine why. Remember that we are focusing on doing something not only for pleasure, but also for profit. You can write the most beautiful poem in the world for your own delight, but if you want to sell it, you must understand the market.

When you have done your research, you will need, in the case of a song, to copyright your original material with the Library of Congress* and then have a demonstration audiotape made. This will involve hiring musicians and a singer and renting a studio. Count on studio rental time not only for the recording, but also

*See Appendix

for prior practice. You can anticipate that a demo-tape will cost you $400–$500. Once you have your tape, send it to a performer or group you admire, and hope for a sale.

If you have written a song, a poem, a short story or a novel, copyright it immediately, before submitting it to a literary agent for consideration. It is better to be affiliated with an agent than to approach the publishing houses directly, or "over the transom," because your work stands a better chance of being read. The writers making the most money appear to be the authors of popular romance fiction, but beware! There is an art to this art. Most publishers prefer their authors to work from what is known as a Tip Sheet, in which the major characters, their roles and relationships are quite standardized. The publisher knows what sells and prefers not to gamble. If you think that you want to try your hand at making money this way, first do your homework by reading a selection of books from your local supermarket or bookstore, and then write to several publishers, requesting their Tip Sheets. You could do very well if you don't object to writing to formula.

Bear in mind that the income-producing areas we have mentioned are not bound by parameters of age or sex. You can be a writer at any age. You can lecture on a cruise ship at any age. And there is another area in which your age and your sex will work to your benefit, and that is in Real Estate. There is an organization called American Women in Real Estate. Contact them for information about the field. If you want to make a lot of money, don't think solely in terms of showing and selling houses to families. Think of commercial Real Estate and sell buildings to corporations instead.

At midlife, the most likely way in which you can make a lot of money is by running your own business. The fastest growing segment of business in the United States today is woman-owned business, and the reason for this is that women are beginning to realize that if we are to have a real share of the economic pie we must live by our wits and be entirely responsible for our own future. Many women who have been in business for years, along with some who have reentered the job market more recently, have come to understand the nobody else is anxious to promote them to really high places. Bright, capable women are still perceived as threatening

to the established order and most businesses do not feel it appropriate to have a woman at the head of the company. This attitude, and the awareness of its reality, is leading increasing numbers of women to go it alone. Primarily through loans from family and friends, women are drawing up business plans and starting their own empires. Would this be the right move for you?

If you have ever dreamed of owning your own company, the most important question you must answer for yourself is:

- Am I a decision-maker? Do I enjoy making decisions and acting upon them? If the answer is yes, you next need to ask yourself:
- Can I make decisions without having all the facts?
- Can I work independently?
- Can I work without supportive feedback from others?
- Can I handle rejection?
- Do I like to win?
- Am I persistent?
- Am I creative?
- Do I use my intuition?
- Do I know people who have the skills I lack?
- Do I know what skills I lack?
- Can I access enough capital to live for one year without making a penny?
- Do I want to be my own boss so badly I can taste it?
- Am I able to ask for help when I need it?
- Can I overcome setbacks?

Once you have honestly come up with affirmatives to these questions, then you can feel excited and right about taking the big step! First, seek advice from people you really trust. (Be prepared for a negative reaction from some friends and relatives because they may relate your ambition to their own lack of initiative and find it quite threatening.) Secondly, approach an organization like the American Women's Economic Development Corporation*, which

*See Appendix

was established to advise new and prospective women business owners. Your state may have a regional government office that is set up similarly, and most states have a Small Business Administration office to which you can apply for help. Women are considered Minority Business Owners and can make use of certain "set-asides" and special programs designed for minority group members. Call your local legislator's office for information if you are unable to find it yourself. Your biggest problem, once you decide to go ahead, is likely to be raising capital, but with sufficient determination and research, you can track down all possible sources of short-term loans to finance your dream. Most advisors will tell you that the likeliest source of financial support will come initially through the FFA—Family, Friends, and Acquaintances!

Lillian Katz, the wizard behind the hugely successful Lillian Vernon Corporation, started her company on her kitchen table, when she was pregnant with her first child. Her original intention was simply to add to the family income. Starting with $2,000 of wedding gift money, she purchased both some supplies and a small advertisement in a national magazine, and offered personalized handbags and belts for sale. She says that she chose the mail order business because it was a way she could work and be a mother at the same time.

Incredibly, within six weeks of her first advertisement, Lillian had received $16,000 worth of orders, and, as we know, since then she has gone from strength to strength. Revenue for her mail order catalogue in its most recent quarter has jumped by almost 15% from last year, and the business does over $115 million per year. What are the reasons for her success? The primary reasons seems to be that she really cares about her business and her customers. She says that her motto is, "I never sell anything I won't have in my own home." Additionally, she works very hard, spending sixteen weeks a year away from home, on buying trips around the world. And, just as importantly, she is not afraid of making decisions. It is said that she can cover a trade fair, an enormous complex of booths and merchandise, in a few days, and decide on orders in

minutes. The company's mail order catalogue reflects the home-oriented quality of her own personality. The focus is on gifts and on items that will make a woman's life easier in one way or another, reflecting the zest of a woman who cares about her customers.

Perhaps the single most important factor of Lillian Katz's success, however, is that she has chosen to spend her life doing something she loves. This is true of all really successful entrepreneurs. They listen to their intuition and allow it to lead them into a career in which work becomes play, and play becomes work; a career in which those two elements intertwine. Why shouldn't life be spent doing what we love to do? So many of us have been taught in subtle ways that work is something divorced from pleasure, just a way to pass the time from paycheck to paycheck. The truth is that doing daily what we love to do, makes us happy, and happy people radiate that happiness and satisfaction to those around them. Why not follow your instincts and use your uniquely personal talents to create a business of your own? The most likely conditions for success are these: you must be able to get in touch with exactly what it is that you most enjoy doing; you cannot allow yourself to be sidetracked by thoughts of what you or others think you should be doing; you need to perceive what you enjoy doing as having value for a segment of the public; you must be prepared to take risks, overcome rejection and handle setbacks; and you must be ready to motivate yourself to work diligently and long. If you can meet conditions like these, and believe wholeheartedly in your own capabilities, then you can prosper both yourself and others!

We are limited only by our own thoughts and fears. Any woman, at any age, can make her own way in this world, if she has the imagination and the determination to do it. If you can see yourself as a success, you have the ability to become a success! Some people's lives have been turned around by participating in something that scares them, and proving to themselves that they can overcome the fear. If you have a fear of water, for instance, consider taking a sailing course! Sailing courses for women only are being offered by Womanship Waves*, a Baltimore company founded and operated

*See Appendix

by women. Even walking on fire is popular now! It has been proved that, with a couple of hours of motivational coaching, individuals can actually walk on burning coals without scorching their feet. Tolly Burkan, one of the pioneers of this challenging event, is a man who, when young, attempted suicide twice, but who has subsequently survived a bout with cancer by actively and intensively visualizing the cancerous tumor in his body dissolving. He claims that once you know you can walk on fire, you know you can do anything at all!

You may not feel that you need the experience of facing up to physical danger in this or any other way in order to compete as an income-producer. We do need, however, to conquer whatever seems to be holding us back by recognizing our apprehensions and facing them with courage and determination. If you need more than a basic wage to survive, allow yourself to realize that not only are you capable of earning more, but that nothing is going to stop you from doing so. You may need to join a group of women who have similar goals. If you can't find a group, start one! Form your own network. Women understand each other because, even though our individual experiences may differ, there are too many commonalities for us to ignore. We are all learning the ropes, and as each one of us bends down to help the other, we all climb up.

If you do not want or feel ready for a job, consider going back to school. Or think about going to college for the first time. Or decide to finish high school by studying for the High School Equivalency examination. Wherever it was that *you* stopped your academic learning, take it up again. The days of colleges being filled only with young people are over. Colleges are now marketing institutions looking for customers and are welcoming mature students, both male and female. If you have no idea where to start, go to the research section of your local library and look through the local college catalogues or Adult Education brochures. Call a school that interests you and ask for an appointment with an advisor. Don't be shy about being a mature student. You are not going to raise anyone's eyebrows on campus anymore, because so many midlife women have taken this route already, knowing that to be competitive in the marketplace, a woman needs as many academic credentials

as she can get. Start slowly by taking one course, so that you can get the feel of being back in school. As with everything else, the first step is the hardest. Once you are back in the classroom you will feel that time has stood still. Tucking your books under your arm and crossing the campus with new friends will make you feel younger, more alert and more confident.

If you are unsure about which to do first—to look for work or go to school—you might want to combine volunteering in a work environment that interests you, with auditing one or two academic courses (attending without being graded). It is difficult to return to school with a clear focus on employment if you have no current or recent work experience, because both the language and climate of work have changed a lot in recent years. If you tackle both work and school by combining the relative flexibility of a non-paid employment position with the non-exam, non-credit demands of a one or two-course academic load, you will gain a great deal of experience without taxing yourself too much too soon. You will also learn which way you want to go, whether it is full-time school, full-time work, day-job and evening-school or some other combination. Don't be afraid to ask for guidance from the college admissions office. Counselors there are trained to help people like you.

If you think you are too set in your ways to get up and go off to school, consider the history of Valerie. As a married woman of fifty, she decided that she was tired of being simply her husband's assistant in his law office. She applied to law school and began the demanding task of studying to become a lawyer herself. She did extremely well and, after four years, having completed the course load and passed all necessary examinations, she was admitted to the Bar. She and her husband worked as law partners until his death following complications resulting from heart surgery. Now she runs the law firm herself, specializing in divorce cases. What if she hadn't taken that untraditional step of entering graduate school at a late age? What if she had listened to all those friends and neighbors who told her that Law School was too tough, too much work? What would she be doing now? Chances are that she would have settled for a slow-paced, quiet life as a suburban widow. While for some women, this would seem to be enough, for Valerie it would

not have been a satisfactory answer. She is very intelligent, very energetic and very up-to-date. Becoming a lawyer has not prevented her from continuing her personal interests, and she manages to find enough time to serve as president of her local church congregation. The old truth still holds true. We find time for exactly as much or as little as we want to do!

You can go back to school or work if you really want to. You can design a freelance job if you really want to. And you can start your own business—if you really want to. You simply need to remember two things. *Number One: the ideal job for you is out there somewhere. Number Two: it won't come looking for you— you must go out and find it!*

16

Home Is Where the Heart Is

Finding affordable ways to live.

Reaching the middle or late-middle of life often means an uprooting from familiar places. Divorce or separation can mandate relocation to a smaller home, often with children, while widowhood sometimes leaves a woman in the situation of owning a home on which the mortgage and utility payments are no longer affordable. Women who find themselves without access to pension plans, and who are too young for Social Security can face difficult circumstances when it comes to paying all the family bills. The cost of housing has escalated alarmingly in the last five years throughout the country, and insurance benefits that had been thought ample to cover the cost of shelter for surviving spouses often turn out to be inadequate. Even if this situation has not happened to you, now may be a good time to look at the cost of your current housing and to find out if it will continue to be affordable to you in the future, in the event of any changes in your domestic situation.

If you are a married woman and you do not already know your fixed monthly costs, ask your husband what the dollar amounts are of the mortgage (or the rent), the gas and electric bills, the telephone bill, the car and gasoline payments. Make yourself as knowledgeable as you can about all the monthly or annual debts involved with occupying your particular living space. If you have

a second home, take this into account, too. If you own your home, is it listed in both names, yours and your husband's, on all deeds and other legal documents? The more informed you become now, assuming an intact and stable marriage, the less likely you are to be overwhelmed if the marriage ever ends. Could you afford your home if your husband were to die or to leave you? Don't be afraid to ask about the insurance that is currently in effect. Is it sufficient to cover anticipated increases in cost of living, rental rates, or other variables? In most cases, we outlive our husbands and asking such questions is not morbid, but realistic. Your goal is simply self-education.

What if you do find yourself in the situation of suddenly being alone and unable to afford your rent? What action can you take? It appears likely that our accustomed style of living, one family per home-unit, is going to be undergoing substantial change in the next decade. Because the cost of housing has risen so sharply, many people find themselves in the situation of owning a piece of property that has increased tremendously in dollar value, but when looking for a smaller property with which to replace it, they find that the price of a much smaller home is just as high! Many widows have had this experience. Additionally, younger people these days find it harder to buy that first home because of the high cost. A first home now requires two incomes, rather than one.

If shelter is becoming too costly for both the young and the old, what's to be done? One trend may well be that of home-sharing, a concept of community living that spreads the expenses out among several compatible people. For example, if you are a widow living alone in a big house, saving rooms for visiting family and friends, ask yourself if you wouldn't be happier sharing your home with other women or with a young couple with a child or two. You could either become a landlady in your own home, or you could sell shares in it. If you decide to consider the latter, be sure to seek legal advice before making any commitments.

Another alternative would be for a group of friends who find themselves in similar circumstances to purchase a home together. A typical row house in a city could provide four or five separate apartments, a whole floor for each buyer. In this case, you would

first form a legal entity, a partnership, before making your purchase. This type of arrangement solves several problems at once. It makes the purchase (rather than the rental) of a valuable property possible, because the expense is being divided among three, four, or more individuals. It means that if privacy is important to you, you can have it. At the same time, however, you are surrounded by others you know and care about. Ideally, a situation can develop in which you have both intimacy and privacy—as much or as little as each person wishes. There have to be ground rules, of course, but such a mini-community, or restructured family, can be very emotionally satisfying. The property you buy in this manner can be reasonably expected to maintain or to increase in value. Since one partner may want to sell her or his share before another, it is essential that the legal agreement be designed to cover this type of possibility. In an age when families often split by divorce or geography, or both, this type of arrangement can provide the comfort and security that has evaporated with the changes in relationships. If you are a mother or grandmother whose special people are scattered across the land, sharing your home with younger folk may provide you with an alternative form of connectedness. If you are a single parent, why not buy into or share rental of a larger space with another single parent? It is possible to form a loving family group through alternative living arrangements, not as traditional as the Nuclear Family perhaps, but just as real.

If you cringe at the thought of having a roommate after all these years, and feel that you would be going backwards if you shared, realize that you are not the same you of twenty years ago, and neither is anyone else. The squabbles and hard feelings that may have accompanied dormitory living are not to be anticipated as a necessary component of sharing today! By forty, you have faced many challenges and gained an immeasurable amount of experience. So have others. By using your feelings, rather than criteria of age, sex, profession or education as guidelines, you will be assured of a relatively harmonious relationship that could be a source of continuing pleasure and satisfaction.

On the other hand, if you find yourself in the position of having change forced upon you, why not give some thought to living somewhere else—in another state or even another country? Perhaps a change of scenery and lifestyle is just what you need to lift you out of your current situation, especially if you are finding it a little bit dreary. We tend to hang on to what we know out of a false belief that our security lies outside ourselves. People stay in the same home for years, surrounded by the same furniture, the same objects, eating the same food and drinking the same drinks. Not out of desire for any of these things, necessarily, but rather out of inertia. It isn't always bad to have change forced upon us. It often gives us an opportunity we would otherwise never have to look at our situation, analyze it, decide if we really like it and, if not, to do something about it.

How would you feel about living somewhere else? Is there any particular place you have often wondered about, or any town you have visited on vacation that has lingered in your mind? Have you ever wondered what it would be like to live in one of the most exciting or one of the most beautiful spots on earth? After all, people do live and work year round in the Caribbean, in Mexico, in Hawaii, in all those wonderful places that most of us just visit once in a while, if we're lucky. If there is a dream lurking in your mind, why not release it from the dream state and take a look at it in the clear light of day? Would you consider visiting your dream city or picturesque village on your next vacation and asking people who live there what it is like as a place of permanent residence? If you can afford it, take a trip and use your visit to price housing, investigate job possibilities, and inquire about schooling, if necessary. If you have children and hesitate to move because of them, ask them how they would feel about it. Many mothers assume that their children would hate to move, and do not get as far as asking them. If this has happened to you, ask yourself if it is really your child's opinion that is molding yours, or if you might be using it as an excuse to remain immobile. Children adapt faster than adults to many kinds of experiences, including moving and finding new friends.

Think about the possibility of moving to a foreign country. A sojourn abroad would give you the opportunity to become fluent in a second language and to experience another way of life. As with other fresh starts, a move like this would rejuvenate you and give you the opportunity to look at life from a different perspective. Living abroad can be less expensive than it is here in the United States. For example, it is currently possible to buy a house in Costa Rica for $10,000.00. The weather there is delightful, the government appears to be stable, and foreign residents are treated as well as native citizens. If you live in the cold northeast, consider Mexico. If you feel more adventurous, consider Portugal or Spain, popular as retirement areas because of their climate and cost of living.

A move doesn't have to be a permanent commitment. You might want to consider renting out your home for a year or six months and exploring what daily life is like on the other side of the globe. With the cost of housing as high as it is today, your rental income could pay for your trip, if you plan wisely. If you have a hobby such as writing or photography, you could use this sabbatical as the basis for future magazine articles or even a book. Find a focus that is different and pursue it! If you are a city-dweller who has wondered about rural living, look in your local bookstore for a Bed and Breakfast or Home Exchange guide. Even a sojourn of one months' duration can answer a lot of questions you may have about the possibility of living elsewhere.

The most important aspect about living arrangements is to keep an open mind. Remember that the world does not end at the corner of your block! The National Shared Housing Resource Center* in Philadelphia is an organization that was founded in 1981 to assist in increasing the availability of shared housing programs throughout the United States. The Center's definition of shared housing is, "A housing arrangement in which two or more unrelated people pool their personal, financial and physical resources and share a dwelling. Each individual has his or her own private room, but shares common areas such as the living room, dining room and kitchen."

*See Appendix

The Center states that formalized shared housing programs have increased threefold since 1980, reflecting the current housing crisis, a crisis which adversely affects a disproportionate number of women and older individuals. Many people, wishing to return to a form of family-style living, are taking advantage of professionally organized programs rather than sharing informally. Currently, there are more than 400 shared housing programs operating in thirty-eight states.

Two types of shared housing services are offered by programs affiliated with the National Shared Housing Resource Center. A Match-Up program matches homeowners who have vacant rooms with individuals who want to rent. Both parties are interviewed by the home-sharing agency and then matched according to their common needs, interests and preferences. Many matches are intergenerational. A Group Shared-Residence program puts together four or more unrelated individuals. They share a house operated by a sponsor such as a church, temple, community housing group, government agency or an investor. Shared residences usually fall into three categories: a resident-managed household, a minimally-serviced household, or a service-intensive household, and individuals are carefully guided into the most suitable arrangement.

If you think you might be interested in the concept of shared housing, you can become a member of the National Shared Housing Resource Center for an annual fee of $35.00. Membership entitles you to a one-year subscription to the quarterly magazine and two telephone consultations. You may contact SHRC for a copy of the national directory or a listing of state program. If there is no program near you, you may want to think about pursuing homesharing on your own. If so, contact SHRC for its "Self-Help Guide for Homeowners and Renters."

If you decide the share housing costs with someone else, you will probably find that you are in the vanguard of a new national movement, a change in lifestyle. Individual housing may well become a luxury that we remember fondly. The current concepts of condominiums and townhouses point to an alteration to the familiar detached house, single-unit housing style. Sharing will be different, but it can, like any other change, be a very positive and

happy experience. As one woman describes her situation, "Like many women, I faced the dilemma of not being able to afford my own home any longer. I chose instead to share my house with others and it has been a wonderful experience. I think we are very compatible. I really don't like living alone—I prefer living with other people. I had lived on my own for two years and found that I was more family-oriented. We're on equal grounds with one another. It's a very brotherly and sisterly relationship."

So, consider the many possibilities there are in moving and/or in sharing. And, when you think about the annual cost of shelter, remember that warm, sunny areas of the world will cost you less year round, because you will save on the costs of clothing (you won't have to heat the house) and possibly vacations too—since you won't have to travel to find the sun!

National and Global Perspectives

17

What a Wide and Wonderful World We Live In!

In surveying a diverse group of women before writing this book, we found that many of them were concerned not only about their personal and family lives and their own economic well-being, but also about the conditions of the towns they live in, the state of the nation and the future of the planet. This concern was expressed in a wide variety of ways:

- "World situation—will we live to see the 'future'—because of nuclear threat."
- "Powerlessness to have impact on world community."
- "Pollution of air, water and land."
- "An increasingly alien world society in which it is difficult to belong."
- "Corruption in government."
- "Lack of morals in today's society."
- "Drug addiction in young people."
- "World problems and what I can personally do about them— the nuclear arms race, world hunger, women's rights and equality issues."
- "People's behavior toward each other."
- "Television violence."

- "Crime."
- "Pessimism."
- "Homelessness. All those people I see lying in the streets and the parks."
- "Future in store for grown children."

and

- "Peace in the world."
- "Hope for the future."

Women, as a group, care. We care for and about our husbands, our children, our parents, our friends, our neighbors, our jobs, our environment, our country, and our globe. We also care about those less fortunate than we are. We care about our relationships at work. We care about the past, and we care about the future. Many of us feel intensely about the way things *should* be, about justice and about ethics. Women have sometimes been accused of feeling too much and thinking too little. When it comes to feelings, however, we often feel powerless and believe that there is nothing we can do to bring about beneficial change. Is this true?

We have a right to wonder what the world would be like with more female judges, doctors, professors and politicians. Many of us believe that it would be less dangerous and more humane. We have to face the fact, however, that although there has been an increase in the number of women in positions of official power, it will require decades of similar progress at the same speed before there are any noticeably genuine changes, such as a decrease in television and movie violence, a reduction of armaments worldwide, and an increase in respect for women's intelligence and capabilities rather than looks. We still have a long way to go.

Nevertheless, one woman can make a difference! Every woman can make a difference. What can you do to have an impact on your world?

It is our hope that today, if you have used the exercises in this book to explore your feelings, your motives and your desires, you will know yourself somewhat better than you did yesterday, and that you will feel more confident about yourself and your abilities. Knowing more about yourself will enable you to decide what steps

you want to take in order to make your personal difference to your environment. But first you need to know what it is that *you* think is wrong with the world. Of the quotations listed on the previous page, which one rings a bell for you? Not one of us can hope to tackle all the problems in our world, but each of us can select one area, scale it down to a manageable size and try to effect positive change.

An example, if the subject of homelessness upsets you more than any other, what can you actually do to help solve the problem? Here are some suggestions for research:

- Call your local church or temple to find out if it is offering shelter at night to local homeless people.
- Is there a soup kitchen providing a nourishing meal at mid-day?
- Is the church or temple collecting and distributing clothing or blankets for the homeless?
- Call your local legislator's office to find out what is being done by your elected representatives in this regard.
- Contact your local mental health association. Do they need volunteer counselors for the street people?

If nothing has been organized in your neighborhood, offer your services to a church or community service organization to take charge of a segment of a project to help the homeless. You cannot tackle the whole problem by yourself, but you can select an area of particular interest to you, whether it is collecting food, cooking, serving or delivering food, soliciting local merchants for donations of clothing, or contacting the street people themselves.

If you are most aroused by the incessant use of violence on television, why not:

- Write to the producers whose names are listed among the credits at the end of each program, protesting unnecessary violence in their program.
- Keep track of the number of shootings, stabbings or killings shown on one television or cable channel in the course of one evening, one week or one month and complain to the president of the network.
- Complain to the Federal Communications Commission.

- Write to your legislator.
- Do some research to discover if there is a local or national group of people who think the way you do about this. If you can't find one, start a group of your own. There is always more strength in numbers, as we can see in the striking success of groups such as Mothers Against Drunk Drivers*. Why not pull together a new group and call is W.O.T.V.—Women Opposed to Television Violence.

If you have a talent for writing, use it to express your outrage at the misuse of animals for research, the abandonment of babies, or the pollution of our rivers. If you have a talent for organizing and motivating, create a task force to study ways to improve conditions where you make your home. Find other people who believe as you do and join together to bring about positive change in your community, in whatever ways are most meaningful and important to you. If you don't know such people, place a small advertisement in your local paper, asking for other wild-life lovers, toxic-waste haters or bureaucracy-questioners to contact you. Be an initiator! Don't wait for someone else to solve the problems that bother you! It is possible that someone else does not notice the problem, doesn't want to see it, or is suffering from inertia. Why don't you be the one to galvanize others and bring about change?

It is not essential that there be any obvious problem to solve. For instance, what can you do, in your own way, to bring about some lessening of distrust and suspicion between people of different backgrounds or from different parts of the world? Would you consider opening your home to a foreign student for a summer, a semester, or a school year? If you are interested in one-to-one diplomacy, call your local school to find out if the school board sponsors any exchange programs. Look in your local telephone book to see if there is an organization that handles exchange visits. If there is none, why not start one? Perhaps there is a need for a Senior Exchange on a single or couple basis, an international cultural

*See Appendix

exchange for people of retirement age. Could you organize a consultancy or small business that would enable retirees in different countries to exchange homes for a month? There is nothing more effective than citizen diplomacy to create more goodwill in the world. Fear of what is foreign or unknown can always be replaced by understanding and even affection once the *strangeness* is translated into personal terms.

Too often, we sit back and complain that we do not like things the way they are, yet we take no steps to bring about any change. We feel powerless. But we are not! Consider the Women of Greenham Common, Englishwomen who banded together to oppose nuclear weapons and who picketed the military base at Greenham Common, day and night, standing up to both police and political authority. These women were not sophisticated, politically savvy militants. They were women who didn't want nuclear weaponry in their back gardens, their community, and who were brave enough to say so. Remember the Irish women who marched for peace in Ireland. Remember the slogan, "War is not good for children and other living things!" That slogan originated in the mind of one individual. Who knows how many people it affected?

We may declare that The Troubles still exist in Ireland, and that nuclear disaster could still erupt on English soil, and that no difference has been made by these concerned individuals. But this would be untrue. Even if these women's actions have increased just one person's awareness of the dangers of hatred and fear and how these emotions can escalate so easily into violence, then their courage has been worthwhile. The truth is, however, that many thousands have been inspired by a single woman, a Mother Theresa in India, caring for the hopeless and loveless, a Clara Hale in Harlem, tending to the babies born of drug-addicted parents or an Elisabeth Kubler-Ross opening up dialogue and understanding by working with those near death.

One single woman taking a stand against injustice and offering love can never know how many lives she affects. It is impossible to count the ripples spread by a single small pebble. Never feel that one individual standing alone for what is right cannot make a difference! If you want to see changes in this world in which

you live, this world you love, then look around, decide just where you choose to make an impact, and start today! Don't wait for tomorrow. Don't wait for someone else to do it first. *You* be the one to say, "This needs fixing. I'm going to fix it!"

For example, if you are a woman whose primary role of caregiver has been diminished by the marriage of children, or their departure for college, and whose own marriage has ended, but feels a need "to do something worthwhile," have you ever considered joining the Peace Corps? Begun under President Kennedy, the Corps is still quietly but vigorously active in many countries around the world, and recruits not only young people fresh from college, but mature volunteers, too. Ardath Cifuni, for example, joined the Peace Corps some time after her retirement from the teaching profession. Her decision to engage in work far from home for little money, was not a hasty one. In fact, she and her husband, the director of an urban community center, had discussed such an undertaking many times and had planned to join the Corps together, upon their retirement. His death, however, forced a change in his wife's plans. As she describes it, "When I joined the Peace Corps, I was 65. My husband and I had been talking about joining, influenced, you know, by the beginnings of the Peace Corps. Unfortunately, he died before he retired, and it took me a few years to adjust to that."

Having spent a lifetime as an educator, Ardath knew that her skills and training would always be useful somewhere, but when she first retired, she was not sure exactly where to put her talents to best use. Her initial idea was to teach English as a Second Language, and she signed up at a local university to take the appropriate courses. Her thoughts, however, kept returning to those old dreams of the Peace Corps, and she decided, at the age of 65, that she wanted a change of scene.

She applied to the New York Recruitment Office of the Peace Corps in January, 1982 and was qualified to two programs: Teaching English As a Second Language, and Teacher Trainer. He application was processed, and on her sixty-fifth birthday in April, she received the official Letter of Invitation from headquarters in Washington, D.C. announcing her assignment to Sierra Leone, West Africa as a Teacher Trainer.

After one week in Philadelphia, meeting the other trainees in her group of sixty, all of whom were going to the same country, she left for West Africa and additional training.

Ardath, who is now back in the United States working as a recruiter for the Peace Corps, explains that training differs from assignment to assignment, depending upon the specific job to be done, the terrain, and the social customs of the host country. Her own program included six hours of language instruction each day, along with technical and cultural awareness training. The importance of cultural awareness was strongly emphasized, covering many important aspects of religion, politics and tradition. She describes her training this way. "The first week in Philadelphia was really a looking at yourself, making sure this is really what you wanted to do. They had trainers from the country come over, and tell us about the place. They too were looking at us and how we reacted to certain situations.

"Then the first week in Sierra Leone, we were at a college campus, which is a little different from a college campus here. We were there for a week and we started the three aspects of training, namely native language, technical training—meaning how you do that specific job in that country, what facilities they have, what they expect of us—and then cultural awareness of the beliefs, the religion, and the politics. After that first week we were taken to a very small village with no indoor plumbing and no electricity. We were taught how to wash ourselves with a bucket. In the village we each had a room which was part of a family's house, but it was a private room for ourselves. Peace Corps had also brought in their own generator so that we would have electricity at night. And we had very intense training from seven o'clock in the morning to nine or ten at night. It continued the three aspects of the program, plus the doctor coming back and telling us where he would be stationed, when he would come to visit us, and so on. He did not come to visit us personally, but once a month he would come to visit different areas. It was amazing to me that after a week or so all of us, including the seniors, began to be very comfortable with the lack of amenities, because you sort of expected it as part of the culture of the country you were in." It was during this part of the training

program that some of the trainees (those who were to help in the Primary schools) were asked what type of area they would prefer living and working. Ardath requested that the site be in a small village rather than a large town or city because, having done some traveling, she felt she would have a better opportunity to really get to know the people and begin to understand their culture in greater depth in that type of situation.

After three months' training, Ardath was assigned to her small village. "When I was sent to my site, the villagers had cleaned up a little mudbrick house for me and had built a latrine for me, and put in a seat! That was great—I loved the village immediately!" Her gray hair has proved, she believes, "very beneficial."

After five or six months, during which time she visited all the schools in the surrounding villages, organizing workshops, conducting demonstration lessons, and watching the teachers conducting similar lessons, she was invited to move down to what was called the Teachers' College. Finding that the college differed greatly from an American version, because it did not teach how-to-teach, she helped to organize a curriculum on teaching methods. She stayed at the college for two years, the standard length of a Peace Corps assignment, and was then asked to stay for an additional year—which she willingly did.

She says that she enjoyed her time in Sierra Leone immensely and would recommend the Peace Corps (or PC, as it is known to its members) to anyone. Joining was not a career change for her, nor a finding of herself. As she puts it, "I had found myself some years before. I already knew who I was!" She would like women to understand that the Peace Corps actively recruits not only "seniors" (people over 55) of both sexes, but also women of any age who may feel that they have little to offer in the way of experience. Anyone who has a college degree may apply, but degree-less women who have stayed at home to raise a family will be considered for Home Economics or Nutrition extension programs. Literacy is a necessity, and a background in any other language, especially Spanish or French is a great asset.

Some sixty countries in three areas of the world curently welcome Peace Corps volunteers. Assignments are possible in three major areas: Africa, Latin America, including the Caribbean, and the Asian Pacific. In every country there is a Peace Corps office in the capital city, and there is an evacuation plan so that in case of any emergency, volunteers would be immediately taken to the American Embassy. The Peace Corps has "scarce" area assignments in agriculture, education and the skilled trades. A new emphasis is put on the area of expertise in Small Business Management, because many of the Third World countries are now interested in marketing something they can produce, such as native crafts. The teaching of basic business skills is another major focus. Volunteers may express a preference for placement in specific areas or countries, but a particular assignment is never guaranteed, and the Corps prefers applicants who are flexible and willing to be assigned wherever the need is greatest.

If you think that you might be interested in applying to the Peace Corps*, the following facts will be of value. The application process may take anywhere from six months to one year and is keyed to the Federal Government year which begins in October. The process includes a personal interview in the recruiting office nearest your home town, followed by a nomination from that local office. There is an evaluation during which an applicant is screened, references are checked and procedures such as fingerprinting are undertaken. Once the nomination has been made by the local recruiting office, an approximate date of departure can usually be provided.

The Federal Government pays all expenses relating to a volunteer's service, including air-fare and medical and dental examinations, and provides a living allowance during the assignment abroad. The allowance enables a volunteer to live a little better than the masses of the country he or she is in, but as Ardath says, "Not too much better, because PC philosophy is that you live and work with the people." A travel allowance is provided if a volunteer wants to travel, explore or visit within the country to which he or she

*See Appendix

is assigned. In Ardath's experience, most of her colleagues had no trouble living within their allowances. The Government also sets aside $175 each month that volunteer serves, so that by the end of a two year assignment, an amount of $4,200 has been accumulated. What about the woman who is widowed, her children grown and gone, and who is living alone in an empty house? Could she safely sublet her home and save some money during a Peace Corps assignment? Ardath's advice is, "Don't do anything until you get that formal invitation from Washington. Don't sell your car. Don't give up your apartment. Don't give up your house until you get that letter because, until you get that letter, you may be stuck anywhere within the system. It is competitive!" She emphasizes, however, that a woman's experience and talents are welcomed by the Peace Corps, at any age. Any PC program that uses the term "extension" is a generalist program for people with experience that was not generally gained in school. Ardath comments that, "Health and Nutrition Extension is what it says. If you know something about nutrition, you can get into that and it's a wonderful field, because it is so important. You would not believe how many young children die in the African countries that we go to because the women do not know what to do when a child becomes dehydrated, yet there is a simple solution that all Peace Corps members are taught. And they don't know enough about balancing meals. The only fruit they ate when I was there was the orange, yet they grow grapefruit, lemon and lime. They grow pineapple and papaya, but don't eat them. It's absolutely amazing! The Nutrition program is such a helpful program, and any woman without a degree who has raised a family can get into it or into the Home Economics Extension program, with a little more training.

"Women can do *so* much—expecially in developing countries. Even if they were secretaries, they can use those skills in business education. Some countries will take women without a degree if they have had five years' experience as a secretary. If they have any Spanish background at all, they can teach literacy. And if they have French, they can teach English as a foreign language. Sometimes a degree is needed, but some countries are willing to take somebody who just has experience."

What is it like to change your whole way of living to go off to an unknown country? Ardath comments that some people do leave during training. "Some seniors leave because they have not been to school in years and they feel that the young people with whom they are training will laugh at them." Is this fear justified? Ardath talks of her own experience. "A young woman, fresh out of college, talked incessantly during the homeside stage of training about missing home, but she was determined to make it, and she refused to go home. As soon as she got to Sierra Leone, arriving during the religious celebration of Ramadan, she panicked and had to go back! A young man left one week into training, the last day before the group was to go up-country, because his guitar had been stolen. An older woman tried two different sites, but could never bring herself to go out and meet the people and introduce herself to the chief of the village. She eventually left."

The answer seems to be that, whatever your age, *you must know and understand yourself and your motivations* before you make a commitment to the Peace Corps or to any other enterprise that will involve drastic change! If familiar suroundings or personal property are essential to you, don't join the Peace Corps. If you are shy and insecure, joining the Peace Corps will not cure you! But, if you are fairly self-confident and open to change, it can be the most exciting experience of your life. As Ardath says, "I learned to be laid back. If you can reach one or two people and save one child, or teach one child so that he can pass an exam, or help one farmer learn how to double his crop, or help a woman earn some money and gain some respect from her town by being able to market something, then it's worth all of it. You grow a tremendous amount when you're there!"

What about culture shock upon returning home? Ardath describes an experience she had of walking into a supermarket soon after her return from West Africa, and of having to walk out again because of the superabundance of food. Cornflakes had been a luxury in her African village, and here in her local market she saw fifty varieties of cereal.

She reports that ninety-nine percent of all Peace Corps volunteers claim that they gained more from their experience abroad than the people they were sent to help. She feels that it is an especially valuable experience for mature individuals. "They have so much to offer people who have little—and I *don't mean money!*"

Of course, not everyone wants or is able to leave the country to promote world peace, but there are many small groups throughout the country who are practicing what is called Citizen Diplomacy, by visiting the U.S.S.R. and making personal contacts there. Artists and musicians are frequently in the forefront of these informal organizations, but in Maine recently a farmer, depressed about the possibility of nuclear war, was inspired by his wife to go on a tour of Soviet farms. While there, he purchased 1,300 pounds of wool. Returning home, he combined the wool from the Black Sea farm with wool from his own farm, and named the mixture, Peace Fleece. Not only does he now sell the wool in kits, but a weaver is making garments from the yarn for musicians to wear during a concert tour in the Soviet Union.

One idea will always lead to another. One individual's innovative idea can eventually affect the actions of many, and people working singly or in small groups, can effect changes more readily than governments can. If you feel that you want to make a contribution to peace on the planet, but feel that you do not want to leave this country to do so, then you might consider contacting VISTA* (Volunteers in Service to America), a national volunteer assistance program administered by ACTION, an independent government agency. Individual volunteers are assigned to local sponsors in the United States, and are expected to commit their efforts to improving the lives of low-income people. You would be provided with health insurance, a basic subsistence allowance and a stipend upon completion of service. If you join VISTA, you will live and work among the poor, sharing your skills and experience in such fields as education and literacy, drug abuse, neighborhood revitalization or economic

*See Appendix

development. You must be a United States citizen, and you may be assigned to any part of the country or to Puerto Rico, the Virgin Islands or Guam.

Another, quite different experience would be to join a workshop at Arcosanti*, an energy efficient, self-sufficient, city-in-the-making in the Arizona desert. Arcosanti is the result of a unique vision. Architect Paolo Soleri has combined his love for and experience in both architecture and ecology in designing and building this futuristic looking environment. Participants of all ages come to the site in the desert two hours north of Phoenix, to live and work in community with creative men and women of varied background and experience, in building a very special place. Fifty or sixty people live at Arcosanti year round, while others stay for periods as short as five weeks. 3,000 people from the United States and other countries have worked over the years at Arcosanti on a temporary, "workshopper" basis, living in basic accommodations below the mesa, while contributing their talents and efforts to the ongoing construction. Although there is no financial reward, there are many intangible benefits derived from being part of something special. Culture is a most important feature of life there, and music an integral part.

If you prefer to stay close to home, but want to make an impact in some manner on the way things are in your neighborhood, look in the yellow pages of the local telephone book for names and numbers of local organizations which are attempting to make life better, whether in the area of environmental protection, civil rights, global peace, substance-abusers' rehabilitation, shelter or food for the homeless, etc. There are literally thousands of organizations throughout the country that exist because somebody saw a need for improvement and set about forming an association to do something about it. Some of these are national organizations, some state, and some local. Every one of them has an ongoing need for workers who are committed to their particular cause and who are willing to give some time to make their little corner of the world more beautiful or more livable.

*See Appendix

Perhaps you would prefer to work on a one-to-one basis, in a situation that could provide you with the pleasure of seeing your efforts directly rewarded. In this case, consider tutoring a child in a subject that you enjoy, or teaching an illiterate adult to read. Literacy Volunteers of America* can provide you with a local contact if you are interested in any English-teaching project. There are many foreigners arriving in this country, daily. Asian wives who accompany their businessman-husbands here often find our ways strange and our language difficult. Think about teaching a small group or an individual how to cope with a new way of life! Personal notices in supermarkets or in local newspapers can often lead you to people who need your help. Be the initiator! Don't wait to come across a notice asking for help. Post a notice offering your services—either free, or on a fee-paying basis. What about reading and recording books for the visually impaired?

Manning a telephone hotline is another way in which you can see an immediate result from your efforts. Consider volunteering your time as a Crisis Counselor in any of the following fields: Child Abuse, Domestic Violence, Rape, Drug Abuse, Alcoholism, Suicide or AIDS. You do not need to have prior experience in the field, but you do need to have a love and concern for people, a willingness to listen, and a large amount of patience. If you are interested in one of the areas listed above, pick up the telephone and call now to obtain information as to how you can be trained to man a Hotline.

There are many organizations designed specifically with women's needs and interests in mind. The Older Women's League* and Wider Opportunities for Women*, along with the National Ogranization for Women* all focus strongly on legislative and political issues of special importance to women. As yet, we do not have an Equal Rights Amendment in the United States. If you feel strongly that such an amendment is necessary to the life, liberty and pursuit of women's happiness, contact your local office of the National Organization for Women to find out how you can contribute to making the ERA a reality in your lifetime. The American Association of University Women* is but one of many organizations which

*See Appendix

performs not only networking functions but also sponsors community service projects. Employed or unemployed, career woman or homemaker, you can find in the *Encyclopedia of Associations* (in the reference section of your library) a complete listing of organizations that would welcome you as a member and that would offer you plenty of scope for meaningful and personally rewarding work.

The greatest single threat to your happiness as a midlife woman is your own acceptance of situations as unchangeable, and your life as unimportant. Once you have accepted yourself, any step that you take to reach beyond your immediate needs, and out into the community, whether local or global, is a step that will lead you into a fuller life. A life beyond the self, one that has its share of challenge, change and commitment, is a life that can provide you with joy and peace of mind! Change should not be feared but welcomed as the opportunity to stretch, to grow and to remain young in spirit.

In an earlier era, Ben Jonson is reported to have said, "The man who is tired of London, is tired of life." Let us rephrase that famous statement for ourselves, to read: "The woman who is afraid of change, is afraid of life." Now let us turn that into a positive comment by declaring, "The woman who loves a good challenge, loves life!"

Living does indeed begin at forty! Let us rejoice and be exceedingly glad that our generation, at this stage of Western civilization, has been given the chance to fulfill ourselves in innumerable ways. Our child-bearing days may be over, but we can now give birth to new ideas. Our nurturing of one particular family may no longer be needed, but we can now extend our nurturance to ourselves and then to others in our larger, global family. We have the opportunity to lead the way into a new type of civilization, one dominated less by a paternal, militaristic mode of conduct than by a cooperative, intuitive, caring style. As governments learn that world peace and security can be neither created nor guaranteed by an arsenal or nuclear warheads, a new trend in governing will develop, one that responds to the needs of people within their natural environment.

We are on the cutting edge of a new awareness of the limits of planetary devastation by humankind. Let us, as women of experience, compassion and intelligence, create for ourselves, one by one, each in our own way, a second part of life that results in a joyful and satisfying experience for us all.

18

I Am, I Can, I Will!

It is our hope that the earlier chapters in this book have stimulated your imagination, expanded your awareness, and reinforced your belief in your own capabilities. When you find yourself faced with yet another challenge, remember that you happen to be a member of a unique generation, someone for whom the rules of the game changed dramatically, so that the role you anticipated playing throughout your adult life may have been rendered unfashionable or even unnecessary. Although changing circumstances can throw us off balance for a while, bear in mind that everything that happens in life can be seen in one of two ways, either as a setback or as an opportunity.

If you become separated, divorced or widowed, if your children have grown up and left, or if you have been let go from the job that you thought you were going to have forever, you have the choice either to dwell on your loss or to adjust, adapt and open up to new experiences and personal growth. Just as we need to give up outgrown or outworn clothing before buying new, we cannot begin a new relationship without giving up an old one. Marriages and family or career relationships can all run their course, and sometimes the best cure for an unhappy situation is to end it. Divorce or separation, for example, need not imply failure, as many women seem to believe. The termination of a marriage may simply mean

that the necessity for the marriage in its present form no longer exists. Partners often grow apart because individuals develop at different rates and in different directions. No one is at fault when this happens. Why would we expect two individuals to mature in identical ways? It is actually more remarkable that so many men and women are able to maintain a long-term relationship than it is that many choose not to do so!

If then, you are mourning the loss of what you had thought would be a permanent relationship, make every effort to forgive both yourself and your former partner, and decide to move on to the next part of your life. Particularly if you are divorced or separated, do not allow yourself to consider that you have been part of a "failed marriage." Marriages that fail often remain marriages! It can be more healing to bring a relationship to an end, thereby freeing two people for more growth, than to cling to a formally recognized union that has outgrown its optimum lifespan.

And, just as important as letting go of old patterns and old roles, is making a healthy decision to accept the aging or maturing process for yourself, without accepting the societal stigma associated with it. If you find it hard to convince yourself that being over forty or fifty is fine, you may find it helpful to use a personal affirmation on a daily basis. For example, every morning or evening, try saying to yourself, either aloud or mentally, "I am perfect the way I am," or "Life after forty is fun." You may not believe in what you are saying at first, but it's a case of "Let's pretend until we mend!" Using affirmations may seem very odd when you begin to do it, but if you think of the process as the re-recording of an old tape, or the re-programming of your subconscious beliefs, you will understand its importance at this stage of your life.

As we have discussed, many women suffer from seriously negative early conditioning, so that our self-esteem and self-confidence tend to be very low. Much of this lack of self-respect stems from comments made to us in our childhood, by parents or teachers. Often such comments were not intended to diminish us, but rather to keep us safe. If you are a parent yourself, haven't you felt that it was your responsibility to protect your child by keeping him or

her "in line?" The ultimate net effect, however, of negative conditioning is to lessen our intrinsic belief in ourselves and in our own competency and ability to make good judgements. Forms of negative or defensive programming vary from family to family or culture to culture, but the effects are so common as to make such conditioning appear to be almost universal. Very few women—or men— have true confidence in themselves, but, generally speaking, men hae been trained and encouraged to head straight for the goal they or others have set for them, while women have not been so trained. And this makes a big difference! Most women have been programmed to believe that if we behaved ourselves, the goal would somehow materialize for us! When we discover that this is not so, we tend to criticize ourselves for our shortcomings, not realizing that we were raised with a certain mythology. The use of personal affirmations or "self-talk," done regularly, will help to counteract and eventually erase those childhood-based negative beliefs or feelings of unworthiness that we have developed over the years.

On a scale of One to Ten, how would you rate your own Self-Confidence Quotient? If it is less than a Seven, compose a few personal affirmations and write them down. Make them very personal to you and your life. If you are not sure how to start, take the aspect of yourself about which you are the most critical, and deliberately re-phrase the criticism as approval. For instance, if you feel that you are a procrastinator, make your affirmation, "I am highly motivated and I take care of things promptly." If you do not think you are good looking, make your affirmation, "I like the way I look." Find something about your appearance that you really do approve of, and remind yourself that you have some fine assets. Too often, we concentrate on what we don't like about ourselves and it weighs disproportionately on our minds. You may feel particularly sensitive about one particular aspect of your appearance, but if you were to ask friends or acquaintances what they notice or remember about the way you look, you would probably be surprised to learn that their focus is on an entirely different and attractive feature, and that they see you as a beautiful person! It is essential that we, as women over forty, begin to see ourselves

in a more positive light, because otherwise we are in danger of buying into the current societal misbeliefs and demeaning ourselves in our own eyes.

Psychoterapist, Gilda Ligorner, a strikingly attractive divorced mother of three grown children, unequivocably states, "On some level, this whole business of being forty is such a harsh stereotype for women that it is time for us to say, 'I am who I am and I am how I look!' This struggle to be *other*, to be different from what we are, is so clearly an American woman's cross to bear! She and the world are never satisfied with her the way she is. Women are unable to look at each other and say, 'This is great—I've reached the age of wisdom!' Instead, it is, 'Oh God, I'm forty!'"

She goes on to say that she believes every woman has the right to decide what she wants to change in her lifestyle, rather than what she thinks the world wants her to change. She comments. "One can decide at forty to act, feel and be grown up, and to say that this is what we've been getting ready for!" She adds, "I think it is especially important for women to turn that corner, because we've been so infantalized and rewarded for being childish,—and it's nice to give that up. Women have been denying their ability to act grown-up for a long time, thinking that is is more attractive not to act all-knowing, or to show their intuitive wisdom. So I think it's not so much deciding to begin to be smart, but rather it's a decision not to let your intelligence be hidden any more. It's a bit like virginity—after all, what's it to be saved for?" She declares that there is a joy in being able to say what you think, and a joy in relishing your own intelligence. "It's time to stand up and be counted, and it's time to finally speak up! Do we have to be old and gray and ill before we can decide that we are old enough to be wise? And, of course, the joke is, that if we wait that long, we're likely to be dismissed as too old and incapable! It's time for enhancement, not diminishment! Women, by and large, do not feel entitled to their share of the pie. Men, on the other hand, presume they've got it all coming—whether it's in the form of money, power or women! But women assume they have to *give* it, and they're stuck with it! The secret is to tell people what you want. If you don't, you're probably never going to get it."

Ms. Ligorner has strong opinions about the need for women to take a stand on their own behalf and to develop their own strengths and unique beauty. Her beliefs appear to be substantiated by the research of renowned psychologist, Dr. Daniel Levinson, who recently studied a group of women, ranging from businesswomen to homemakers. It was reported that he found that even the most traditional women struggled with questions about work and family, independence and marraige. The biggest difference between his studies of men and women appeared to be that men are able to form a picture of what they want to become and how they want to live their lives, while women have great difficulty in doing so. His research indicates that society supports the male concept of achievement and growth, but has not encouraged the same type of self-actualization for women.

It is probably true that we, as women over forty, are more confused about the changes in society's expectations of us than any other group of women in history. As members of a unique generation, caught in the crossfire of opposing belief systems, we need to create our own guidelines and to "dream the impossible dream." Many people believe that the simplest and yet the most effective technique for achieving a sense of who we really are, is that of daily meditation. Unfortunately, the word meditation is one of those which is considered "loaded" because of its apparent connection to Eastern mysticism, a belief system largely known in the west. Perhaps we could call meditation by another name, such as Relaxed Centering, or Relaxed Concentration, indicating simply a period of quiet time, during which the mind is allowed to drift away from the daily stresses and concerns into an inner state of calm centered on or in oneself. Such fifteen to thirty minute relaxation breaks, taken regularly, can keep us in touch with our intuition and help prevent the emotional highs and lows that can so often throw us off balance. And once we are in touch with our own intuition, we will have a sense of "coming home."

Another method of reaching this comfort stage is through the practice of another Eastern import—yoga. Yoga is basically a simple and gentle exercise method which, in conjunction with certain breathing techniques, can induce a similar feeling of emotional and

physical balance. When we are in a state of ease, rather than anxiety, we react to everyday challenges with, if not perfect equanimity, at least a sense that we cannot be overwhelmed. Surprisingly, physical exercise is a form of relaxation and emotional balancing, too, and there are various forms of exercise which are claimed to bring about benefits similar to those enjoyed by meditators. For example, jogging is known for its calming, therapeutic effects. As we mentioned in an earlier chapter, vigorous or focused walking can achieve the same results. Swimming is, of course, an ideal exercise, both for its physical streamlining and for its soothing effects. Immersion in water always reduces one's stress level—even soaking in the bathtub can bring positive results, while the mere thought of sitting by the ocean, watching the waves is often enough to bring us back into a relaxed state. If you can't get near the ocean, listen to a cassette tape of the sound of waves braking on the shore. Find your own, personal route to good mental and emotional balance. Reciting your personal affirmations while you are exercising or relaxing can do you nothing but good!

Fully enjoying being forty or older can be likened to living in a big city. If you, as a city dweller, spend each day worrying about the possibility of being attacked, afraid to use mass transportation, and scared to walk home alone after dark, then your life becomes simply an exercise in existing. If, on the other hand, you respond to city life as a challenging, often humorous experience, in which you relish the diversity of faces, activities and neighborhoods, then your life becomes an example of joyful excitement. At forty, we can begin to understand that life does not happen to us, so much as it is designed by us. We have choices to make! We can see the ugliness or we can see the beauty. We can think of the problems or of the possibilities. Above all, *we can choose to make life what we want it to be,* by refusing to think of ourselves as invisible and unwanted, but instead, as highly visible and desirable, both in terms of work and personal life. We can give up being victims of circumstance. Look around you—there are thousands of bright, funny, original, warm-hearted, talented women over forty in this world. And you are one of them!

So please use this book as a starting-point, a jumping-off place from which you can strike out on your own. Refer to it for guidance, but make your own adaptations and improvements. Remember that it is still possible, living in the Western world, to live your own Rags to Riches story. All you need is motivation, determination, and love—both for yourself and for others. Good luck!

Appendix

Counseling or Referral
(General)

Alcoholics Anonymous and Al-Anon Family Intergroup (for family member, teenagers and adult children of alcoholics): (212) 473-6200 or check your telephone book for local branch listing.

American Medical Association, Chicago, IL (312) 645-5000

Displaced Homemakers' Network, (202) 347-0522, and see separate listing.

Divorce Support Center, 370 Central Avenue, Mountainside, NJ (201) 232-6054

National Association of Social Workers, 7981 Eastern Avenue, Silver Spring, MD 20910 (301) 565-0333

National Institute on Alcohol Abuse and Alcoholism, (301) 468-2600

Displaced Homemakers
(Separated, Divorced or Widowed Women)

Displaced Homemakers' Network (Headquarters)

755 Eighth Street, NW, Washington, DC 20001 (202) 347-0522.

Displaced Homemaker Regional Offices

Region I: Displaced Homemakers' Center, 150 Washington Street, Providence, RI 02903

Region II: Volunteer Bureau of Bergen County, 389 Main Street, Hackensack, NJ 07601

Region III: Displaced Homemakers' Project, Villa Julie College, Greensburg Valley Road, Stevenson, MD 2153

Region IV: Center for Continuing Education, Valencia Community College, PO Box 3028, Orlando, FL 32802

Region V: Women's Development Center, Waukesha County Technical Institute, 800 Main Street, Pewaukee, WI 53072

Region VI: Displaced Homemakers' Services, PO Box 44064, Baton Rouge, LA 70864

Region VII: The Door Opener, 215 North Federal Avenue, Mason City, IA 50401

Region VIII: Phoenix Institute, 383 South 600 East, Salt Lake City, UT 84102

Region IX: Displaced Homemakers' Program, Career Planning Center, Inc., 2260 West Washington Boulevard, Los Angeles, CA 90018

Region X: Displaced Homemakers' Network, PO Box 2386, Seattle, WA 98111

Employment and/or Advocacy

(See also Displaced Homemaker Networks, Professional Organizations and Women Business Owners)

National Organization for Women, Washington, DC (202) 347-2279

Wider Opportunities for Women, 1325 G Street NW, Washington, DC 20005 (202) 783-3143

Women's Action Alliance, 370 Lexington Avenue, New York, NY 10017 (212) 532-8330

Women's Bureau, Office of the Secretary, United States Department of Labor, Washington, DC (coordinates 200 Regional Offices) (202) 523-6611

Housing

National Shared Housing Resource Center, Philadelphia (coordinates 400 programs throughout the country) (215) 848-1220

Legal

American Academy of Matrimonial Lawyers, Chicago, IL (312) 263-6477

National Association of Black Women Attorneys, 3700 Lochearn Drive, Baltimore, MD 21207 (301) 298-5931

National Association of Women Lawyers, 1155 East 60 Street, Chicago, IL 60637 (312) 947-3549

National Organization for Women, Washington, DC (202) 347-2279 (and branches in major cities)

NOW Legal Defense and Education Fund, 99 Hudson Street, New York, NY 10013 (212) 925-6635

National Women's Law Center, 1616 P Street NW, Washington, DC 20036 (202) 328-5163

Medical

American Society of Plastic and Reconstructive Surgeons, Chicago, IL (312) 856-1818

American Medical Association, Chicago, IL (312) 645-5000

American Psychological Association, 1200 17 Street NW, Washington, DC 20036 (202) 833-3410

Minority Women

National Council of Neighborhood Women, 198 Broadway, New York, NY 10038 (212) 964-8934

National Conference of Puerto Rican Women, PO Box 4804, Washington, DC 20008

Older Women

Gray Panthers, Philadelphia, PA (215) 438-0276

National Action Forum for Midlife and Older Women, State University of New York, Stony Brook, NY 11794 (516) 246-2256

Older Women's League, 730 11 Street, Washington, DC 20001 (202) 783-6686

Widows

International Association for Widowed People, PO Box 3564, Springfield, IL 62708 (217) 562-4750

Volunteers

Arcosanti, c/o Cosanti Foundation, 6433 Doubletree Road, Scottsdale, AZ 85253 (602) 948-6145

Literacy Volunteers of America, (National Headquarters), (315) 445-8000

National Volunteer Center, 1111 N. 19 Street, Arlington, VA 22209 (703) 276-0542

Peace Corps, P-301, Washington, DC 20526 (800) 424-8580

Volunteers in Service to America (VISTA), 806 Connecticut Avenue NW, Washington, DC 20525 (202) 634-9445

YWCA of the USA, 726 Broadway, New York, NY 10003 (212) 475-5990

Professional Organizations

American Association for Counseling and Development, 5999 Stevenson Avenue, Alexandria, VA 22304 (703) 823-9800

American Association of University Women, 2401 Virginia Avenue, NW, Washington, DC 20037 (202) 785-7700

American College of Nurse-Midwives, 1012 14 Street NW, Washington, DC 20005 (202) 347-5445

American Federation of Teachers, 11 Dupont Circle NW, Washington, DC 10036 (202) 797-4400

American Massage and Therapy Association, Box 1270, Kingsport, TN 37662 (615) 245-8071

American Society of Travel Agents, 4400 MacArthur Boulevard, Washington, DC 20007 (202) 965-7520

American Society of Women Accountants, 35 East Wacker Drive, Chicago, IL 60601 (312) 726-9030

American Translators' Association, 109 Croton Avenue, Ossining, NY 10562 (914) 941-1500

American Women Composers, 7315 Hooking Road, McLean, VA 22101 (703) 827-8346

Association for Women in Computing, 407 Hillmoor Drive, Silver Spring, MD 20901

Association of Part Time Professionals, PO Box 3419, Alexandria, VA 22303 (703) 734-7975

Federally Employed Women, 1010 Vermont Avenue NW, Washington, DC 20005 (202) 638-4404

International Association of Personnel Women, 211 East 43 Street, New York, NY 10017 (212) 867-4194

International Women's Writing Guild, Box 810, Gracie Station, New York, NY 10028 (212) 737-7536

National Association for Practical Nurse Education and Service, 254 West 31 Street, New York, NY 10001 (212) 736-4540

National Association of Bank Women, 500 North Michigan Avenue, Chicago, IL 60611 (312) 661-1700

National Association of Black Journalists, PO Box 2089, Washington, DC 20013

National Association of Black Women Entrepreneurs, 2200 Woodward Towers, 10 Witherell, Detroit, MI 48226 (313) 963-8766

National Association of Executive Secretaries, 3837 Plaza Drive, Fairfax, VA 22030 (703) 691-1312

National Association of Social Workers, 7981 Eastern Avenue, Silver Spring, MD 20910 (301) 565-0333

National Association of Women Artists, 41 Union Square, New York, NY 10003 (212) 675-1616

National Association of Women Business Owners, 500 North Michigan Avenue, Chicago, IL 60611 (312) 661-1700

National Federation of Business and Professional Women's Clubs, Inc., 2012 Massachusetts Avenue NW, Washington, DC 20036 (202) 293-1100

National Federation of Press Women, Box 99, Blue Springs, MO 64015 (816) 229-1666

National League for Nursing, 10 Columbus Circle, New York, NY 10019 (212) 582-1022

National League of American Pen Women, 1300 17 Street NW, Washington, DC 20036 (202) 785-1997

Professional Secretaries International, 2440 Pershing Road, Crown Center, Kansas City, MO 64108 (816) 474-5755

SAG-AFTRA, Screen Actors Guild—American Federation of Television and Radio Artists, 1700 Broadway, New York, NY 10036 (212) 489-9150

Society of Children's Book Writers, Box 296, Mar Vista Station, Los Angeles, CA 90066 (213) 347-2849

Women in Communications Inc., Box 9561, Austin, TX 78766

Women in Theatre, PO Box 3718, Hollywood, CA 90028

Women Library Workers, 2027 Parker, Berkeley, CA 94704 (415) 540-6820

Women's Council of Realtors, 430 North Michigan Avenue, Chicago, IL 60611 (312) 329-8483

Women's National Book Association, 950 University Avenue, Bronx, NY 10452 (212) 588-8400

Women Business Owners

American Women's Economic Development Corporation, 60 East 42 Street, New York, NY 10165 (212) 692-9100

National Association of Black Women Entrepreneurs, 2200 Woodward Towers, 10 Witherell, Detroit, MI 48226 (313) 963-8766

National Association of Women Business Owners, 500 North Michigan Avenue, Chicago, IL 60611 (312) 661-1700

Office of Women's Business Enterprise, 1441 L Street NW, Washington, DC 20416 (202) 653-8000

Small Business Administration: check your local phone book under Federal or State Government offices

Miscellaneous

Expert Lecturer Service, PO Box 95, Hillsdale, NJ 07642

Recordings for the Blind, 1-800-221-4792

Ross Reports, TV Index, Inc., 40–29 27 Street, Long Island City, New York, NY 11101

TRW Credit Data, 5 Century Drive, Parsippany, NJ 07054

United States Copyright Office, Register of Copyrights, Library of Congress, Washington, DC 20559 (202) 287-5000

Womanship Waves, 137 Conduit Street, Annapolis, MD 21401 (301) 267-6661

Other Books from Mills & Sanderson

Winning Tactics for Women Over Forty: How to Take Charge of Your Life and Have Fun Doing It by Anne DeSola Cardoza and Mavis B. Sutton. A multifaceted guide for those women now in their forties and fifties who have suddenly found themselves having to adapt their lifestyles to a world for which they were not prepared. Explicit chapters cover such essentials as health, personal growth, adapting to loss, financial planning, housing options, etc. The connections, techniques, resources and options available to these women are extensively covered. **$9.95**

Aquacises: Restoring and Maintaining Mobility with Water Exercises by Miriam Study Giles. Unlike most of the exercise books presently available. Aquacises is devoted to both the physical and psychological fitness of those millions who just want to feel better—and move around better in their normal activities. Written by a former dancer who has taught swimming and exercise for more than half a century, this book is primarily focused on senior citizens' needs, but is also an invaluable resource for those suffering from physical handicaps and those too self-conscious about their shapes to join in community calisthenics. **$9.95**

There ARE Babies to Adopt: A Resource Guide for Prospective Parents by Christine A. Adamec. Author-researcher Adamec, an adoptive parent herself, provides a tremendous amount of valuable information and advice aimed at helping you adopt the baby you want. Gleaned from both personal experience and in-depth interviews with over a hundred other adoptive parents, social workers, and other adoption specialists, this practical guidebook dispels the popular myth that there are no healthy babies available for adoption unless you are willing to wait five to seven years. **$9.95**

Fifty and Fired! How to Prepare for It; What to Do When It Happens by Ed Brandt with Leonard Corwen. The authors lead the middle-aged, middle-manager through the trauma of age motivated job dismissal using actual hard-hitting case histories to show what can be done before and after the fact to defend your career and dignity, and rebuild your livelihood. **$9.95**

Your Astrological Guide to Fitness by Eva Shaw. Find out what your astrological sign has to say about your ideal exercises, sports, and menus. There are also astrologically keyed gift ideas and comparison charts to help you choose your ideal mate or traveling companion. **$9.95**

Bachelor in The Kitchen: Beyond Bologna and Cheese by Gordon Haskett with Wendy Haskett. From Beer Jello to Duck with Cherries, San Diego chef Gordon Haskett shows you quick and easy recipes for yourself and/or that special someone in your life; also, how to be the hit of any party or Pot Luck. **$7.95**

60-Second Shiatzu: How to Energize, Erase Pain, and Conquer Tension in One Minute by Eva Shaw. The author explains how acupressure relief can be self-administered amidst the frustrations of commuter rush hours, college exams, family fights, or office hassles. It's fun, it's easy, and it works! **$7.95**

Smart Travel: Trade Secrets for Getting There in Style at Little Cost or Effort by Martin Blinder. The author's thirty years of globe-spanning travel have taught him many secrets for getting the best of everything for as little expense as feasible, and he wants to share those secrets with you. **$9.95**

The Cruise Answer Book: A Comprehensive Guide to the Ships and Ports of North America by Charlanne F. Herring. This book offers a tremendous amount of information about ships, itineraries, shore excursions, and ports that is not included in other cruise guides, and that will help you decide which cruise is best for you at any particular time. This book concentrates on cruises around North America, the Caribbean, Bermuda, Hawaii...the areas where most Americans choose to cruise. **$9.95**

Adventure Traveling: Where the Packaged Tours Won't Take You by T.J. "Tex" Hill. Whether you're looking for the keen edge of real danger or trips that invoke the tingle without the threat, here's an international menu of itineraries and guidelines for the vacationer who is looking for a "different" kind of vacation. **$9.95**

Order Form

If you are unable to find our books in your local bookstore, you may order them directly from us. Please enclose check or money order for amount of purchase plus handling charge of $1.00 per book.

() Winning Tactics for Women Over Forty @$9.95 _____

() Aquacises @$9.95 _____

() There ARE Babies to Adopt @$9.95 _____

() Fifty and Fired! @$9.95 _____

() Your Astrological Guide to Fitness @$9.95 _____

() Bachelor in The Kitchen @$7.95 _____

() 60-Second Shiatzu @$7.95 _____

() Smart Travel @$9.95 _____

() The Cruise Answer Book @$9.95 _____

() Adventure Traveling @$9.95 _____

 Add $1.00 per book handling charge _____

 Add 5% Sales Tax if MA resident _____

 Total Amount enclosed _____

Name _____

Address _____

City/State/Zip_____

Mail to: Mills & Sanderson, Publishers
 442 Marrett Road, Suite 5
 Lexington, MA 02173